Fact and Symbol

"Fact and Symbol„

ESSAYS IN THE SOCIOLOGY OF ART AND LITERATURE

CÉSAR GRAÑA

New York OXFORD UNIVERSITY PRESS 1971

Foreword

An awkward alloy of Greek and Latin, "sociology" has never succeeded, despite the many years of its usage, in becoming a comfortable word. Still more, ever since Flaubert read Auguste Comte with a mixture of amusement and scorn, the *idea* of such a mode of knowledge has appeared to literary intellectuals as an ignorant illusion, fostered by pseudo-scientific enthusiasm and incapable of dealing with the intricacies of human behavior, or—what was more vulnerable and reverently to be considered—the "human condition." In the case of the sociologists' efforts to offer their understanding of literary and artistic works the suspicion was even deeper and more sour. The anticipation was always that sensitive imaginations would be forced to witness the spectacle of the great testaments of "meaning"—memorable, depth-rich, elusive—subjected to the irrelevant commentaries of brazen and reductionistic minds.

One answer to all this is to say that, just as there is a vulgar sociologism there is also a vulgar anti-sociologism. W. H. Auden advises the humanist "never to commit a social science." And remembering the excruciating banality of some

sociological writing, one's first impulse is to applaud Auden gratefully, even defiantly. In the end, however, we must see that his is a frivolous remark. An act of posturing, witty, of course, about the sacred frailties and mysteries of man and art, an easy gesture toward one of the most celebrated objects of intellectual piety and sentimentality: "the dignity of man."

It would be comfortable to have things Auden's way, with humanist criticism, tactful, thoughtful and sensitive on the one hand, and sociology, oppressively and naïvely pretentious on the other. But I hope to show that to think in this fashion is cheap, melodramatic, and false. This book contains some examples of what I believe the sociology of taste and ideas can do. They are essays, that is to say, exercises, tests, and trials, and the reader should not set for himself the task of deciphering an expected "theoretical scheme." They are not illustrations of some general notion about the social origins of thought and imagination, or demonstrations by equation of the symmetric bond between social "factors" and their "reflection" in the world of images and concepts. They are discussions of specific literary and artistic questions in relation to specific cultural episodes, situations, and traditions. I make no reference to such categories as "modern" or "industrial" man, or to "ages of" (anxiety, etc.), terms employed at times by literary critics and *Weltanschauung* commentarians, and which appear to me as thin, ad hoc, and self-justifying as the most barren conceptual inventions of the sociologists. Nor do I fall back on such notions as "bourgeois society" or "mind," used by some with confident and protean imprecision, and mostly for polemical purposes. More generally I should simply say that, while there is no room here to discuss what I think of the Marxist method, so influential as philosophical flavoring or doctrinal standard among cer-

tain critics of art and literature, my reservations to it can be inferred throughout.

The first essay is a summary of the most obvious—the word is probably "overwhelming"—feature of literary life since the romantic movement; that is to say, the refusal, inconsolable or implacable, to accept the terms, social or symbolic, of Western culture following the political, scientific, and economic events of the first half of the nineteenth century. I have dealt with a number of emblematic attitudes and emotions: anti-rationalism, aestheticism, heroic or fastidious personalism, cynicism, antiquarianism both artistic and social, despairing, catatonic or hedonistic irony, the revulsion against "progress," and the rejection of democracy as a cultural style. I have also endeavored to show the ties among these, and the remarkable force of an intellectual tradition, endemic by now, leading from Flaubert and Stendhal to Nietzsche, Gide, Orwell, and Norman Mailer or even Bertrand Russell and Arthur Miller.

Some segments of the book, like the discussion of the French impressionists, deal with the correspondence between external details of style and inflection and the artist's implicit understanding of the nature of social events. The essay compares the psychological conventions of Western European painting before the nineteenth century with the impressionists' perception-depiction of metropolitan life as a succession of moments at once fleeting and absolute. Others, like the analysis of John Dewey's *Art as Experience,* consider the difficulties in arriving at a social understanding of art starting from an aesthetic *philosophy,* even one which, in the eyes of its author, had shaken itself free of the intellectual artifices of the past and restored to its true significance the place of daily life in the formation of aesthetic sentiment. Laboring to break down the boundaries between art and existence,

and unable to escape the notion that all meaningful psychological energy must flow either toward the environmental others or toward the "characteristically valuable things in the normal processes of living," Dewey seems to invite a wedding of pragmatism and a kind of populistic sentimentality in aesthetic doctrine.

Art museums, the subject of another piece, is about the paradoxical nature of this recent—and extraordinarily successful—creation of Western culture. Intended to allow the populace to look freely upon the great works which are, supposedly, its own rightful heritage, museums are actually often engaged in the curious and perhaps intractable task of democratizing the heirlooms of a secluded and privileged past. The long examination of Neil Harris's study of the American artist looks at the same question from a different and converse point of view. By this I mean the transformation of the industrial and commercial elite of America, and of Americans generally, from heirs of a historical morality of utilitarian dedication to voracious acquisitors and consumers of art. I do not offer an explanation for this remarkable fact. But, in the still lingering aftermath of Thorstein Veblen, I suggest that, for whatever reason, new money arising out of the egalitarian marketplace, seeks legitimacy in the odor and tokens of a pre-industrial society.

The note on Louis Sullivan and Midwestern architecture disputes one of the most seductive notions of cultural history and cultural sociology—the belief that, in some osmotic but irresistible way, the "spirit" of the collectivity can guide the hand of the individual artist. Finally, in the essay on the Spanish-American literary utopians, I employ the testimony of a uniquely self-revealing case history to question one of the most consuming, exhibitionistic, self-serving, and self-defeating "issues" of the contemporary cultural scene: the "problem of identity." What I have attempted to show is

that the search for identity is really an act of conjuration, the effort to give life to a metaphor, a metaphor that rests on the imputation to whole people and nations of the self-consciousness, grievances, and demands of the metaphor makers, that is to say, the intellectuals.

I agree with Richard Gilman that art is "what does not have to happen." Art is not needed for the creation or for the survival of a social order. And all the classic claims about the social determination of art or the artistic representation of "reality" suffer from almost insurmountable problems of philosophical consistency or socio-psychological reconstruction. It is, however, more than enough for sociologists to describe the surroundings in which certain forms of artistic imagination become conceivable as commodities of the public taste and understanding and, therefore, as social facts.

C. G.

March 1970

Acknowledgments

Mrs. Robin Pardini and Mrs. Charlotte Cassidy contributed many hours of alert and resourceful labor to the preparation of the manuscript, and I want to offer them my thanks.

Mrs. Edith Meyers, with a generosity born of friendship, gave of her time to the preparation of a section of this book in earlier form. Fortuitously and regretfully I did not give her my thanks then. I wish to do so now.

Contents

Fact and Symbol

1 · Social Optimism and Literary Depression

One of the dominant features of the nineteenth century was a profoundly disturbed intellectual life. Another was the triumph of the idea of progress and the rousing spectacle of economic achievements which for many confirmed the power and the truth of this new faith. The traditions of literary anger and *ennui,* by now seemingly endemic to Western culture, had their beginning at about the same time that the industrial exposition was being invented. Pageants of material conquest and ceremonials of technological pride were being mounted while contempt for the world of machines and factories was developing into a literary and philosophical manner. The religion of beauty and the cult of artistic genius co-existed with the new moral dignity of business which held that, in the new society, economic functions were no longer to be considered as the backstage chores of classes regarded since Plato as tainted by reason of their very usefulness.

Business and technology affected not only the material aspects of modern life but most of the basic perspectives of social worth. The unprecedented skills which they demanded and created for the mastery of the natural environment, and

the techniques of production, transportation, and distribution of goods they caused to develop, were so complex and so palpably successful that inevitably they presented a challenge to the older notions of intellectual and public performance. The day had passed, wrote Emile Durkheim, for the man detached from all and interested in all; the individual capable of appropriating and expressing all that was "best" in civilization no longer had a place.[1]

Increased productivity was not only an obvious fact of contemporary society. It became one of its leading public virtues, celebrated even by those who condemned the social motives of its principal protagonists, the business entrepreneurs, and arousing deep historical curiosity on the part of scholars. Max Weber, leaving aside questions of "social justice" or "exploitation" or the political significance of "class consciousness," embarked upon the study of Protestantism and its connection with capitalism in order to find out what *moral* and *intellectual* events might account for the remarkable industriousness of the modern era. In *The Communist Manifesto* Marx and Engels, after summarizing their version of all history, beckoned the workers and their leaders to take the next step in the logic of that history, an enterprise which, in their eyes, called, of course, for the destruction of the capitalist system. Yet, as they issued that call, they did not forget to look back to offer the bourgeoisie, if not a eulogy, certainly, as Benedetto Croce pointed out, an enthusiastic obituary, praising it for productive and technical achievements far loftier, they thought, than such old romantic wonders as cathedrals and pyramids.

The larger effect of these views was, inevitably, to threaten the traditional European code of civilized existence: the autonomy and superiority of formal ideas, the training of sensibilities, and the unhurried elaboration of artistic styles. In other words, the freedoms and opportunities that leisure

had for so long extended to the life of the mind. They also raised the altogether new question, peculiar, perhaps, to a self-consciously and "philosophically" diligent age, of the productivity of the mind itself, and of the possibility of looking upon the intellect as a work unit with a measurable output. The scandal and alarm felt by men of letters in the face of this suggestion are expressed by Isaac Disraeli* in these words:

> A new race of jargonists, the barbarous metaphysicians of political economy, have struck at the essential existence of the production of genius in literature and . . . art. Absorbed in the contemplation of material objects, and rejecting whatever does not enter into their own restricted notion of "utility" these cold arithmetical seers, with nothing but millions in their imagination, and whose choicest works of art are spinning-jennies, have valued the intellectual tasks of the library by "the law of supply and demand." 2

It is to repeat a commonplace to say that the intellectual tradition defended by Disraeli was an aristocratic one. The aristocracy had been the ambit within and for which literature and art had been largely created in the past, a condition which, while keeping men of letters free of the tarnish of practical affairs, was also often responsible for turning them into specialized retainers of the upper classes. As a cultural reality, however, the facts of this tradition are far more complex, subtle, and indirect than any notion which might suggest a simple exchange of literary services for economic sponsorship, or lead one to the belief that aristocratic favor made all of literature into a series of gestures of class adulation. As Tocqueville pointed out, what made aristocratic literature "aristocratic" was not any one subject or aesthetic. It was rather its ability to reflect a *milieu* which, putting craftsmanship under the shelter of social power, allowed the

* Isaac Disraeli, father of the famous prime minister, was an essayist, poet, and occasional historian.

perpetuation of certain carefully regulated concerns of taste and imagination.[3]*

It is nevertheless true that, in another sense, literary "purity" stood for an idealization of class differences. La Mesnardière,** for example, admonished poets to avoid dealing with "the meanness of avarice, the infamy of indulgence, the horror of cruelty, the smell of poverty," [4] a coupling of moral aberrations with a degraded economic condition which, at first, seems unexpectedly arbitrary (at least in the days before sociology). But the meaning becomes clear if we assume, with the critic, that social distance must be regarded as the index of spiritual qualities, just as moral dignity naturally emanates from certain status heights (that is to say, the aristocracy) which serve them as model and embodiment. This also allows us to understand how, in judging the epic passions of tribal Greece by the courtly standards of royal France, Fénelon*** could be led to the conclusion that Homer's gods and heroes were "unworthy of the idea that we have a gentleman." [5] Traditional literary ideals had a universal rhetoric and a class "image." They sought *la belle nature,* the most elevated possibilities of the human character. But the creature in which this essence breathed was the civilized gentleman, educated

* Tocqueville himself associated the "poetic" with the aristocratic. A suggestion of the marvelous and the remote, he thought, always flowed from two social characteristics of the aristocrat's behavior: the awe-inspiring personal distance he kept from the rest of the world, and his inscrutable reverence for the past. On the other hand, aristocratic art could fall into nothing more than the cultivation of manneristic delights or, as Nicholas de Malezieu put it, "toiling in the galleys of sophistication." Besides coining such painfully demure figures of speech, Malezieu (who served as chief cultural entertainer for the Duchess of Maine, Voltaire's patroness), also invented a parlor game requiring the players to write a poem dictated by the initial letter drawn in a lottery. Those who drew an "O" wrote an ode. Those who drew an "A" wrote an apotheosis.

** Hyppolite: Jules Pilet de Mesnardière (1610–63).

*** François de Fénelon (1651–1715).

in the classics and trained in propriety, and thus turned into a living monument to poise, discernment, and learning.

Even so, we must regard the demands of the modern intellectual not only as the product of aristocratic antecedents but also as an appropriation and peculiar re-creation of these antecedents. Jean-Paul Sartre, discussing French literature after 1789, explains it as a case of class ideology surviving class structure. Pre-revolutionary writers, he says, though in the service of the elite, had themselves been men of the bourgeoisie, and it would have been logical for them to return to their own class for approval and status when this class became the ruling force following the Revolution. But the bourgeoisie, if exploitative, was also hard-working, and writers, trained by prolonged aristocratic contact to abhor utility and to regard their craft as pure art free of obligations to daily life, found it impossible to return to a world dominated by the spirit of social pragmatism. As for the bourgeoisie itself, it hardly could have been expected to become the sponsor of a literature dedicated to "values," and indifferent to its supporter's social interests.[6] What Sartre does not take into account, however, is the distinction between the non-utilitarian posture of traditional leisure-class culture and its literary spokesmen, and the passionate proprietorship of the mind assumed by the intellectuals as the self-created leaders of society, now that the actual aristocracy, that is to say, the political and economic aristocracy, had been destroyed by revolutionary change. Aristocratic literature had been asocial in the sense that it was not intended to serve some general public need or gratify a vast audience. But it remained a class art even though it transmuted its class tastes into a language of universal values. There is a great difference between this and the art created by a "pure" aristocracy of thought and sensitivity that emerged in the nineteenth century. Such art was aristocratic in a new and peculiarly auton-

omous way. It was the artist's art, the expression of a class-
less spiritual caste sure of the privileges to which it was
entitled by virtue of its peculiar gifts. "If there is in the
world a sacred property," Balzac wrote, "if there is something
that belongs to man, is it not that which man creates between
heaven and earth, that which has no root other than in-
telligence?" [7]

On March 26, 1847, Prime Minister Guizot of France arose
on the floor of the Chamber of Deputies to speak against an
amendment to the electoral law that would give the vote to
persons of intellectual distinction without regard for property
or income.* In France, Guizot said, the vote was not conceived
as the momentary act of an individual but as an extension of
the individual's membership in social groups, the civic in-
terests and responsibilities of which *groups* entitled the indi-
vidual to parliamentary representation. The admendment
would grant political rights to intellectuals without taking
into account their social station and would, in effect, recognize
intelligence as a social rank in itself. To this Guizot objected
as follows:

> Gentlemen, I have infinite respect for intelligence; it is one of
> the virtues, and will be one of the titles of honor of our time to
> have high respect for knowledge and give its due. But I myself
> do not blindly trust intelligence nor do I believe that others should
> have such trust, least of all in our time. Excessive confidence in
> human intelligence, human pride, intellectual pride—let us call
> things by their names—these are the disease, the cause of a large
> part of our errors and our evils. Intelligence, as I have had the
> honor to say in this chamber so frequently, must at all times be
> guarded, restrained, guided by social conditions. The proponents
> of the amendment treat modern intelligence as one treated in

* Property qualifications at the time limited the voting population of France
to a "legal nation" of 250,000 out of a total population of 35,000,000. See:
Sherman Kent, *Electoral Process under Louis Philippe* (New Haven: Yale
University Press, 1937).

former days the aristocracy. It seems that one should demand of intelligence that it be noble and that it be nothing else.[8]

We are provided here with a peculiarly French scene: an intellectual question argued at the highest levels of drama, rhetoric, doctrine, and politics. But we can recognize in Guizot's speech, and the issue to which it was addressed, an episode in the general struggle over the singular demands and uncertain rights of the present-day intellectual. Disraeli's argument against the new barbarians had rested its case on the old-fashioned values of literary charm and uplift. But the ultimate point at stake was really whether or not the new and independent literary elite, liberated by revolutionary social change from its previous dependence upon the noble classes, was to have a legitimate public place, and whether, in consequence, people would bow before the accomplishments of this self-declared aristocracy as they had once bowed before their traditional or hereditary social betters.

In dealing with this theme, either as a point of ideology or of tactics, the most diverse writers seemed always to be led by their fears and suspicions to the same target: the middle classes. This is true of "scientific" political thinkers and of poets whose contempt for rationality was equaled only by their indifference toward social issues, of Marx and Baudelaire, of romantics and revolutionists. Alexis de Tocqueville, a conservative and finely bridled mind, and Louis Blanc, a partisan and libertarian one, could without strain agree on the moral shortcomings of the bourgeoisie in something like the same language. And if two men as far apart as these in their public and intellectual inclinations could find so readily the same object of denunciation, the question must be asked as to why a class which had triumphantly climbed to political and economic power should have been regarded as the culturally underprivileged segment of society, to be placed beyond all historical dignity or spiritual virtue.

Actually, the tradition of contempt for the bourgeois is much older than the attacks of the nineteenth-century intellectuals. In reading French chronicles of the fifteenth century Johan Huizinga discovered that court writers would conveniently neglect the actual weight of the middle classes in order to retain a stereotyped portrayal of the ancestral order of repute. For the authors of these documents the nobility was the sole embodiment of veracity, courage, and largesse. To the noblemen were naturally entrusted the highest functions of the state, the defense of the church and the safeguard of the people, and no distinction was to be drawn between the meanest laborer and the wealthiest merchant, both being of "servile condition" and incapable of "high attributes." [9] One medieval poet, Thomasin von Zilcaria, described the rise of the middling ranks in his time by saying that stools had climbed on tables, silver fir had descended to the valleys, and moss had ascended to the mountain tops. Another, Freidank, excluded them from the God-intended social order which, as the poet understood it, was constituted by peasantry, the knighthood, and the priesthood.[10] Studying French sermons of the eighteenth century Bernhard Groethuysen found in them a radically dualistic view of moral life which placed the bourgeoisie at a spiritually empty halfway point between the extremes of the nobility and the humble. According to the Gospels, the sermons said, there were in the world two forms of greatness, the greatness of power and the greatness of poverty. The privileges of the powerful were an emanation of God—the greatest among lords—who had charged them with the duty to lift nations to the level of their magnificence. The moral greatness of the poor, "the image of Christ crucified by us," lay in the living parable of their own humility. One class, so to speak, God-like, the other Christ-like. But both belonged to the transcendental order of things and revealed in their lives great teachings and great

purpose. The bourgeois, on the other hand, were neither powerful (power-filled) nor poor. They had neither the spiritual magnificence of the *seigneur* nor the Christ-like resignation of the downtrodden. Everything they did was cautious, limited, and measurable in its rewards and ends. Their lives were *normal* and, for that reason, had no larger meaning and said nothing about man's destiny.[11] An aristocracy of the people, Tocqueville was to say later, could give major ends to a society, but the bourgeoisie could never go beyond an order "without virtue and without grandeur." [12]

Such beliefs, with some modifications, continued apparently until very late in the French eighteenth century—according to Voltaire, "everyone" in his time tried to be an aristocrat by holding the merchants in contempt, while the merchant, "by dint of hearing his profession despised on all occasions, at least is fool enough to blush at his condition" [13]—and though in England social traditions may have differed to some important degree, the mystical glamour of aristocracy as the source of a special cultural legitimacy remained, nevertheless, very strong. It had always been possible in that country for men starting in the marketplace to acquire a respectable standing or, in the language of a seventeenth-century writer, "by good husbandry, and thriftie course of Trading, to raise themselves from meane estates . . . to be potent and mightie." [14] Still, in order to attain final acceptance, successful businessmen often reached for the ornamental and material appurtenances of the upper classes, including the acquisition of "ancestral" lands. In Cobbett's time stock jobbers, merchants, and professional people could not wait to acquire deer parks, mansion, and artificial ruins for their gardens, and insurance men had their portraits painted in hopeful imitations of the pointed sobriety of barons and squires. "[T]he name of the land is still great in England," Anthony Trollope could write as late as the 1860's,

while in the formula of Lewis and Maude, two present-day
sociologists, "the banker turned nobleman was always the
nobleman turned landowner." [15]

In the hands of nineteenth-century writers the heritage of
disdain for the bourgeoisie became not only an attitude of
dismissal but a habit of implacable accusation whose several
forms—rage, savage condescension, or an air of long-suffering
endurance in the face of middle-class grossness—were all ulti-
mately predicated on some psychological or intellectual meta-
phor for the principle of aristocratic ranking. The tenacious-
ness of such symbolic reworking of the life of quality can only
be understood, however, by recalling the factual basis of
aristocracy as a system of social domination and prestige. And
for such purpose, nothing seems more expedient than to turn
to Thorstein Veblen's *The Theory of the Leisure Class,* not
so much as an essay on the sociological drama of money and
the rituals of its expenditure, or as a topical satire on the
American tycoon (both of which it is as well), but as a
treatise on the concept of aristocratic behavior and its rela-
tion to work, productivity, and spiritual excellence.

Though lack of historical and sociological precision is the
great shortcoming of Veblen's book, conceptual suggestive-
ness is its great virtue. According to Veblen, mankind in its
early condition—what he calls "savagery"—was socially, psy-
chologically, and economically collectivistic. Men had no
strong notions of individual ownership. They were peaceful
and sedentary. And there was no elite. This primitive way of
life was replaced by "barbarism," an order resulting from
social aggression—that is, war and conquest—whose economic
system was built on the labor of war captives. The predators
and, in the historic sense, the first masters, were the males.
Women, whose labor was to be later systematically exploited,
were often the first captives. Because of this, "barbaric" society
came to regard almost all provisions of goods and services as

a symbolic extension of female work, and this in turn laid the basis of long-lasting social habits which view all servitude and all routine work as the burden of captive souls, tamed, house-broken, and in some sense emasculated. In its lower stages "barbarism" did not possess a true leisure class, although it began to develop some of the moral and cultural distances which were later to separate worthy from unworthy behavior (for example, hunting, though a practical means of gathering food, was already regarded not as industrious drudgery but as a form of prowess; it is today almost wholly the second, at least in "advanced" societies). But in the final or "high" stage of "barbarism" there appears a definite aristocracy whose tastes, privileges, and endeavors—war, rulership, sports, and the priesthood—are specifically nonindustrious. Furthermore, since the exercise of such activities was made possible only by freedom from the social obligation to work, since this free-dom was based on economic superiority, and since such superiority was rooted in male predatory powers, these oc-cupations and pursuits became not only honorable but spe-cifically masculine.[16]

These are, of course, sweeping, even headlong, though catchy speculations. They are not, on the other hand, flagrant inventions, and something like what they describe can be recognized in the history of Western culture, both pre-Christian and Christian. Yet because they embrace the whole history of social relations (jumping from Oriental to Euro-pean societies without much hesitation) and cannot be tied to specific proof, Veblen's singular and colorful generalities have brought upon him accusations of bogus and oppor-tunistic scholarship. The accusers humorlessly miss the point. Veblen must be read freely and beyond literal meaning, and his accounts must be understood above all as what we might call theoretical evocations aimed at uncovering the symbolic content of our social heritage. Veblen may never be docu-

mented by archival findings or ethnographic files. But who, on the other hand, could deny that the taboo-like indignity of certain jobs and trades in present-day society stems from the generic quality of womanly domesticity attached to them? Or that "uncreative" work, such as is reserved for the laboring classes, is thought to represent not only a social but spiritual form of inferiority, and that we look upon such inferiority as the product of an inner inanimateness and brutishness, just as we look upon nonutilitarian occupations as natural instances of spiritual exertion and moral deed?

All of Veblen's book is in one respect an effort to answer a question not regarded before him as sociologically significant. Why was it that the daily acts of human productiveness, the very tasks essential to the *survival* of society, were precisely those which the society refused to regard as capable of granting honor or earning glory? It was an extraordinary paradox, and in tracing its sources, Veblen scattered through the early portions of *The Theory of the Leisure Class* a number of thoughts which may be brought together into the following chart of honorable and dishonorable categories:

Honorable	*Dishonorable*
nonproductive work	productive work
(exploits)	(drudgery)
spiritual activity	spiritual inertness
freedom	servitude
individuality	collectivity and
	impersonality

One will notice that the honorable, "masculine" categories of contempt for normalcy and domesticity, and obeisance to special, forceful, even wanton deeds, parallel the major phases of nineteenth-century romanticism, the phase exemplified by Byron and Hugo and dominated by the figure of the magically powerful adventurer. It thus becomes possible to

think of romanticism as a rendition, in the form of a literary gesture, of primitive aristocratic behavior in the Veblenian sense. In so doing, however, we must also remember that Veblen described at least two types of "barbaric" prowess, one external and one introspective. The first stood for imposition of the heroic individual upon the ordinary run of mankind through the sheer thrust of an overpowering will. The second for the heroic dedication of the inner person to the mastery of some transcendental mystery. But then much the same is true of romanticism taken as a total literary movement, oscillating as it does between the glorification of impulse and the glorification of unfathomable inner treasures, between the pride that comes from the majesty of unique individual powers over ordinary humanity and retreat into a world of purely spiritual possessions. The alliance between literary manner and sociological imagery is made clear as soon as one becomes aware of the particular definition of freedom accompanying the primitive conception of worth. In its "barbaric" sense freedom stands for the capacity to act in an immeasurably momentous way, for the discharge of specifically nonproductive *expressive* energies—expressive, that is, of some absolute drive or need of the individual or some "reality" or "truth" within him. Freedom of this sort must of necessity transcend the ordinary, "secular" demands of biological and social existence and survival. It is glorious because it is creative, and creative because it constitutes a gratuitous display of personal originality, while labor, of course, is repressive and inglorious because it is spiritually unfree and condemns its servants to compulsive monotony. The realm of freedom presumes and engenders singularity. Work is the lot of the undifferentiated masses.

With this in mind we can now understand what happens when "barbaric" notions of worth and freedom become a symbolic property of what Victor Hugo called "the literary

clergy." In its primitive romantic version aristocracy cele-
brates the impulses which put man "that" side of workaday
reality by entirely overriding it, or "this" side of it by with-
drawal into a purely personal world. This means also that for
the "barbaric" *personality,* as for the "barbaric" *artist,* mean-
ingful behavior could only refer to what is self-bound, self-
determined and, in a literal sense, incomparable (in fact,
there is in such a view no distinction between "meaningful"
and "artistic" behavior). And it follows from this, in turn,
that creativity cannot be experienced, expressed, or pro-
duced by an anonymous collectivity. That it cannot be reck-
oned in terms other than itself. That it is of a piece. That is
has integrity.

It becomes fairly obvious, therefore, why literary men
found it easy to praise themselves; or social classes, like the
aristocracy, which they conceived as repositories of aesthetic
or transcending virtues; or primitive societies, when they
decided to look upon these as spiritual wholes endowed with
memorable and unique qualities—as entities, that is, which
could be portrayed as group versions of the creative indi-
vidual, possessing an originality not unlike that of the *literati*
themselves. It is also interesting to know that nineteenth-cen-
tury writers and contemporary ones have both been at times
more profoundly repelled by the psychological and cultural
features of the bourgeoisie, by the reputed valuelessness of
their lives and anonymity of their souls, than by any moral
sins or exploitative instincts attributed to them. W. H.
Auden, explaining why the poetic temper was drawn to peo-
ple like great warriors, athletes, heiresses, descendants of
well-bred families, or even monomaniacs or big-time gang-
sters, says that for the poet mankind is divided into two
sorts, the gifted few whom he admires because they are
"really themselves" (Auden might have said with Shake-
speare that they were the "lords and owners of their faces"),

and the average mass who are "no one in particular." [17] Contemplating the un-being of the noncreative person Flaubert would simply throw up his hands, amazed and uncomprehending: what *happened* to those not concerned with art? E. E. Cummings, asking himself the same question much later, answered: "nothing." [18]

The industrious man, as he shouldered his way into the leadership of modern society was, of course, bound to menace both the heroic and the introspective views of the creative life. For it was felt that, by making new and unexpected demands on human vitality, modern pragmatism was also likely to undermine man's total sensitivity, his emotional free-play and his capacity for physical pleasure—a capacity which in the past had made available to all people a natural blend of biological and aesthetic fulfillment. When Stendhal, traveling through Europe at the beginning of the industrial age, remarked that one of the consequences of the modern dedication to productivity was sure to be the exhaustion of man's spontaneous gift for the enjoyment of life, he did not mean, as might be the case today, that we should aim at a busy existence soundly balanced by needed recreation. He was thinking rather of the free aesthetics of human amiability which men had traditionally and unself-consciously mixed with their ordinary tasks. He had in mind, that is, the erosion of man's endowments for sensuous as well as erotic escape from routine, and the obliteration of the psychological open spaces of daily experience.[19]

The essential elements in early class differentiation, according to Veblen, had been the capacity for violence of archaic aristocracies which allowed them to reduce their captives to an acquiescent labor force. Stendhal, looking at modern occupational and economic conditions, thought that their novelty consisted in having extended hard work to every social rank, thus turning the choice between fresh ex-

perience and social utility into a universal dilemma. Freud, very likely, would have understood Stendhal's conflict for, though he regarded the conflict between the claims of the self and the demands of social co-existence as universal, he also suggested that this conflict had at least two particular historical aspects. One (a characteristically "civilized" form of "sublimation") was the shifting of psychological impulses away from personal gratification and toward beneficent but abstract social relations, such as humanitarianism.* Another was the choice, imposed by the modern world, between industriousness and eroticism. Men, possessing limited libidinal powers, needed to apportion them among their various tasks. And as society became more complex and exacted greater efforts, it required a corresponding withdrawal of energies from the sexual function.[20] The issue, as the moneybags in Balzac's *Gobseck* saw it, stood between "powerful emotions which use up one's strength . . . or regular occupations which make life an English machine that does its work every time." [21]

Freud worried that the standardization of sexual practice into monogamy, while the foundation of family life, was also one of the family's chief problems; the excising of instincts to accommodate social demands. But for men with an intellectual or artistic investment in the erotic, taken as an indication of personal prowess and, therefore, "expression," this conflict was bound to have profound *cultural* implications. Baudelaire, for instance, thought that no one could be a businessman and a lover, because he saw devotion to lovemaking not as a domestic duty but as a creative manifestation of the sensuous self requiring as its first condition freedom

* Freud did not say, as did George Orwell, that every humanitarian was a hypocrite. He felt, on the other hand, that broad and righteous social concerns were substitutes for a personal sense of erotic inadequacy; in "loving" humanity we were always assured that our love would be returned because the object of that love was no one in particular but an indeterminate "all."

from the necessity of earning a living. This dream of sexuality as a perennial aesthetic holiday is, of course, one of Baudelaire's carefully staged intellectual provocations whose purpose it was to reveal the creed of *l'art pour l'art* in every aspect of existence, even the most intimate. Still it must be taken seriously as a suggestion of the sometimes subterranean but persistent liaison between spirituality and sensuality which is so prominent a feature of the romantic tradition, and which links its literary intuitions with the claims of Freudian psychology. It is through such an equation of eroticism with the grace and the glory of a superior condition, social or spiritual, that we can now understand how nineteenth-century writers came to form an image of the businessman as a sedentary, un-erotic, anti-vital type in whom material success was inseparable from physical and spiritual impotence.

In its erotic version, the nonutilitarian vision of life looked for an anti-hero and found it in Benjamin Franklin, the philosopher of thrift and remunerative temperance. Stendhal saw in the man he called the "Philadelphia artisan" the incarnation of utilitarian morality: the pious and successful bore. Baudelaire went beyond this conventional image and in a brief, unfinished, but significant sketch entitled *The Last of Don Juan,* displayed a vision of Franklin as the demeaning anticlimax of a cultural drama: the downfall of the aristocratic spirit. There are, in this bare and rather crudely constructed scenario, only two characters, Don Juan and his domestic Leporello, both of them barely outlined. The thesis, on the other hand, is unmistakable. Leporello is not only a servant; he is also imbued with the characteristic middle-class passion to better his condition by means of commerce. In this he reminds us of Veblen's theme of the meniality of productivity. But unlike Veblen's serfs, whose chief virtue would be to bow before the superiority of their masters,

Leporello is a self-confident, hale, and strident upstart, clearly about to crowd his social better off the historical stage. As for the aristocrat, Baudelaire makes him not only a storied gentleman, but a weary soul, suggesting once again the incompatibility between the leisureliness of the elite spirit and the materialistic optimism of the businessman. And to this psychological note he adds a social allegory; the name of the doomed gentleman which is, of course, synonymous with sexual exploit. Thus we are led to understand that his defeat at the hands of Leporello marks not only the destruction of aristocracy by the middle class but the fall of Eros before the powers of the marketplace. In the end Leporello is revealed as the embodiment of a particularly modern and therefore energetic style of spiritual corruption in which reasonableness and vulgarity, virtue and economy are naturally associated. A knave, in short, "in the Franklin style." [22]

Not unexpectedly among contemporary writers, D. H. Lawrence also chose to crown Franklin as the prince of philistines, a theologian for whom God was a "heavenly storekeeper," * and a perverted sexual moralist whose recommendation to *use* intercourse for health and procreation could be taken as nothing more than an uproarious and disgusting joke.[23] But all of this is only a prelude to Lawrence's celebrated novel, *Lady Chatterley's Lover,* which is an essay on the attrition of primal experience under the tyranny of

* This peculiar equation of piety and profit, which appeared to literary men as the key to the business personality would, of course, become a famous scholarly thesis with the sociologist Max Weber, who also found in Franklin the archetype of modern economic ethics. *The Protestant Ethic and the Spirit of Capitalism* (New York: Charles Scribner's Sons, 1930). What the historical Franklin really was like is not pertinent to the meaning of the symbol. In Weber's terminology, Stendhal, Baudelaire, and Lawrence saw Franklin as the "ideal type" bourgeois, though they built this type on literary intuition rather than historical evidence.

too narrow and too deliberate a life purpose. The book's concern with sexuality is in itself important, but it must be understood as part of Lawrence's mystical naturalism which maintained that only by releasing man from the "will" and the "head" could a subtle and potent harmony be restored between him and the rest of the biological world. Lawrence, it should be pointed out, advocated sexual freedom in a psychological, not in a social sense. He was ardently partial to monogamy and thought Bernard Shaw a vicious vulgarian for saying that prostitutes rather than priests should have the right to speak on matters of sex. The Pope in Rome, Lawrence said, knew more about sex than the emancipated Shaw, for the Pope regarded physical union as a sacrament while Shaw, the atheist, saw it only as purchasable stimulation. Indeed, Lawrence upheld the right of the clergy to prohibit bare arms in church because this showed that, even considered as an obscenity or blasphemy, eroticism was a religious question. He himself saw such displays as marks of frivolous lust and, therefore, as cynical and "atheistic." [24]

Lady Chatterley proposed the overcoming of prudery in marriage so that lust and frivolity might be cured and instinct ("blood") restored to a sound role in human relations. This restoration, however, required a denial of the entire inheritance of rationalism, and particularly a rejection of industrialization. Lawrence's position before rationalism as a philosophical principle was the position held by European romanticism since the nineteenth century. He regarded it as a pretentious and naïve dogma which subjected the deeper forms of human understanding to the tyranny of naked calculation. Business and industrialization were the social children of such a spirit. More than that, they were the claws employed by rationalism to put nature and feeling under the abasing power of the market. This imposition of the calculating will on man's living surroundings was, in Lawrence's

mind, the most self-destructive of all his "triumphs." It separated him from partnership with nature and, in so doing, produced a peculiar sense of privacy and loneliness not to be appeased by the mechanistic greed for still further domination which had made of modern man a self-driven slave.

Considering the economic problems of a rising population and the indigence ruling many parts of the world, Lawrence's ideas may appear as rampant foolishness and obscurantism: romanticism in the most obnoxious and childish sense of the word. But even those who think this way will find Lawrence more acceptable, or at least more understandable, if they put aside his descriptions of machinery as the perpetrator of a carnage upon nature and consider instead what he has to say about the psychology of modern productivity. In other words, if they think of Lawrence's fear that machinery would suppress a total relationship to the surroundings, a relationship embracing not just the productive but the biological and the aesthetic. And of his conviction that this suppression sapped man's sense of organic integrity committing him to an arid and single-minded pursuit of external manipulation. As he put it in *Lady Chatterley,* it took the destruction of the living, intuitive faculty to release the peculiar powers needed for industrial organization.[25]

Beyond the disruption of man's biological-artistic relationship to nature, the greater danger of a rationalized existence was, however, the loss of the personal bond of communication among men, especially in what Lawrence regarded as its most mystically complete form, the sexual union. As the novel takes us through the mining town of Tevershall we see everything, dwellings as well as landscape, lying, the lifeless detritus of industrial ravenousness. Walls, roofs, pavement, even mud, are penetrated by coal dust. Everything displays the "utter negation of natural beauty, the utter ne-

gation of the gladness of life, the utter absence of the instinct of shapely beauty, which every beast and bird has." [26] As we come to know the mine owner, Sir Clifford, we discover a man deprived of the bounty of intimate feeling and literally a sexual cripple. This handicap is the product of a war wound, which seems to discount a psychological interpretation; Lawrence himself was for a while doubtful about its meaning. But as he thought of Clifford, he came to see in his wound a sign of the modern condition. He wrote in *A Propos Lady Chatterley's Lover*:

> [T]he novel was written from start to finish three times. And when I first read the first version, I recognized that the lameness of Clifford was symbolic of the paralysis, of the deeper and passional paralysis of most men of his sort today.[27]

Still another version of the opposition between "humanity" and the modern economic personality, this time represented, not by the withering passions of productivity but the meretriciousness of marketing, is found in one of the most celebrated events in recent dramatic literature, Arthur Miller's *Death of a Salesman*.[28] Miller's name has been surrounded by a certain revolutionary aura, speaking in the conventional political sense. But actually he speaks for the ideals of an earlier and a nostalgic form of economic imagination. His values are the values of craftsmanship and the principle of a sustained personal relationship to the act of production which presumably existed in a craft society.

If one were to outline the economic morality implicit in *Death of a Salesman* it would appear to be something like this. Men can develop relationships of integrity with other men by exchanging moral values and psychological and social benefits, such as companionship, affection, and solidarity. Men can also have relationships of integrity to objects, provided that they represent acts of expression as well

as production—that is to say, if they stand for creativity as well as productivity. When the product is an outcome of the maker's skills and values it constitutes also a statement of the maker's person. The buyer who acquires such a product becomes an "audience," the recipient of a creative service and therefore, as the selector of the object, himself the performer of a creative act. Thus a commercial exchange may be turned into an exchange of human and aesthetic meanings. What characterizes modern manufacturing, however, is the spiritually empty relationship of the producer to the product. This is equally and perhaps more profoundly true of the subject of Miller's play, the salesman. Nothing in the personal reality of the salesman attaches itself to the product because he is neither creatively nor morally responsible for it. Lacking a significant relation to the product, he must, therefore, enter into a pseudo-significant relation to the customer: that ingenious and degraded travesty of human relations known as "selling yourself." * It is Miller's point that the ultimate victim of this fraud is the salesman himself and that the outcome of a life of hollow, strenuous, and fraudulent sociability invested in the lubrication of the marketing process can only be despair and, finally, self-destruction.

Although Miller is clearly in the tradition of those who hold commerce incapable of creating a dignified human purpose, he is not so much concerned with the stigma of utility

* It must be clear that what one sees in all this is a scheme of intellectual responses to the intellectual's own image of the market, not a historically realistic description of the market itself. Craftsmanship and its time have been idealized in literature since the nineteenth century. However, as C. G. Coulton and other historians have shown, the very high standards of craft imposed by medieval guilds often had to do with such purely economic considerations as control over the membership, or prices, or the elimination of competitors. This does not discount, of course, the pride of the craftsman in his traditional skill.

as with the market's tragic futility. His salesman, Willy Loman, is haunted by the ghost of his brother, and puzzled and defeated by the bitter hostility of his son. The brother went as a young man to seek his fortune on the Alaskan frontier, a stage for real trials and real victories ("That was a Man!" Willy says of him). Biff, the son, refuses the father's advice to put youth and good looks at the service of salesmanship. The frontiersman brother embodies the standard American version of the heroic; the son speaks for the revulsion against personality-marketing and business discipline, and for the return to an earlier, more "creative" economic style—he wants to live outdoors, whistle on the job, and do something he "likes to do." The son and the brother are "real" (even though the latter is a ghost). Willy is "unreal" and in the end succumbs to his own unreality. Much like the suicides of Emile Durkheim's studies, he kills himself because he has lost the capacity for concrete psychological and social possessions.[29]

Death of a Salesman accomplishes the reduction of the conflict between "being" and "doing" to its most graspable terms. The play's lesson is that there cannot be a contructive and permanent human attachment to the market; the market is ephemeral and renders man ephemeral. Willy, who has successfully thrown himself into the bargain a thousand times, disintegrates the moment he cannot sell his merchandise. In many ways his life has no real history. There is in him no rise of individuality, no self-investment and, consequently, no self-possession. In the end, when he is discarded because his personality credit has become exhausted, he must destroy himself.

Flight from the spiritual atmosphere of modern productivity also produced what may be called intellectual tribalism, a phenomenon with at least two principal manifestations. One is the self-conscious return to the archaic and the

primitive (sometimes symbolically, sometimes actually); to a world where, it is thought, no men or values are for sale and life has an undefiled honesty and a spontaneous beauty; to a society whose culture is regarded as in itself a work of art (watching Breton women weep over the dead bodies of their husbands, Flaubert marveled at what he considered their instinct for emotional grandeur). Another is the search for the natural bohemian, for men whose way of life, heroic, stubbornly hedonistic or, in some way, mysterious and transcending, incapacitated them for the understanding of business values.

The first dreams of literary tribalism were of the Orient, the South Pacific, and the American Indian. The romantics, wrote Zola angrily, "escape into the history of dead centuries or in voyages to other countries. Theirs is the hocus pocus of legend, the local color fireworks, the immobility of the Orient, and its filth, which they prefer, with their childish admiration for colorfulness, to the great accomplishments and magnificent conquests of our century of science." [30] Petrus Borel, one of the founders of French bohemia in the 1830's, threatened that unless the country became chaotic and picturesque enough to suit his taste, he would migrate to the wilderness of Missouri; he was an agitator, he said, because he could not be a "savage Indian." [31] Later Lafcadio Hearn fled to Japan (the Japan of pre-industrial days), and Gauguin to Tahiti. D. H. Lawrence left Europe to go first to Australia and later to New Mexico where he wrote accounts of Pueblo ceremonies greeted by Ruth Benedict as peculiarly faithful to the "meaning" of that culture. Then came the long history of gypsy celebration, both in popular romance and in high literature. Flaubert admired the gypsies as people whose very survival constituted a welcome affront to the ideals of bourgeois society. And eccentric scholars, artists and poets, from George Borrows in the nineteenth cen-

tury to Augustus John and Federico García Lorca in our day, praised them as spiritual friends and made them the subject of some of their best work. Curiously, the United States, the great middle-class nation, is uniquely rich in such legendary anti-bourgeois communities, urban and rural. There are the affectionate, joyful, comfortably irresponsible *paisanos* of Steinbeck's *Tortilla Flat* (and later the denizens of his *Cannery Row*). There are the California Armenians of William Saroyan, a sturdy yet whimsical peasantry. There is the colorful and tragic Black microcosmos of Catfish Row in Du Bose Heyward's *Porgy*.* There is the cozily unorthodox household of Martin Vanderhoff, in Hart and Kaufman's *You Can't Take It with You,* in whose living room "meals are eaten, plays are written, snakes collected, ballet steps practiced, xylophones played, printing presses operated." [32] In every case the dream is the same. The disreputable, the idiosyncratic, the useless, the "backward," and the outcast become the core of a highly ornamental and beguiling society which is also a citizenry of human "truth," freed of the materialistic pretense and the shallow anxieties of the middle-class world.

Now, because every generation must experience its own rebellion as a new thing, it is understandable that some contemporary writers would think of their anger and aloneness as belonging only to themselves. For instance, in *The White Negro,* Norman Mailer's famous essay about American bohemia after World War II, the author speaks of the Hipster, the protagonist of this bohemia, as the product of certain giant forces of present-day society and of a human condition peculiar to the United States. The itinerant nihilism of the Hipster is a response to the destructiveness of new weapons, the brutality of present-day totalitarianism, and the expansion of state powers irrespective of political ideology. The

* The source of George Gershwin's *Porgy and Bess.*

Hipster is an abrasive voluptuary, an ironic, raw creature, dedicated to abstruse, raffish, self-indulgent mannerisms of behavior and speech. A scandal to propriety, restraint, and social usefulness. Its model is the American Negro whose sexuality, language, and music the Hipster worships because the Black, as the great outcast, has also become the natural social adventurer, sworn against respectability, conformity, dullness, and emotional timidity.[33]

Quite obviously one does not turn to Norman Mailer for sober-sided sociological theory. His genius (no other word will properly describe Mailer's recent writing on peace marches and party conventions) consists in the creation of great social pantomimes, for which he provides the scenario, the "facts," and the psychological and historical motives. These may be seen as semi-metaphorical reportage, huge "visions" (which somehow reveal cultural and political realities as they might not otherwise be revealed), vast projections of Mailer's own self upon the social spectacle, and finally, or simply, as extraordinary events of the imagination. It is, therefore, useless to say that for Mailer to attribute the spiritual exodus across racial lines to atomic fission and the memory of concentration camps is an overblown, undemonstrable, and too convenient inference. And that to credit oppression for the creative unorthodoxy of the American Negro wrongly, if dramatically, simplifies a complicated history* just as it claims too much for its general significance

* The equation between social inferiority and the boldness and strong taste of the cultures created within it should be drawn very carefully. To the degree that Negro popular culture in the United States has been gritty, colorful, instinctively poignant, and ingratiatingly inventive, it parallels, in primary outline (I say nothing of its unique creations, like jazz), the *lumpen* life of other societies: the Parisian *apache,* the *compadrito* of Buenos Aires, the *chulo* life of Madrid, the *flamenco* world of the Southern Spanish cities, the *lazzaroni* of Naples, the London of the *Beggar's Opera.* It is also very largely an urban creation, and it combines inequality with the freedoms which the city allows. If, on the other hand, we believe certain historians,

(as we have just seen, outcasts and exotics have always pro-
vided a model for the spiritually discontent).

It is not the chronology and sources imputed to it that
makes Hipster alienation striking but its links to the total
history of bohemian marginality. When one first reads a
Hipster writer like Jack Kerouac he sounds indeed like one
of Mailer's spiritual non-Whites wanting to exchange places
with the bold, "true-hearted" Blacks of America. But there
is more.

> At lilac evening I walked with every muscle aching among the
> light of 27 and Welton in the Denver colored section, wishing I
> were a Negro, feeling that the best the white world offered was
> not enough ecstasy for me, not enough life, joy, kicks, darkness,
> music, not enough night. I stopped at a little shack where a man
> sold red-hot chili in paper containers; I bought some and ate it,
> strolling in the dark, mysterious streets. I wished I were a Denver
> Mexican, or even a poor overworked Jap, anything but what I
> was so drearily, a "white man disillusioned." [34]

Nothing is so evident in this passage as the survival of the
romantic tradition in the Hipster's world. Some of the newer
Black writers, like Eldridge Cleaver, can, with contemptuous
pity, speak about the sexual chill of the White man (he ap-
pears to have some legendary and comfortably counter-ro-
mantic ideas of his own in this respect).[35] But this is only an
item of teasing psychological denigration in the midst of
Cleaver's (and others') social fury. Kerouac's complaint, on

"optimal" conditions of oppression, such as the Southern plantation, pro-
duced not the most unconventional but the most tractable types: the willing
clown and the courtly servant; Sambo and Uncle Tom. Then also, it must
be pointed out that massive racial tensions and consequent black defiance
in the United States are the product of denial *and* freedom, frustration *and*
the momentum of expectation. American Negroes suffer from certain restric-
tions and handicaps. But public ideology, political institutions, and a
constantly changing social climate, daily invite them to assert their claims
upon American life. And the very fact that they are at liberty to voice their
grievances serves to deepen their impatience.

the other hand, comes in the personalistic vein of romanti-
cism. It is not about social justice but spiritual nakedness.
What he wants is "darkness," a quenching of his thirst for
mystery, or, in the current terminology, a refuge from the
"one-dimensional" purposefulness of rationalized society.
He would rather be exploited than bored.*

Mailer's profile of the Hipster nevertheless expands the
history of anti-business types, because of its own character-
istics and because of the characteristics of the Hipster's en-
emy, foil, and antipode: the Square. We can all anticipate
the spiritual marks of the latter. For the Hipster, men who
profess to uphold social standards or act as servants of the
community are either bores or self-appointed frauds. The
Square, inevitably, is at best a crassly jovial huckster or,
more likely, an astringent and righteous prig, and, in any
case, the possessor of an appetite for conventionality natural
in a "success-oriented" creature. Emotional cautiousness,
calculation, and opportunism, lack of biological intensity,
failure to achieve a personal style of expression, all of which
are of course the price paid for social and economic adjust-
ment, are the armor and the curse of the Square. But the
Hipster, while having a sardonic, detached, "cool" side, has
also another, "hot," side; his headlong embracing of "life"
and his gift for torrential and transcending experience,

* Of Kerouac's conception of Negro life James Baldwin wrote: "I would
hate to be in Kerouac's shoes if he should ever be mad enough to read this
aloud from the stage of Harlem's Apollo Theater." *Time*, May 17, 1963, p.
23. Richard Wright would also disagree with Kerouac but for reasons which
other Negro writers today might find difficult to accept. He thought that the
emotional life of Negroes was not passionate but rather empty. "I used to
mull over the strange absence of real kindness in Negroes, how unstable was
our tenderness, how lacking in genuine passion we were, how void of great
hope, how timid our joy, how bare our traditions, how hollow our memories,
how lacking we were in those intangible sentiments that bind man to man,
and how shallow was even our despair." *Black Boy* (Cleveland-New York:
The World Publishing Company, 1950), pp. 50–51.

erotic or aesthetic.* Like all bohemians, the Hip (or Beat) bohemian aims to become the personal embodiment of his ideals. The entire rhythm and effect of his behavior must reflect the ease and freedom of his withdrawal from the commonplace, his surrender to "genuine" experience, and his deep possession-taking of that experience. The Square is marked by his gracelessness and by the absence of that ready intensity inevitable in someone who uses his personality as a social investment rather than as an independent creative act.

There seems to be a fairly widespread intuitive recognition of the fundamental social attitudes represented by the Hipster and the Square, and the depth of the gulf between them, at least to judge from the currency which these terms have gained outside the Hipster world itself (I am speaking of the United States, of course). But the Hipster-Square duel serves also to clarify much that was obscure in the terminology of earlier literary discontent. For, when we are told that the Square is a man always caught in unyielding bonds, we know that we have encountered him under an older title of infamy.

Stendhal, Hugo, Baudelaire (and many others, of course) made large and voluble use of the word "bourgeois" to mean a social class, a dimension of life and a personality type. But no one displayed as encyclopedic and unforgiving a nomenclature of the spiritual taints to be described under it as Gustave Flaubert, for whom hatred of the middle class was "the beginning of all virtue." [36] By "bourgeois" Flaubert understood the following: all symbols of social propriety and professional ambition ("as dully bourgeois as the wooden benches of the Law School"); the kind of imagination (or

* The "cool"-"hot" distinction in the Hipster's personality is not Mailer's but my own. However, in the context of *The White Negro*, which owes so much to the psychology of jazz, it came naturally, since both these words are such an essential part of the emotional vocabulary of jazz musicians.

lack of it) that insisted on being "to the point" (he thought
some remarks of Musset's about inconsistencies in *Hamlet*
were "utterly bourgeois"); the inability to understand cer-
tain forms of longing ("last night you jeered like a bour-
geoise at the pathetic dreams I had when I was fifteen");
any desire for success, even intellectual success ("[W]hat
makes me mad is the *bourgeoisisme* of our fellow writers.
Such businessmen. Such vulgar idiots."); the prestige-con-
scious fads of the ignorant and the insensitive ("if a critic says
of a sculptor that 'he neglects form . . . but is a thinker'
the bourgeois proceed, with cries of joy to make themselves
admire what really bores them"); the inability to rise above
commonplace sentiment, personal or social (speaking of a
visit to a lady friend whom he expected to find old and ugly,
he says: "a bourgeois would say that I'll be greatly disillu-
sioned: But I have rarely experienced disillusion having had
few illusions"); the inability to appraise aesthetically the
quality of one's own behavior, even the most intimate (writ-
ing to Maxime Du Camp about his sister's funeral he says:
"I was dry-eyed as a tomb, but horribly tense. I wanted to
tell you this, thinking that it would give you pleasure. You
are sufficiently intelligent, and love me well enough to un-
derstand the word 'pleasure' which would make a bourgeois
laugh").[37]

Certainly such an array of images attached to one name
makes it difficult to follow the enemies of the middle class
through the history of their denunciations. But, as with the
rebels of today, the answer for the nineteenth-century hunt-
ers of the bourgeois curse was that they knew what they
meant. A word had been found to serve as a tuning fork
for a whole company of related images. The current label
is humbler in origin than the historic epithet but equally
universal in intention. By comparing the two we know that
one thing that bourgeois meant was Square.

In his collection of miscellaneous writings, *Advertisements for Myself*, Mailer offers a list of Hip concepts, notions, feelings, and images, and their Square opposites (Hip is the adjective for the noun Hipster), which makes the relationship between the historical and the present-day perceptions of the literary ideal and its enemies even clearer. Induction, Mailer says, is Hip; deduction is Square. And so with self as opposed to society, crooks to cops, saints to clergymen, body to mind, manners to morals, night to noon, questions to answers.[38] Since one of the things that Mailer's *List* intends is to celebrate the nonrational (and to test our own capacity for the understanding of it), he rightly says nothing about the grounds for his choice; we should simply *know*, without the need to question or explain.* But the very intuitive felicity of Mailer's categories makes certain guesses irresistible—and possible. We can perceive, for instance, that induction speaks for a boldness of mind, a feeling for the pulse of the concrete and the living; there is in it the freedom, the excitement, and the taste of a personal appropriation of experience. Deduction, on the other hand, suggests a cramped, rigid, and naked intellectual style—safe, impersonal, and reductionistic. The crook is Hip because he is a nay-sayer to market values and utilitarian regularity. But beyond that he is among those who believe in self-assertion at whatever risks. Cops, of course, are the servants of social orderliness. Saints are Hip because they are, as someone has

* This is very much in line with the spirit of direct nonanalytical certitude pervading romanticism, from its historic to its present forms, including the White-Negro psychological-artistic type. One example of it is the legendary, all-meaningful nondefinition of jazz, the White-Negro's and Black-Negro's art form: Question: "What is jazz?" Answer: "If you have to ask you'll never know." I use the expression "Black-Negro" as a matter of simple convenience and not in obedience to the present ideological value attached to "black" as opposed to "Negro." Both words are, of course, exactly synonymous. Negro is an inheritance of the Spanish and Portuguese involvement in the slave trade. It means, in Spanish and Portuguese, "black."

said, men "infatuated with self-perfection," sacred eccentrics.
Clergymen are pious tenants of what Max Weber called
routinized transcendence. The body is Hip because it rep-
resents the breathing, total reality of life, with all its secrets
and irrepressibility. The mind is Square because it repre-
sents caution, calculation, and the element of distance and
control which comes from abstraction—what Freud called
the "procrastinating factor of thought." [39] Manners are Hip
because they have to do with the aesthetic organization of
the self's personal style. Morals are a Square response to
community demands. Night is the hour of intimation and
withdrawal, the time when the hidden is released and the
prohibited beseeched—therefore Hip. Noon is the hour of
explicit activity, of visible participation in the fabric and
rhythm of social life, the hour of repression of the obscure,
the hour of money, normality, and work—therefore Square.
A question is Hip because it is in itself disquieting, unfin-
ished, and beckoning and, when truly a pure question, does
not go beyond the flow and counterflow of wondering. An
answer kills the suspense of experience by reducing the ques-
tion to measurable terms. It forecloses the state of wonder-
ing and socializes, that is, de-individualizes, experience by
solving the problem and creating the possibility of pragmatic
action.*

Both these matching oppositions, then, Hip and Square,
Romantic and Bourgeois, denounce the man of measurable
temper, the undertaker of "services" (civil, managerial, or
economic), the careful, reliable personality, the job-doer, the
producer; the anal man, in Freud's disquieting terminol-
ogy.[40] What alone is positive, according to this view, are the

* In the spirit of Hipsterism the comedian-satirist Mort Sahl says of social
problems: "After all, if we couldn't laugh about these things, we might do
something about them." Cited in Robert Price, "The Fury," *The New Yorker*,
July 30, 1960, p. 40.

forays of the unmoored ego into self-expression, or its with-
drawal into self-contemplation; whereas participation in so-
cialized action is always regarded as threatening to dismantle
the irreducible "I" and to dissipate it into indistinct energy
placed at the call of impersonal usefulness.

Quite different, of course, intellectually, psychologically,
and in its public intention, is the *political* opposition to
"bourgeois society," whose spirit, particularly if we speak
of what has become its most influential expression, Marxist
socialism, must be characterized as rationalistic (at least in
principle; the historical outcome is another matter) and
altruistic (or more accurately, collectivistic). Literary men
looked upon the bourgeosie as the embodiment of social
triviality and a gross enervation of the mind; it was, Victor
Hugo said, simply "the contented part of the population." [41]
For Marxism, on the contrary, the bourgeois represented a
crucial stage, not only in the history of social relations but
in the organization of human intelligence. One of the things
that Marx inherited from Saint-Simonians, Fourierists, and
other "utopian" socialists was a positive *pride* in rationalism,
efficiency, and technology, the last two of which he ap-
plauded as zealously as the loudest progress-booster, just as
he applauded the bourgeoisie as one of their instruments.
Furthermore, he looked on the "objectivity" of human rela-
tions brought into the world by the middle class as a great
scientific opportunity. Some of the early pages of *The Com-
munist Manifesto* appear at first to suggest that the materi-
alism of the bourgeoisie had affronted a regard for tradition
still lingering in Marx's mind. We might even think that
Marx had been shaken by the power of the bourgeoisie to
reduce the honored professions—the law, poetry, and science
—to the condition of wage labor, and to drown chivalry
and religion in the "icy waters of calculation." But as we
go on we discover that Marx's point is quite the opposite;

namely, that the middle class had achieved the destruction
of social sentimentalism by substituting naked and direct
exploitation for exploitation "veiled by religious and polit-
ical illusion." The result, he thought, was a clarification of
the nature of social reality and an enlargement of historical
rationality. Through the bourgeois revolution of social rela-
tions man would, at last, be compelled to "face with sober
sense his real conditions of life, and his relations with his
kind." In fact, Marx was led by this conviction to some of
his broadest cultural predictions. Due to the massive and
international character of bourgeois economic enterprise, the
countryside had finally been made completely dependent
on the towns and, in the process, had rescued a considerable
part of the population from "the idiocy of rural life." Cos-
mopolitanism would replace localism in material and in
intellectual production. And just as capitalism had become
the first world-wide economic and social system, intellectual
life would become, for the first time, universal.[42]

But when we turn to literary discontent among Marx's
contemporaries what we find is a flight from the scientific
and rationalistic climate celebrated by the socialists. Ca-
thedrals were worshiped, not machinery, and even agnostic
writers bewailed secularism as a threat to the sensitive ap-
prehension of life and beauty. What the literary imagination
craved was the very "veiled" relationships exposed by cap-
italist economics. In the drama, in the novel, in poetry, this
was the age of medievalism, purple emotion, ancient gold,
and archaic blood ties—the age of local color and the pictur-
esque. Creatures of urban civilization that they were, the
literati often suspected cosmopolitanism and yearned for
remote and unspoiled societies. The uniqueness of regional
and national life became a stylistic and a psychological pas-
sion (as well as a doctrine of historical philosophy). So did
the hatred of technology—the violator of nature's integrity

and mystery—and the love of craftsmanship as a personal, intimate, "subjective" mode of production.

A different anti-bourgeois position meant a different characterization of the bourgeoisie itself, a different system of accusations and suspicions. For the socialists the great intellectual handicap of the bourgeois was their inability to carry further the work of history and to lift their intellectual powers beyond the limits of their class interests. From the literary point of view, their flaw, their great inner deformity, was a creative poverty, a cowardice of the imagination natural in men who were slaves to pragmatic design. Inevitably the artist was portrayed as the fated carrier of the "instinct for the beautiful," and his enemies, just as necessarily, as creatures "utterly devoid of grandeur" and given to "the cult of the materialistic ego." [43] Recalling the early days of his acquaintance with Lenin, Trotsky writes that, as the two walked around London, Lenin would point out certain "bourgeois" landmarks to him saying, "that's *their* House of Parliament, that's *their* Foreign Office." An English writer visiting Eugene Delacroix in Paris in the mid-nineteenth century tells us that although the artist's manners were impeccable "he could hardly be polite to the middle classes." [44] The first of these anecdotes carries the Marxist "dialectical" flavor. Lenin speaks from without the walls of present powers but as the representative of rising political force, a man already on the other side of the world-historical watershed, looking on bourgeois institutions as still standing but irrevocably undermined. The second is typical of anti-bourgeois feeling determined by cultural and aesthetic considerations. It is a personal gesture of recoil from the commonplace as the first line of defense in the battle for spiritual dignity and self-identity.

At this point one must ask again: what is it in the spiritual scene of modern society that may account for such intel-

lectual touchiness, willfullness, and bitterness? What made
Flaubert say of all middle-class occupations that they were
"little employments," or, of a magistrate friend, that his
was an "idiotic" job worthy only of a cuckold? (once again
the equation between usefulness and sexlessness). What
made Baudelaire speak of the useful man as "something
particularly horrible" and of all the professions as the "sta-
bles" of mankind? What in the sight of the middle classes
caused Stendhal to want "to weep and vomit at the same
time" and provoked Flaubert "almost to the rage of hydro-
phobia"? [45]

The answer may be found only if we consider, not only
the middle class but something more general of which the
middle class has been regarded as a historical instrument,
namely, the process of "rationalization," whose power to em-
brace and dominate social experience the nineteenth-century
writers were among the first to perceive. If, for example,
we take Norman Mailer's one-word aphorisms for what they
really are, still one more statement of the romantic rejection
of rationalism,* we will see also that they are directed at
rationalism in at least two meanings of this word: as a
philosophical method, and as a social process. The first in-
tended to reduce all experience to analytical terms. The
second tended to force all social life into a system of inter-
related elements, functioning according to procedures and
leading to consistently foreseeable results.

It is in this second sense that Max Weber regarded ra-
tionalism as the basic drift of modern society. One example
of it was the legalistic nature of the contemporary state, as
compared with ancestral or purely personal ("charismatic")

* It is, of course, impossible, in philosophical or literary history, to make
absolute distinctions between romanticism and its opposite, classicism, be-
tween feeling and reason, and so forth. What is discussed here are ideological
preferences and the deliberate attempt to cultivate or glorify some intellec-
tual features and to denigrate others.

forms of authority. Bureaucracy (public, private, political, or technological), with its insistence on fixed administrative formulas, regular duties, and authority based on skills rather than personal obligations or favors, was another.[46] Veblen, too, observed that rationalization was the main feature of modernity, but saw its chief tool not in institutions, public or private, but in technology and its capacity to weigh, measure, test, classify, and manipulate the natural environment. The consequences, he thought, would be not only external but philosophical. Technology would render man's material existence more orderly and predictable. It would also make his intellectual life more objective by destroying "anthropomorphic" habits of thought.[47]

In a hundred ways the literary mind has, on the whole, remained unreconciled to rationalism, its human aims, its psychological tastes, and its social instruments. Speaking of the Middle Ages, and of the admiration which "reactionary" intellectuals felt for it, Marx remarked that what distinguished medieval life, from the point of view of productivity, were "brutal" displays of vigor followed by periods of the "most slothful indolence." [48] Romantics, on the other hand, preferred to view the oscillation between lassitude and prowess as intrinsically human and artistically intriguing (indolence was picturesque, brutality dramatic; of political disorder in the Spanish American republics Baudelaire said: "At least people kill each other.")[49]* In any case, it does

* The echo of the romantic repugnance for purely pragmatic social goals can be found in unexpected places. This is Bertrand Russell, writing after his first visit to Soviet Russia: "I was stifled and oppressed by the weight of the machine as by a cope of lead. Yet I think it the right government for Russia at this moment.

If you ask yourself how Dostoevsky's characters should be governed, you will understand. Yet it is terrible. They are a nation of artists, down to the simplest peasant; the aim of the Bolsheviks is to make them industrial and as Yankee as possible." *The Autobiography of Bertrand Russell: The Middle Years, 1914–1944* (New York: Bantam Books, 1969), p. 166.

not take much to imagine the term that someone like Flau-
bert would have chosen to characterize Marx's "revolution-
ary" concern with the wasting of productive energies. Bour-
geois ambition, Flaubert said, had penetrated every social
class, and, consequently, hatred of the bourgeoisie would
now have to be extended to "all humanity, including the
people." [50] There was a great revolution in our time, he
agreed, but it involved something more profound than pub-
lic institutions or political practices. It was a revolution
destructive of the quality of life, of what he regarded as
dignified cultural values. It was, in fact, "the raising of the
working class to the level of stupidity attained by the bour-
geoisie." [51]

In the psychological and moral characteristics of the bour-
geoisie, in the structure of modern politics, in the demands
of the machine, or even in the tedious and compelling
efficiency of modern highways,* Flaubert was among the
first to see the full reach of modern rationalism. But even
someone like John Stuart Mill, heir to a philosophical tradi-
tion of social concern and alien to the strenuous aestheticism
pervading French literary arguments, concluded that certain
forms of the rational spirit had created questions of personal
freedom reaching beyond the traditional conflict between
self-determination and political authority. As he saw it in
1859, freedom was now faced with an altogether novel dan-
ger, pressing on the psychological and—so to speak—artistic

* Flaubert was not the first writer to speak of roads as an example of the
modern passion for cutting through the natural complexities of society and
laying it bare and open to direct communication. Recalling the highway
policies of pre-Revolution France, Tocqueville wrote: "The Highways Depart-
ment was as fascinated then as it seems to be today with the perfectly straight
line, and studiously avoided making use of existing roads if they showed the
slightest deviation from ideal rectitude. Rather than make a detour, however
slight, our road makers hacked their way through ancient estates, defacing
and destroying valuable parklands." *The Old Regime and the French Revolu-
tion* (New York: Doubleday Anchor Books, 1955), p. 189.

rights of the person, and challenging his private imagination, his sense of being himself and no other as a spiritual and social actor.

Mill received, at the hands of his father, an early and merciless drilling in the right principles of social felicity, and this may have contributed to his belief that there was something "pinched, hidebound and narrow" in the "modern theory of life." But his explanations were based on what he regarded as the intellectual directives and sociological conditions of the contemporary world. With many others, Mill blamed Calvinism for maintaining that whatever was not duty was sin. He held also that peculiar forms of self-censorship had been prompted by the mixed ambitions and uncertainties of modern life, and that a curious sense of exposure had developed which made each individual ask himself not what was in accord with his personal disposition but what suited his position, not what he might do as an individual but what was usually done by persons of his station or, worse yet, by persons of superior station and circumstance.[52] This paradoxical partnership between conformity and social mobility (recalling Tocqueville's thoughts on the tyranny of the majority), he stated as follows:

> In whatever people do conformity is the first thing thought of; they like in crowds; they exercise choice only among things commonly done; peculiarity of taste, eccentricity of conduct, are shunned equally with crimes; until by dint of not following their own nature, they have no nature to follow.[53]

It was not that men refused to make original choices out of hypocritical calculation. It was rather that (and here Mill sounds like a contemporary psychologist of "mass society") having bargained away personal character and the impulse toward individual wish, men had lost any genuine ability to choose. "I do not mean that they choose what is customary in preference to what suits their own inclination. It does

not occur to them to have any inclination, except for what is customary." [54]

It would be, of course, wrong and foolish to say that intellectual life is always unhappy, withdrawn, or dedicated to private dreams. Modern political rationalism itself was the creation of two great and distinctly optimistic intellectual dogmas: the liberal faith in the individual as capable of sorting out universally worthy aims for the conduct of human life, and the belief in a "scientific" rearrangement of political insitutions which would make them the instruments of justice and a logically apportioned beneficence. But Mill's gloomy anticipations of the future exemplify again the power of the rationalistic specter to depress and alarm even somebody who could scarcely be regarded as a stereotypically wounded romantic soul. Automatons might as well grow corn and build houses, Mill said, in a world where human life was not "rightly employed in perfecting and beautifying . . . man himself." [55] And he insisted that something better was needed to guide modern existence than the views of "that very common character, the worshiper of 'our enlightened age' . . . struck by the multiplication of physical comforts, the advance in the diffusion of knowledge, the facilities of mutual intercourse, the great works accomplished throughout the globe by the cooperation of multitudes"; to take counsel from such a mind, he thought, would be to succumb to "passionless stupidity" and to the desolation of a life dedicated to "executing, by fixed rules fixed tasks." [56]

As we have observed until now, and taking Veblen's language in an ample symbolic sense, the opposition between the creative and the productive life was drawn upon psychological and aesthetic versions of the concept of masculine exploit. These versions comprised physical power, "mystical" (that is to say, spiritual and introspective) power,

erotic power, and of course, erotic mysticism. But this is only one aspect of the Western intellectual tradition, both generally and as it applies to the issue of modern rationality. Before the romantic age, we will remember, it was women who served as the carriers of culture, experts in sensitivity and organizers of family participation in civilized existence. When one looks at the *salons* of the French eighteenth century, for instance, one finds their administration typically divided between the husbands, as the investor, and the wife as the stage manager of cultivated gatherings. In fact, some anecdotes of the period treat the relationship between intellectuals and fashionable women as one linking natural partners in the game of imagination and taste, while husbands appear both as skillful money-men and sleepy-minded bores, lost amidst the eloquence of their wives' guests. As for the parlor intellectuals themselves, they seem too explicitly bright, supple, and polished to stand as a literary reflection of Veblenian prowess and, if anything, suggest a somewhat lady-like approximation to their patrons in their concern for graciousness and charm.

Yet, conveniently it is Veblen himself who offers a way out of the difficulties presented by the existence of other, "feminine" styles of aristocratic life. For there are actually in Veblen two theories of the origins and characteristics of cultural elites. According to one, aristocracies are created by the practitioners of extraordinary primordial deeds, both objective and external, subjective and spiritual. But a second speaks of periods of economic plenty during which, after "protracted contact with accumulated wealth" and unbroken privilege, the socio-economic elite develops a cultural manner dedicated to courtly form and the aesthetic elaboration of leisure. There are, in nineteenth-century literature, enough examples of the first type, both dramatically and philosophically, from glamorous tales of antique heroism to the orac-

ular message of cultural redeemers, from Walter Scott and
Victor Hugo, to Carlyle and Nietzsche. But there is also
at least one monument to the "feminine" cultural mode;
Baudelaire's invention of the finicky virtuoso of nonutili-
tarianism, the intellectual Dandy, a figure of fanatical ded-
ication to a sober yet exquisite elegance of mind and of
appearance.

In part, and not as oddly as one might think, the Dandy
was derived from Baudelaire's admiration for cats. Bertrand
Russell once remarked that romantics, having always put
beauty ahead of utility, preferred tigers to worms; Blake,
a poet and a romantic, admired the tiger; Darwin, a scientist
and, as such, not a romantic, turned his curiosity to worms.[57]
Baudelaire had the romantic repugnance for homely and
dutiful exertions. However, having also a calculated and
voluptuous sense of form, gave his devotion to cats, who
appeared to him as the embodiment of well-managed, lux-
urious self-involvement. In his own version of the relation-
ship between the spiritual and the physical he stated the
goal of the Dandy as the imitation of the cat's virtues—"the
cult of oneself as the lover of oneself." [58] And he left no
doubt as to the social intentions of this symbol when he
added that cats were always hated by the democratically
oriented rabble.

An anticipation of the Dandy may be found in the diaries
of Baudelaire's contemporary, Barbey d'Aurevilly, who in
one of his entries tells us of the hours spent choosing the
precise coat and trousers appropriate to the events of a
certain day, a matter, as he puts it with straight-faced ex-
aggeration, "grave [and] almost religious." [59] But it was
left to Baudelaire himself to develop the spirit of foppish-
ness into a significant cultural affectation or, in his words,
"a rigorously artificial code of behavior" to serve as the

status mantle for the intellectual's singular position in society, a position at once vulnerable and defiant.

That Baudelaire sought to materialize in his own deportment the spirit of the Dandy as a one-man cultural ceremony, can be seen from this description of the poet by one of his admirers:

> Slowly, with a slightly swaying, slightly feminine gait, Baudelaire crossed the avenue of trees at the Porte de Namur. He was meticulously careful to avoid the mud, and, if it was raining, hopped on the pointed toes of his pumps in which he liked to look at his reflection. He was freshly shaven with his hair combed back in a bunch behind his ears. He wore a soft collar of snowy white which could be seen above the collar of his cloak and which made him look like a clergyman or an actor.[60]

But this finely staged spectacle was, of course, only the visible side of an internal discipline, of a monastic narcissism portrayed in the following voucher.

The Dandy is

> A great man and a saint for his own sake.
> [He] lives and sleeps in front of a mirror.
> [He] is a man of leisure and general education.
> [He] is rich and loves work.
> [He] works in a disinterested manner.
> [He] does nothing useful.
> [He] is either a poet or a warrior.
> [He] is solitary.
> [He] is unhappy.
> [He] never speaks to the masses.[61] *

The occupations and interests of the Dandy were, therefore, the traditionally transcendental occupations—art, war,

* Baudelaire also says that the Dandy "never touches a newspaper." This is, however, a very specific repugnance, a particular grievance of Baudelaire's against the spread of popular "communications," and doesn't really belong within the more general outline of the Dandy as a "historic type."

and the divine. But they included also the angelic—that is, aesthetic—manipulation of the devil powers of money. Like Frédéric Amiel, Baudelaire believed that "high life" was a form of poetry and once remarked that French writers of upper-class novels were always careful to provide their characters with sufficient financial substance so that they might devote themselves to the unobstructed pursuit of fantasy *and* of love. Used in the interest of sensitivity, money made possible the translation of reverie into reality. It also made possible the purchase of time-freedom without which, Baudelaire said, eroticism would be not art but vulgar pleasure, requiring the "repugnantly useful" [62] duties of marital life. Finally, the Dandy is marked by certain peculiar forms of intellectual suffering as well as certain singular intellectual privileges. Through the sainthood of self-adoration Baudelaire sought to provide the Dandy with a training adequate to those who choose distress as the price of self-imposed cultural demands. For suffering was not only the Dandy's lot, but a need and, in some ways, a right. It was, in short, the philosophical justification of egocentrism, giving it a dramatic, even an "heroic" quality, and teaching that, in a culturally debauched society, narcissistic display represented not self-indulgence but rather a struggle for higher values. "You are a happy man," Baudelaire wrote to Jules Janin; "I feel sorry for you." [63]

Nevertheless Baudelaire insisted that the first obligation of the Dandy was, not to immoderate material elegance, but to the avoidance of excess. And on this issue the grounds of Dandyism begin to shift from a concern with the conditions of cultivated inactivity to a description of the precise contents and boundaries of the Dandy's intellectual stand. Baudelaire asked himself, "What is the passion which, having become doctrine . . . is capable of forming such a haughty caste." His answer was:

> In such troubled times [as the present] some men repelled, jobless, taskless, but rich in native powers, come to conceive the foundations of a new sort of aristocracy, one which is especially difficult to destroy because it is built upon the most precious and most indestructible of endowments, and upon heavenly gifts which neither labor nor money can confer.[64]

Melodramatically, and in anticipation of the injuries that the Dandy would suffer at the hands of the philistines, Baudelaire recommended that he take up the cultivation of dangerous sports. This and others of his proposals, like the robing of the Dandy in a manner appropriate to one who would be "priest" and "victim" of his own "strange spiritualism," cannot avoid the flavor of uncomfortable posturing. Yet there is no doubt that Baudelaire took the Dandy quite seriously as a model for a life style which, like the medieval orders, would shelter values in a time of cultural destruction. In a democratic age, he thought, only the exclusivism of the cultural *déclassé* could preserve the last glimmers of the aristocratic tradition in the face of a spiritually preempted egalitarianism. The Dandy was conceived as the founder of such a *caste provocante*, pledged to "what was best in human pride; the need, rare today, to combat and destroy triviality." [65]

In one of the most telling moments of the French Revolution, *The Declaration of the Night of August 4, 1797,* the *Convention Nationale* abolished all feudal privileges and stated that "no useful profession shall imply loss of honor." [66] But even before that, in his celebrated handbook on the historical aspirations of the bourgeoisie, *What Is the Third Estate,* the Abbé Sieyès had claimed for that class the right to represent the whole nation because, he said, the labors it performed were always "directly useful." [67] Tocqueville, speaking of the United States as a paradigm of democracy (in the sense of a public system where every class tends to converge socially and politically toward a boundary-less mid-

dle ground), once remarked that there all "honest" callings
were regarded as "honorable," adding that, since physical
well-being appeared to such societies as the readiest transla-
tion of the principle of equal opportunity, democratic peoples
had developed a new kind of pride, the pride of gain, which
allowed them to work *openly* for the sake of material ad-
vantage.[68] Later Anatole France concluded that, whereas in
every ordered society wealth was a sacred thing, in a democ-
racy it was the only sacred thing.[69]

Tocqueville certainly realized that the pride of profit, in-
herent in democratic man, and the contempt for gain, which
was the inheritance of aristocratic honor, were often a matter
of external gesture; aristocrats, he conceded, actually per-
mitted high and low motivations to intermingle "in the
depths of their souls." This historic moral distinction, on the
other hand, is important in its "ideological" projection as a
means of understanding the anxious and devoted forms of
self-cultivation practiced by literary elites. For it is a funda-
mental characteristic of the gentleman *of the mind,* when
compared with the gentleman by virtue of ancestry or ma-
terial possessions, that having no title of excellence other than
his own *inner* virtues, he must forever make a meticulous,
often strenuous, sometimes self-piteous public cult of his
adherence to higher values.

The issues of stylishness as a social weapon, and of manner-
istic uselessness as a defense against middle class notions of
occupational dignity, and of material gain as a measure of
self-respect, were well understood by Charles Dickens, as
we can see by comparing Baudelaire's Dandy with Josiah
Bounderby, the businessman of Dickens's *Hard Times.* The
Dandy ideal called for a necessary, and also unaccountable
condition of material well-being; his was a "natural" state of
leisure which allowed him to develop his life into the
supreme example of a personal art form. Bounderby is the

incarnation of naked market success—a banker, merchant, and manufacturer who glories in his early poverty and in the implacable self-reliance which allowed him to overcome it. The Dandy was regal but restrained, possessing what Baudelaire called "the majestic modesty" of the man of letters. Bounderby was lowly but aggressive; Dickens called him a "bully of humility." One speaks for the distance and composure of "intrinsic" values. The other for the muscular self-congratulation of the pragmatic. This is the way Bounderby himself explains the difference:

> I am a Coketown man. I am Josiah Bounderby of Coketown, I know the bricks of this town, and I know the chimneys of this town . . . and I know the hands of this town. When a man tells me anything about imaginative qualities, I always tell that man . . . that I know what he means. He means turtle-soup and venison, with a gold spoon, and that he wants to be set up with a coach and six.[70]

The seriousness with which Baudelaire and others (Flaubert among them) argued the relationship between spirituality and elegance reveals the vacuum left in Western society by the passing of an aristocracy capable of embracing within one class not only grace and "distinction" but splendor and power. It exposes, too, the strain inevitable in attempting to create or even imagine an aristocracy based solely on cultural exertion, on "the heavenly gifts which neither labor nor money could confer." * Yet, having made the deliberate, if highly symbolic, decision to stand for aristocratic values, the

* According to Max Weber, the principal task of the Mandarin, the state manager of classic China, was to make his person a flawless mirror of inward harmony because this alone would support his claim to public esteem and public power. Flaubert used the word Mandarin to refer to a similar personality and with the same public claims, but in the sense of a *purely* (non-bureaucratic) literary figure. He was the first to do so, though the term was later to be employed fairly commonly in this meaning. See, for example, *The Mandarins* by Simone de Beauvoir.

anti-bourgeois *literati* of the nineteenth century had no choice other than to bend every intellectual and psychological passion to attacking the principle of utility.

Given the social and economic circumstances of the time, this could only face them with some inescapably paradoxical prospects. The literary aristocracy was conceived as a moral and aesthetic gesture against money, that is to say, as a restoration of the honorific side of economic leisure. But the property basis of that leisure, land, rents, and courtly favors no longer existed. This forced Flaubert into devising a means of profiting from the undeniable realities of the market while avoiding its spiritual pollution. Whereas in the past one class had provided the material services while another cultivated values, a modern intellectual might attempt to embrace both functions within one individual, provided that he was careful enough to keep the management of property from infecting his mind and imagination. A successful man of letters, he said, would "live like a bourgeois but think as a demigod." [71]

Baudelaire, however, was not so resourceful, even at this theoretical level, and could do no better than to create illusions that would keep money flowing, mysteriously, into the Dandy's pocket; the Dandy, as we remember, "happened" to be rich, though he loved to work. This fantasy of a lifetime of unlimited credit appears to coincide in part with the manner in which, according to George Bernard Shaw, gentlemen see the proper relationship between society and themselves. A gentleman, Shaw says, is a man who thinks as follows: "I want to be a cultured human being; I want to live in the fullest sense; I require a generous subsistence . . . and I expect my country to organize itself in such a way as to secure me that." Shaw adds, however, that the true gentleman also says: "In return I am willing to give my country the best service of which I am capable," [72] whereas the Dandy

offers society nothing beyond the self-justifying spectacle of the cultural prince, presumably meeting all obligations by his mere existence and thus providing an excuse for the sensitive soul as a confidence man, such as one finds in Thomas Mann's *Felix Krull*.[73] As for the Flaubertian partnership of art and business, its best example can perhaps be discovered in the wedding of capitalistic skills and intellectual *savoir faire* with which Disraeli endowed the character of Sidonia in his novel *Coningsby*. The head of the world's most powerful banking family and a man able to pay the English national debt out of his own pocket, Sidonia is nevertheless the prototype of the unorthodox intellectual aristocrat—a kaleidoscopic and opulent world-bohemian who befriends authors, artists, philosophers, gypsies, and Carbonari, who is at home in Paris, Naples, Africa, or Brazil, and whose wizard mind has mastered "all the sources of human knowledge . . . the learning of every nation, and all the tongues dead or living, of every literature, Western and Oriental." [74]

For better or for worse, Dandyism and its techniques of "self-presentation" have become a part of the modern literary manner. For Thorstein Veblen leisure—"protracted contact with wealth"—created the phenomenon of "conspicuous consumption," the glory of the unnecessary, from expensive furs to the worship of "classical education." Max Weber's representative of the ethical revolution of the modern market was the Calvinist hero of "earthly asceticism," whose rigorous inner discipline and uplifting energies were always transformed into economic results. The Dandy may be considered an unexpected and specialized blending of these two models. He is, of course, a notoriously nonproductive type, but what he so conspicuously consumes are always and only spiritual goods. He is also a figure of restraint and stern self-discipline, but his asceticism is an aesthetic one in which all impulses are directed toward artistic craftsmanship and all dedica-

tion to the perfection of the personality alone. It is as part
of this modern tradition that one can understand the "moral-
ity" of Tennessee Williams's immeasurably refined poet
whose ethical fiber resides in his ability to surrender the
pleasures of the table so that he would remain slender and
youthful forever.[75] It is also within such tradition that we can
understand André Gide's Lafcadio, who practiced originality
as Pascal beseeched salvation. Pascal stabbed himself with a
pin when he was guilty of sinful thoughts. Lafcadio used a
similar method as penance for having entertained common-
place ideas.[76]

In his book *The Two Cultures* C. P. Snow expressed con-
cern with the unrest and homelessness of literary men which,
he said, not only had created an awkward rift within Western
civilization, but represented an actual danger to its survival.
The problem, in his opinion, was that the soul-stricken alarm
displayed by literary intellectuals in the face of the modern
world—and which was now as much an American as a Euro-
pean attitude—entailed really nothing less than an irrational
refusal to accept the scientific and technological revolution of
the last two centuries. To the customary gesture of recoil
from "cheap, naïve optimism and materialism" Snow answers
that materialism, properly understood, not only has not made
either scientists (the presumed main protagonists of it) or
ordinary persons any less human but is, rather, looked upon
by the majority of people in all countries as a blessing, not a
disgrace. Most men of science, he says, have a sense of the
"predicament of man." They know that much in life is dis-
appointing and solitary. They see no reason, however, why,
if the *human* condition is tragic, the *social* condition should
also be so. Nor do they understand why writers and artists
should think of industrialization—the creature of material-
ism, science, technology, and so forth—as a horror, when it
is in fact the only hope of poor societies to escape their

poverty, as such societies often prove by industrializing as soon as they can.[77]

Now, even though industrializaton can have some very painful immediate consequences, there is no doubt that what Snow says about the desire for it in economically stationary countries is true. Yet such recognition contributes nothing toward an explanation for those literary tendencies which Snow deplores. Indeed, past a certain point in the book, he leaves the question behind altogether and contents himself with issuing a general warning about the dangers of neglecting scientific training in a world where the fulfillment of revolutionary dreams is likely to fall into the hands of those who can provide its technological fulfillment.

Not that Snow is lacking in his own sense of alarm and irritation. He has been known to say on occasion that the literary repugnance for science and technology constitutes a kind of "social treason"—and he regards the politics of some modern writers, Yeats, Lawrence, and Eliot among them, as "silly when not wicked." But again, why? Why should a society which deliberately sets out to attain a happier physical existence for its citizens make the literary mind depressed, particularly since it is difficult to imagine what writers and artists would stand to lose, in a material sense, as a result of general prosperity. The answer, we must conclude, is related, not to fear of social dispossession, but to conflicting cultural "styles."

Men of letters are frequently ignorant of the rudiments of modern science, and their easy-going dismissal of scientific discoveries as trivial and pretentious gimmickry is regarded by Snow, quite correctly, as something of a scandal. Yet Snow believes that scientists should not repay in kind. He suggests on the contrary, that they should be better read and more sensitive to the concerns of the humanistic mind. Such peace-making proposals are no doubt likely to induce decorum and

amiability at the intellectual dinner table. But they probably won't settle the question, since they actually have very little to do with it. What one must understand is that the strange sense of oppressiveness shown by poets, novelists, and artists in the presence of scientific precision and rigor, and all other manifestations of rationalized purpose, comes from profound differences in the concept and the feeling of intellectual freedom. To the scientist, unfreedom and constraint are represented by the inability to solve specific problems. In literature, on the contrary, a sense of intellectual foreclosure, of the end of the imagination's ability to move, to inspect, and to consider is produced by the possibility of *solving* the problem. If literature is regarded as a form of knowledge it must be regarded as knowledge of a different kind, and whether or not one thinks of it as a profound index of social reality the fact remains that its magnitude as art or as document does not depend on its capacity to provide answers in a scientific sense. It would be the height of idiosyncratic antiquarianism for a physicist to ask his pupils to base their training on a mastery of Aristotle or of seventeenth-century texts. But if the same standards were applied to English departments, large portions of them would have to be disbanded. In literary art the opportunity for intellectual exertion, curiosity, in a word, freedom, depends precisely on the possibility of returning to the "human predicament" on the assumption that human problems are in some sense insoluble, just as the moral and aesthetic imagination is in some sense inexhaustible.

According to Max Weber, the smooth and predictable discharge of administrative, legal, and economic functions characteristic of modern social systems presumed the elimination from the workings of institutions of all "unreasonable"—that is to say, subjective—motives. This process was in many ways desirable since no one could dispute that it provided for an

efficient organization of public services. But even the sociologist and the rationalist, both of which Weber was, could not help being repelled by and even vaguely fearful of the human type needed for the operation of modern bureaucracies, the creature of narrow goals and small, airless mind living by legalistic snobbery: "the Puritan willed to be the vocational man." [78]

The literary man was, of course, equally repelled and alarmed, but he extended his concern to the whole of the modern social climate. He perceived, for example, that while all systems of political rule must attempt to guide and determine people's destinies, none did so with such deliberate regularity and such appetite for manipulation as the rationalized social order. Edward Shils has remarked that governments in the past have been able to count on the traditionalism of the governed—that is, on their acceptance of an immemorial human "condition"—as the basis on which power existed. In modern societies, on the other hand, rulers invited novel expectations on the part of their subjects and then proceeded to stake the legitimacy of their power on their ability to fulfill these expectations. In other words, modern political power rested on the stimulation of mass hopes and on the mass approval that follows mass gratification. And it followed from this, as Shils also noticed, that the *kinds* of social aspirations first promoted and then adopted as political programs by modern regimes were, naturally enough, those whose benefits could be counted, measured, and explicitly distributed: technological advance, economic productivity, material welfare, and a system of education designed to increase the share of the general population in technical, professional, and bureaucratic opportunities.[79]

It was the central thought of Tocqueville's famous study of democracy that there was a connection between modern egalitarianism and a pragmatic and materialistic public at-

mosphere, and, taking this loosely, we may regard modern governments as generally democratic in the sense that they are pledged to advance the interests of the masses. There is, however, an important difference between Tocqueville's classic account of the psychology of egalitarian behavior and Shils's analysis of mass-oriented governments. What Tocqueville saw was a spontaneous taste for material gratification on the part of the populistic man. What Shils wishes to point out is that modern political organization is conceived as a device for the continuous solution of social problems and that, because of this, these problems themselves are conceived in such a way as to make them amenable to explicit and general solutions in the bureaucratic style. Modern governments and efficiency-seeking societies will therefore actually and constantly press men toward larger-scale and ever more simplified realms of social and personal experience.

The convergence of rationalization and political scientism are distinct features of present-day experience. The literary man's fear is the fear that increasingly successful instruments of public policy may represent a threat to traditional ways of individualized existence. We may regard that fear as rational or irrational, responsible or irresponsible, but we cannot deny that it has become a fairly general form of social perception and not just an item of literary sensibility.

It is quite natural, therefore, that contemporary writing should have sought those far reaches of experience that escape the rational mode. That it should have incited both ends— the defiant and fastidious as well as the movingly and "significantly" tormented—against the comforting middle. That it should have celebrated self-expression and self-cultivation, the intimate and the excessive. Haughty intellectualism, the aesthetics of life-playing, and nobly afflicted and ironic failures. Heroes of arrogance and heroes of despair.

Nietzsche, Hemingway, Stendhal, Dostoevsky, and Scott

Fitzgerald are all understandable as part of this tradition. But so is the non-hero of George Orwell's *Nineteen Eighty-Four,* a book whose title has become a gloomy password in our day. Orwell was nurtured on a number of "advanced" social causes. He later became disappointed with them, and *Nineteen Eighty-Four* is (it certainly has been taken to be) an attack on what Orwell sees as the general contemporary movement toward political totalitarianism, of the left as well as of the right. Orwell describes the nightmare of living under an insatiably dogmatic ideological system armed with the tools of absolute domination. But in a more embracing sense, he also portrays the deadly and unequal battle between a personal way of life and the propensities of forced rationalization carried to its ultimate fulfillment; the people in his novel succumb not only to the political but to the "human" implacability of modern power and its appetite for predicting behavior and, finally, thought.[80]*

According to Baudelaire, a poet was never to cater to the sites of power or to the shallowness of modern optimism, but should seek instead the company of everything "feeble, destitute, orphaned and forlorn." [81] Like Baudelaire's poet, Winston Smith, Orwell's protagonist, is drawn to frail and

* A premonition of totalitarian orders, ideological and bureaucratic, is found, again, in the nineteenth-century critics of social rationalism. Flaubert regarded the political teachings of Comte and Saint-Simon as a form of materialistic pietism (he called them "philosophico-evangelical vermin"). He thought of these prophets as pedestrian fanatics ("bookkeepers in delirium"), afire with the trivial vision of satisfying mass wishes and the fearful one of destroying "all individual initiative, all personality and all thought." He had no doubt that, in the hands of a compulsive reformer, the state would become an omnipotent force: "a sort of monster . . . which will direct everything. "A sacerdotal tyranny is at the bottom of these narrow hearts (the social positivists and reformers). 'It is necessary to regulate everything, to refashion everything, to put everything on a new basis.' There is no nonsense, no vice which will not find its blueprinters and its dreamers. I believe that man has never been as fanatical as today." *Selected Letters,* p. 209; *Correspondence,* II, p. 117.

useless things which seem to offer him a respite from the inexorable purposefulness and single-mindedness of his surroundings. The destruction of ancient buildings inexplicably saddens him. And he has a curious passion for secondhand stores and old-fashioned gimcracks. Winston's doom, however, follows his attempt to satisfy the most profound of all personal needs (somehow still alive in the modern social robot), love. And in this he too belongs to the romantic tradition, which flaunted not only the mysteries of art or the glories of sensuality but the integrity of love against the claims of a political order wishing to reorganize all feeling in the name of communal reconstruction. At the height of the Jacobin period Robespierre said that the mission of the new politics was "the guidance of human passions towards objects useful to the general prosperity," [82] a doctrine which, followed to its ultimate consequence is bound to look upon falling in love as a falling out of society and a deliberate renunciation of its goal (Max Weber, the great theorist of bureaucracy, well understood this when he said that the "boundless giving of oneself" was an act "as radical as possible in its opposition to all rationality and all generality.")[83] *Nineteen Eighty-Four* not only tells us that love represents the final withdrawal from public demands. It also forecasts the obliteration of love at the hands of a state which will not allow the survival of this last shelter of nonpublic purpose.

Symbolic techniques for the avoidance of cultural equalization change from time to time, but they remain close in spirit. Baudelaire created the fastidiousness of the Dandy's elegance. The American "Beats," living in an environment where affluence is the rule and fashion is distributed on the mass market, have adopted the "new poverty," the elitism of conspicuous nonconsumption. One traditional response to the loss of aesthetic surprise in a society thought to be swamped by uniformity was the cryptic willfulness and out-

rageous style of idiosyncrasy* invented by nineteenth-century bohemians and still practiced by their heirs. Another was the literary enthusiasm for happenings whose sole value is a moment of great poignancy or a display of memorable singularity. Thus, for example, Hemingway explained that the boredom of a poor bullfight might be relieved by looking closely at the bullfighter's face. One could then see his fear, and *that* was interesting. Baudelaire, we recall, thought that, though Spanish American politics were barbarous, at least they caused people to kill each other. The only form of political activity to interest Flaubert was the riot, that is to say, the uproarious failure of politics.

Such remarks may, of course, be regarded as picturesque gestures themselves and no more responsible than the things they intend to praise. Yet even Bertrand Russell, a man who had dedicated his life to the support of the scientific method (and Snow might have noted this), later became fearful of institutionalized rationalism; he went as far as saying that the rule of the "administrative type" at the service of efficiency for its own sake, was the greatest of our present dangers outside of atomic destruction.[84] Indeed, it is possible to discover in modern literature, not only a rejection of efficiency but a positive attachment to the charm of failure. There is reverent pity for the sensitive victim of a mechanized existence, just as there is delight at the spectacle of modern machinery falling flat on its face. One can hear the joy and relief of someone like Honor Tracy when upon entering Spain, a country not yet entirely afflicted by progress, she realizes at once that bathrooms can now be expected to behave comically, nobody is likely to obey rules, and public services are

* It would be hard to conceive of an intellectual epoch other than our own in which one would be expected to see the point of the explanation given by the Spanish novelist Ramón del Valle Inclán for his taking a trip to Mexico; it was, he said, the only country with an "X" in its name.

a charade of infuriating but colorful confusion.[85] If philis-
tines are upset by late trains or poor plumbing a whole
minor literary genre has grown in our day dedicated to cele-
brating societies where technological reliability is low but
human excitement is high.

The champions of "personalization" in an "age of im-
personality" have appealed to many things—the worship of
art over routine, of pleasure over discipline, of the individual
over the community—and they have done so with passion and
defiance as well as anxiety and distress. The first reaction and
the earlier attack was against the "middle class." Sociologists
have argued about the meaning of this term.* *Literati* have

* Some European sociologists seem to have a fairly clear notion of where one
class begins and another ends and even of the social and economic provinces
within each. Writing of the middle ground of English society, Lewis and
Maude contrast the white-collar families of the turn of the century, lan-
guishing below the "public school" circuit in a suburban proliferation of
"Acacia Villas," with the high-bourgeois gentlemen of Arnold Bennett's
recollections, men of "assured, curt voices and proud carriage," who belonged
to a caste "completely free from the care which beset at least five-sixths of
the English nation." On the other hand, a uniformity of terms does not
always accompany such careful distinctions. Some French sociologists use
the expression "middle class" to refer to an essentially provincial world of
small businessmen and small-town civil servants. Others put the middle class
between the upper class (consisting of large-scale industrialists, the profes-
sional elite, and great state functionaries) on the one side, and manual and
white-collar workers on the other. In America two famous surveys, which
are now part of the sociological folklore, showed that between 79 and 88 per
cent of Americans think of themselves as members of the middle class. Later
studies made by Richard Centers disputed these findings, and later still, the
several volumes of W. Lloyd Warner and his associates offered a precise
classification of the American social order breaking down the three major
classes, upper, middle, and lower, into upper, middle, and lower registers
within each. Yet, for all these clarifications and additions, a sense of evasive-
ness persists. In his *Class in American Society*, Leonard Riessman points out
that because of a belief in social equality, class in America tends to have
the invidious subjective meaning of "caste." He also finds that, according to
"Hometown," his model sample, "the number of classes that may be recog-
nized varies depending on the number of social differences the Hometowners
can detect and agree upon." Seymour M. Lipset and Reinhard Bendix, in a

used it in an essentially polemical sense. But the two come close to an agreement when the focus is shifted from income, property-holding, and certain criteria of occupation and prestige to a portrayal of social motives and an assessment of human goals. One common ground in this respect is the distinction made by sociologists between the "short-run hedonism" of the lower classes and the middle class practice of "delayed gratification." The distinction, that is to say, between the unconcerned embrace, among the lower ranks, of whatever delights daily existence might bring, and the capacity of the more "self-respecting" orders to postpone pleasure and, as a consequence, to accumulate the economic resources needed for eventual social "advance."

Such terminology is really another way of evoking the general view of middle-class morality contained in Max Weber's "Puritan" thesis and preached by a long line of didacts of industriousness like Daniel Defoe, who in 1745 wrote: "I cannot allow any pleasures to be innocent when they turn away either the body or the mind of the tradesman from one needful thing which his calling makes necessary: I mean the application of both his head and his hand to his business." [86] Still it serves to remind us once more that the doctrine of anti-bourgeois behavior was guided, by the spirit

copiously documented study, maintain that, contrary to common opinion, there are no substantial differences in the fluidity and mobility of American and European societies, and that the seemingly greater mobility of the United States really has to do with the style of manners and the means of acquiring and exhibiting social symbols. See: W. Lloyd Warner and Paul S. Lundt, *The Social Life of a Modern Community* (New Haven: Yale University Press, 1941); W. Lloyd Warner and associates, *Democracy in Jonesville* (New York: Harper and Bros., 1949); Ruth Rosner Kornhauser, "The Warner Approach to Social Stratification," in Reinhard Bendix and Seymour M. Lipset, *Class, Status and Power* (Glencoe, Ill.: The Free Press, 1960); Seymour M. Lipset and Reinhard Bendix, *Social Mobility and Industrial Society* (Berkeley: University of California Press, 1959); Leonard Riessman, *Class in American Society* (Glencoe, Ill.: The Free Press, 1960).

not only of the intellectual baron but of the intellectual and psychological gypsy. One side of the doctrine spoke for the discretion and loftiness of the self-made intellectual aristocrat before the money-and-tools secularity of the businessmen. The other for an admiration of tavern folk and "street corner societies," "White-Negroes," interesting derelicts and hard-living non-self-improvers, men with "character" though, perhaps no "future," practitioners, in other words, of the ancient and spontaneous art of "short-run hedonism." The prudence and prudery of the middle classes might look with horror upon lust, waste, irresponsibility, superstition, and violence. They might, for that matter, seek, through middle-class reform, to eradicate them from society. But for the literary imagination these traits were often the companions of charm, grace, courage, and amusement. They offered the timeless mixture of human triumph and human failure, and within failure, survival, a spectacle always reassuring to those bored with the relentless and hygienic optimism of the present age.

Weber's larger views of rationality, Shils's observations on modern bureaucratic populism, Orwell's black utopias, and the history of political disappointment among many figures of contemporary letters point also to something larger, and, in the eyes of the literary, far more disastrous than the curse on life and culture brought about by bourgeois piety, materialism, and success. This is the possibility that individualism, creativity, and emotional free play may find themselves threatened under all the political and economic dispensation of the present day. If, as Flaubert said, the great revolution of our time was the conquest of modern society by the spirit of the middle class, intellectuals might have found consolation, and, presumably, the solution of their problems, in the victory of Marxist political forces in Russia and elsewhere. And it is true, of course, that many writers and artists of the last two generations chose for a time to look upon the Soviet

Union as the very instrument of their salvation. This, however, was followed by a painful though protracted collapse of such illusions, not only among the distinguished and the important, but among the obscure members of the intellectual rank and file. Of some of the Americans of the "Beat Generation" Lawrence Lipton has said:

> We felt that all the Bolsheviks had succeeded in absorbing so far were the headaches of the ruling class, the manufacture of things, the production and distribution of problems, the bookkeeping that went with it. We were expropriating the things of inner gratification and lasting value, and we were doing it without overthrowing the rich.[87]

As a weary dismissal of all things not of "lasting value" or incapable of producing "inner gratification," Lipton's statement may appear as one more echo of the painted and supercilious soulfulness of the romantic inheritance. But the tone is above all Stendhalian.* The Bolsheviks are the new bourgeoisie, the new managers of that "collection of ugly details" which, according to Stendhal, constituted the great concern of the middle class. In Baudelaire's words we might say that nothing much had happened other than the emergence of a new generation of workhorses in the stables of mankind.

Max Weber saw no sign of retreat in the growth of either political or economic rationalism. Marx, on the other hand, promised that political institutions would dissolve because the individual himself would become the carrier of a universal rationality. As everyone knows, the "withering away" of the state has yet to approach its beginnings in the Soviet Union, half a century after the revolution. Yet some contemporary literary attacks on Soviet reality seem to complain,

* A comparison to be allowed only in the service of illustration. Lipton's book, interesting as a document, is a tawdry and fairly low-grade piece of bohemian self-glorification.

not so much about the failure of a human rationality to emerge as to the excess of rationality, perverted, to be sure, which already exists. There are in Soviet literature too, non-heroes whose personal sentiments are unable to withstand the tide of collectivized purpose, like the would-be production manager in Yurii Olesha's *The Wayward Comrade* whose downfall is the outcome of an attachment to archaic feelings —vanity, jealousy, honor, the "old" feelings "glorified by poets," which still haunt him and of which he would like to organize the "final parade." [88] D. H. Lawrence may have spoken for many non-Marxists as well as post-Marxists when he said that all of modern society was "a steady sort of Bolshevism; just killing the human thing and worshipping the mechanical thing." [89]

The problem of a scientific versus a literary culture reaches, therefore, into much more intractable areas than those suggested by C. P. Snow. It is not merely a question of vain and superstitious disregard for science, or the provincialism of humanists who refuse to accept the enormous managerial problems of the modern world, or the willful social obscurantism of the romantic mind. It is a question of the essential effect of an ever more rationalized mode of existence upon the life-space available to some of the oldest forms of human imagination. If a scientifically intended society means putting human experience on a flat, well-lit plane which leads in a straight line toward a perennially deliberate future, the literary mind may be said to represent in its most rebellious form a case of intellectual fatigue before the secular version of infinity.

2 · French Impressionism as an Urban Art Form

There is among sociologists a conventional, perhaps notorious reluctance to acknowledge art as an aspect of culture consequential to their researches.* Yet, curiously, it is also true

* None of the "classic" figures of American Sociology have addressed themselves to aesthetic questions. And it is typical for widely read classroom primers like Robin M. Williams's *American Society* to spend several hundred pages on every aspect of the "value system," including religious behavior and educational institutions, without once mentioning art or literature. Such indifference (or distrust) can be explained in part by the professional history of sociology in the United States. In Europe, until quite recently, sociologists dwelled within the traditional company of the man of letters. The world of learning they inhabited was small in number and vast in its interest, and sociology itself could be regarded as a widening, through new visions, of the historical, philosophical, artistic, and literary scholarship in which these men had been bred. The spirit of American sociology, on the other hand, possibly because its beginnings were so largely tied to the field of "social problems," has been "secular," brisk, immediate, unapologetically factual, devoted to the exhaustive accounting of human relations and every conceivable or at least describable aspect of the social environment. Still, the sociological status of art may in time require, or even more demand, an explanation. A discipline which claims to provide a systematic accounting of human culture cannot ignore as much as it has what in the eyes of tradition, if nothing else, are regarded as the articulate monuments of that culture. Not

that those to whom this rule does not apply have shown a trust in the significance of art that is not only passionate, but from an intellectual point of view, excessive. The normal ways of sociology require that statements about the "values" of a culture should rest on whatever one can find out about behavior and belief among a *number of people* which, with one or another justification, might be regarded as representative. Some sociologists of culture, however, embracing what is in fact a traditionally romantic view of the relationship between social life and aesthetic expression, fall to writing as though the work of artists, the work, that is, of a minority of the uncommon, should be taken as the final testimony of a culture's true character, or as the act or gesture *defining* the quality of a social period.

It seems clear, at least to me, that a sociology of art moving at such a glamorous level of abstraction would be constantly faced with the temptation of taking the unique eloquence of art as *proof* of its social representativeness, thus circumventing the very thing that sociologists should be required to demonstrate: the connection between ordinary, unselfconscious experience and the memorable creations of the few. Before speaking of the urbanism (or the urbanity) of the French impressionists, therefore, we should decide what the sociological version of urban culture might be. It is just at this point, however, that one must first struggle with allegations which are either conflicting or one-sided.

Some urban studies have been done in the style of a higher zoology, describing the spectacle of an organism which grows and decays as it consumes and transforms its natural surroundings. But others have turned away from such faceless

that it should bow to the tenets of that tradition. Sociology may be the source of a new interpretation of art. Or it may disprove customary beliefs in the weight of art and literature as *representative* expressions of a culture's qualities. Its contributions would be of equal significance in either case.

plotting of biological (or metabolical) movements to chronicle the ethnology of streets and neighborhoods and to portray the folk singularities and stubborn provincialisms which racial and cultural communities are able to keep alive within the larger metropolitan creature. Further still, the notion that cities constitute a peculiar moral and intellectual environment has taken not one but two dissimilar and contradictory forms. One of them holds that urban social distances and urban uprootedness are, in fact, the sociological preconditions of modern analytical intelligence. Urban anonymity, the abandonment or destruction of communal support and membership, make the city man vulnerable. But they also make him detached and adventurous and commit him to a reliance on *ideas* or, what in an older meaning of the language is called "wit." In this version of city life—one of the stately commonplaces of cultural history—urban "impersonality" and urban "objectivity" are seen in an approving light as incitements to resourcefulness and freedom of judgment and as the very arena of "creative" ferment.

But another and equally venerable account of the same circumstances charges them with fostering something, not only quite different, but altogether menacing and deplorable. What it describes is the historical appearance of a massive but shallow social habitat swept by meaningless agitation and peopled by lonely, driven men living in a state of social and psychological orphanage. As Georg Simmel portrays them in an essay considered by many as one of the classic pieces of "value-insight" in sociological literature, the human recognitions of the city, though swift and resourceful, are always tangential and uncommitted, their very nimbleness made possible by an underground of moral thinness and disembodiment. For, as Simmel tells us, the adaptability to stimulation of urban psychology is the subjective arm of a devotion to money, that is to say to the power whose "objectivity" as

measure of social position and transactions has been built on the ruins of all that was intimate and selfless.[1]

Simmel remains within the prudence and abstraction of tone befitting the professional academic, but the nature of his argument moves him inescapably to the edge of an ethical message. And what that message is may be found in the words of another, earlier student of the city, the self-described "doctor of social science," Honoré de Balzac who, assuming the novelist's right to moral comment and moral characterization, could speak for the cynicism and melancholy clearly felt by the sociologist.

This is Balzac speaking for the Parisian of his time:

> By virtue of being interested in everything he ends by being interested in nothing. . . . He grumbles about everything, he is cheered by everything, he mocks everything, forgets everything, sees everything, likes everything, embraces everything and, with *insousiance,* dismisses everything. . . . In Paris no sentiment can stand the stream of outside events, a flow no passion can survive. There, love is nothing more than desire. Hatred is only a whim. And there is no kin but the thousand franc note.[2]*

Simmel's share of discreet philosophical despondency about

* It is interesting to compare Balzac's statement with these passages from Simmel: "The psychological basis of the metropolitan type of individuality consists in the *intensification of nervous stimulation* which results from the swift and uninterrupted change of inner and outer stimuli. Man is a differentiating creature. His mind is stimulated by the difference between a momentary impression and the one that preceded it. Lasting impressions, impressions which differ only slightly from one another, impressions which take a regular and habitual course and show regular and habitual contrasts —all these take up, so to speak, less consciousness than does the rapid crowding and changing images, the sharp discontinuity in the grasp of a single glance, and the unexpectedness of onrushing impressions. These are the psychological conditions which the metropolis creates. (Italics in the original)

Money is concerned only with what is common to all: It asks for the exchange value, it reduces all quality and individuality to the question: How much?" Simmel, op. cit. pp. 409, 411.

the nature of modernity was inevitable, given the suspenseful cultural "issue" of his main argument—the preservation of individuality before an "overwhelming . . . external culture"—a notion that makes him a precursor to some of the familiar lamentations of the contemporary world. These complaints may come from genuine reflective anguish or simply from the querulousness of the professionally "sensitive." They are heard among elderly social metaphysicians as well as among the messianically outraged young. And they all have at least two things in common. One is a view of modern life as a depthless and lonely mechanism. Another, a belief that the ancestral relationships of pre-industrial and pre-metropolitan societies are ever "meaningful," and that painful and oppressive restraints upon individual conduct are wholly the creation of contemporary "rationalized" existence.

Yet Simmel actually knew better, for as he himself tells us, primitive and folk communities are dominated by stereotype values. Still, as he unfolds his picture of the city as a gray and featureless labyrinth, he makes himself suspect of a conventionally romantic reverence for the presumed truth, profundity, and spontaneity of the primitive and ritualized. Nor is his fear for the survival of individuality devoid of some obvious contradictions. If, by his own account, cities were the scene of an extraordinary proliferance of new occupations, self-awareness and, for that matter, self-centeredness (just as they were the breeders of new forms of self-reliance), how could they also be the enemies of personal experience and free play? The answer seems to be that for Simmel, individuality is not the name for a species of intellectual and psychological "style" but a species of moral feeling: a primordial and easily wounded root of human integrity to be protected against what he calls—and his language is here specially revealing—

the "cold, heartless and unmerciful" factual spirit of modern society.*

Because Simmel chose to look at individuality in the solemn terms of moral sensibility, he also tended to look at the urban invention of new personal styles as nothing more than "precious" and "tendentious" peculiarities: a kind of posturing superficiality to which men were driven in a corrupt and desperate attempt to assert "human" reality and "integrity" against the merciless objectivity of modern life. For the same reason, there is no doubt that he exaggerated the extent and the consequences of modern rationalization. For example, he failed or refused to see that if industrial and commercial time was the artifact gearing the straddling mass of the city's population to a common pace, cities as total cultures were also characterized by the suppleness and ingenuity of their styles of time-avoidance. Urban life rhythms are not dictated by antique custom or long-obeyed rituals. Urban work must be done and urban services consumed and delivered within conventionally devised blocks and stretches of temporality. (Simmel wondered what would happen if, in different ways, all the clocks and watches of a great city were to go simultaneously wrong by as much as one hour.) But precisely because of that, cities are equally places where time itself becomes a luxury and where ornamental and resourceful ways of "wasting" it provide the basis for novel, even

* There is, then, in Simmel's formulation, a measure of obscurity and sentimentalism which fails to render explicit what I believe is the real and remarkable paradox of modern urban psychology. Namely, that the conditions of city life create or permit forms of individuality that these same conditions cannot easily accommodate; that they invite forms of self-consciousness leading to a feeling of loneliness amidst the surroundings which make such self-consciousness possible. In its size and "anonymity" the city allows the flowering of vividly personal sensitivities. These sensitivities must, on the other hand, sustain themselves. And this explains why men feel not only aroused and released by the city, but also submerged and powerless in its vastness.

defiant modes of social existence. If cities are places of fixed hours and of men bound to desks and machines, they are also—and uniquely—the breeding soil for an accessory universe of chance experience and human exploration, the stage for a new artistry of personal behavior, discreet, fanciful, elegant, or bawdy.

The impressionist painters pointedly and charmingly confirm us in this conclusion. One usually thinks of impressionism as a supremely *pictorial* display, as a marvelous aesthetic sport, void of content, for which the world is only a dappled, bursting, tremulous mass of light, where color palpitates in the waters and rustles in the leafery, and even cathedrals are engulfed and vanish in the sunlight and shadow of the changing day. And this is, of course, true of one sort of impressionism. The impressionism that so joyously and even ostentatiously lavished its attention on the outdoors, the *plein air* of Renoir's dreamy meadows, flowered by red poppies and ladies' parasols, of Monet's waterlilies, where all substance seems to become suffused in a filmy, vibrant mirage of itself. But there is also in the impressionists a world of psychological and social annotations, of city parks, beer gardens, street corners, theaters, coffeehouses, music halls, and tearooms, where their quick and casual brilliance was applied not to the unveiling of the landscape, but to the exposure of passing human episodes in all their immediacy, elusiveness, and impermanence. They show us, then, that the city is not merely a dismal, somnambulistic, and monotonously haunted machine, not just a marketplace of ideas and commodities, but a stage for the disengaged and exuberant curiosity, the self-exhibition and reciprocal surveillance of onlookers and bystanders, *boulevardiers,* opera-goers, pubmen, clubmen, gentlemen of fashion, and gutter dandies.*

* Cities are also the creators of new emotions and even emotionality; what could be more sentimental than the modern urban song. Furthermore, Sim-

Arnold Hauser, in his extensive and, by some, much admired work, *The Social History of Art,* has made the relationship between impressionism and the city the major premise of his analysis of the style. But, unhappily, the effort miscarries because of Hauser's solemn but incoherent effort to fit it within the materialistic interpretation of history. Still, in questioning Hauser's sociological and historical claims (as well as his artistic judgment), we find ourselves arriving at a more distinct account of what aspects of the city's moral and emotional flavor may be witnessed in impressionist painting.

Impressionism was urban, says Hauser, not only because it discovered the landscape quality of the city, bringing painting back from the country into the town, but also because it saw the world through the eyes of the townsman, reacting to it with the over-strained nerves of the modern technological man.[3] Still more inclusively, impressionism was to be regarded as one of the manifestations of a well-structured process in contemporary social history. In this respect, he maintains, it was important to see that impressionism and the aesthetics of the naturalistic movement, so prominent in the second half of the nineteenth century, could not be clearly distinguished. There was a fluid borderline between one and the other which corresponded to the continuity of economic development and social conditions under the dominance of the upper middle class.[4]

Hauser has had no lack of enthusiastic reviewers. Thomas

mel's rationalistic vision of the city failed to notice entertainment as an industry; that is, the staging and marketing of nonrational imagination which is one of the characteristic features of a developed urban economy. Night clubs resembling feudal hunting lodges, restaurants which re-create Polynesian villages or gypsy caves, theaters which suggest Islamic temples, all these testify to the city's demand not only for order which will permit it to function, but for fantasies and illusions which will ease some of its very realities.

Mann marvelled at his learning. Meyer Schapiro admired many of his opinions. But I, myself, find this crowded work strangely unconvincing, chiefly because it illustrates the difficulty of finding illustrations that will measure up to the sort of grand theory that Hauser regards as indispensable for the sociology of artistic symbols, particularly shown in this case by Hauser's Marxist-flavored efforts to relate impressionism to naturalism and to portray both movements as twin flowers of the conditions of the capitalist market.

According to Hauser, the dots and flashes of the impressionists actually represented the transformation of a scientific formula into an artistic form, the visual rendering of the philosophy of empiricism with its view of reality as nothing more than a collection of sense data.*

And since naturalism as an aesthetic creed is also an offspring of empiricism, the two were to be understood as different postures and nuances within a common ideological "climate."

Such an argument could only come from first, the shuffling of certain essential principles and ideas and, second, a description of impressionism which is clearly not in agreement with the facts. In its least disputed form, naturalism holds that the natural world is the whole of reality and that the facts of social life are to be understood as aspects of the same universe. In this sense, there is no question that philosophical

* The argument is not original with Hauser. It can be found in F.S.C. Northrop, who speaks of the parallel between an "aesthetic continuum . . . constructed by placing separate, independent, isolated sense data" and the theory of ideas as an "association of sense data" contained in the philosophy of Hume and Locke. (See: *The Meeting of East and West* (New York: The Macmillan Co., 1947), p. 119.) Northrop, however, restricts his examples to Pissarro (I think incorrectly) and, above all, to the pointillisme of Seurat. And, we will remember, the results of pictorial "atomism" in Seurat were not the flow and vibrancy of feeling and movement characteristic of the impressionists but a frozen immobility and an extraordinarily hard surface.

naturalism provided the basis for *literary* schools of the kind
that struggles to eliminate from works of fiction all sugges-
tion of chance events, personal motivation, or the obscurities
and ironies of human "destiny." * But it is seriously deceptive
to take the pictorial devices of the impressionists as, in them-
selves, the reflection of a metaphysics and, particularly, a
naturalistic metaphysics. Whether it reflected the shifting
lights of the landscape or the psychological elusiveness of
urban encounters, impressionism was a peripatetic, tremu-
lous art, thoroughly occasional and typically free of philo-
sophical proclamations. And it must be regarded as a mystery
that Hauser should have decided to suggest a kinship between
it and the rigorous purview of the naturalists. Furthermore,
not only was naturalism exclusively a literary movement; it
was also the ideology of the rebellious intelligentsia of the
Second Empire. Impressionism on the other hand, was, quite
obviously, an art created by men who felt socially comfortable
and politically unconcerned and who celebrated with a kind
of amiable lyricism the bourgeois pleasures surrounding their
lives. Among the painters, it is difficult to name anyone out-
side Gustave Courbet who might be considered the repre-
sentative of the naturalistic position. And it would be harder
still to think of anyone more removed from the impres-
sionists in his aesthetic and political sentiments.**

* In the words of his great theoretician and practitioner, Emile Zola: "The
naturalistic novel was a continuation and complement of the science of
physiology which, in turn, depends upon chemistry and physics; it substitutes
for the study of man as an abstraction, man as a metaphysical entity, the
study of natural man as the subject of physio-chemical laws, a being deter-
mined by the influences of his environment." Cited in: William K. Wimsatt,
Jr., and Cleanth Brooks, *Literary Criticism: A Short History* (New York:
Random House Vintage Books, 1967), p. 458.
** Hauser knows this himself, since at one point he speaks of the impression-
ists as leisurely, passive, "aristocratic" aestheticians. He should have been
careful, therefore, not to allow his readers to infer that there was, during
the Second Empire, a single community of artists and writers. But then this

Courbet rejected landscape painting (in theory rather than in practice, to be sure) and, seeking in his work the signature of "nature itself," dismissed all license of the imagination as an affectation of and for the privileged. Peasants and workers, he concluded, were the noblest subjects of the artist's concern (a belief he carried into political act by joining the Paris Commune in 1871). We must ask what link could exist between such doctrines and Degas, Monet, or Renoir, the painters of Sunday promenades, boating parties, afternoons at the races, and evenings at the Opera?

Indeed, Hauser is eventually compelled to readjust his thesis when he is no longer able to reconcile its contradictions.

is only one of his several oversights. On page 171 of the fourth volume of his work, he explains the impressionist disregard of subject matter (he neglects, by the way, to say that this is true of landscape impressionism and not of urban impressionism which is full of psychological and social subject matter) as a product of the "anti-romantic outlook of the period," a period wishing to do away with the traditionally stately qualities of art. Just one page before, however, he describes the "self-centered" aestheticism of the impressionists as the "ultimate consequence of the romantic renunciation of practical, active life."

An even more extraordinary inconsistency is discovered by comparing the second and the fourth (and last) volumes of *The Social History of Art*. In the latter, Hauser, as we have seen, explains impressionism through its connections with the social and economic developments of the nineteenth century. This view, however, is totally ignored in the second volume, which discusses impressionism as an independent concept capable of appearing at different times and in the midst of the most diverse cultural surroundings. Hauser even suggests that Heinrich Wölfflin, in his famous *Principles of Art History*, may have been guilty of timidity or ignorance for having found impressionistic qualities in the Baroque of the seventeenth century, *but not earlier*. After all, Hauser says, a "subjectivization of the artistic world-view, the transformation of the 'tactile' in the 'visual'," of substance into mere appearance, regarding the subjective as primary, and emphasizing the transitory character inherent in every optical "impression" had already been anticipated by mannerism and, still before that, by the Renaissance. The words in quotations are almost identically those employed by Hauser to describe later nineteenth-century impressionism. (See: Hauser, Vol. II, pp. 174–75 and Vol. IV, pp. 171 ff.)

For if, as he says, the easy passage from naturalism to impressionism was sustained by the *solidity* of the market through much of the nineteenth century, how was one to account for the shimmering complexities of the impressionist style? What happened, he tells us, was that, after an initial period of free-play business energy, France entered the "stage of high capitalism" which eventually led to a "rigidly-organized and rationalized system." The market became increasingly more intractable. And this, and the shock of the Paris Commune finally dispelled the optimism of the early capitalistic boom, submerging the bourgeoisie in a climate of dismay and anxiety from which it sought remedy in new "idealistic" doctrines and, remarkably, given the secularized nature of bourgeois life, even a reawakening of mysticism. It is only in the course of this development, Hauser tells us, that impressionism loses its connection with naturalism and becomes transformed, especially in literature, into a new form of romanticism.[5]

Now, aside from what impressionism may have been like *before* it lost its connection with naturalism, something neither explained nor illustrated, what Hauser implies is that, in some generic way, impressionistic aesthetics were part of an obscurantist relapse among a bourgeoisie yearningly or cravenly seeking sentimental relief from the internal crisis of capitalism and the external menace of revolutionary unrest. But then he tells us that he is speaking primarily of "literary" impressionism, thus reaching for an all-too-convenient hedge and qualifier. And an instrument of deceptive allusion as well, since it must be insisted that, just as naturalism is a literary concept, impressionism is a pictorial one used by literary critics only in ambiguous and ad hoc ways.* In

* Some of these critics have used the term to describe the kind of introspective recall found in the writing of Marcel Proust. For Oscar Wilde, impressionism meant the reworking of natural reality through the refinement and formalization of artistic awareness. For others, it was an expression of anarchy which denied the moral and social responsibilities of literary judgment.

the absence of examples, it is difficult to say what Hauser himself has in mind. One guess is that he might be speaking of a connection between painting and the symbolist movement, with its exaltation of the oracular and the intuitive. If this is the case, it might certainly be said that Hauser has at least one intellectual ally, Count Tolstoy, who links the art of the symbolists and the impressionists through what he saw as their indecent luxuriousness of feeling and their sickly, elitist obscurantism. But that would only mean that the ascetic aristocrat and self-appointed peasant-mystic was as mistaken in his artistic understanding as Hauser in his historical generalizations. Impressionism is not arch, or narcissistically tortured or perverse. Nor is it nonsecular, recondite, or occult. It is, in fact, precisely the opposite—a pictorial poetry of the middle class's better self and what was most lustrous, gentle, charming, poised, and delectable in the life of that class. It is impossible to imagine what Hauser could see in it that might be interpreted as the expression of a bourgeois failure of nerve.*

Equally troubled is Hauser's attempt to type impressionism as a phenomenon of "modern" civilization bearing two marks of that modernity: its discovery of the landscape quality of the city (the "townsman's view of the world"), and its response to visual stimulation reflecting "the overstrained nerves of modern technological man." It seems remarkable that as learned an art historian as Hauser should hold the first of these views, if we think only of the works of Carpaccio, Pannini, Canaletto, or Guardi.** But even if he were right,

* It should also be pointed out that Hauser makes no effort to prove that the bourgeois layman did in fact provide the audience for the new obscurantism, as he describes it. It is generally very difficult to tell whether by the social in art Hauser means the artist's version of the social surroundings or the demands of audiences for certain kinds of arts. There is, of course, a decisive sociological difference between these two.

** Vittore Carpaccio (1490–1523?); Giovanni Paolo Pannini (1692–1765?); Antonio Canaletto (1697–1768); Francesco Guardi (1712–1793).

he would be doing nothing more than paying a superfluous compliment to the impressionists whose urbanism goes beyond the mere question of the city as "landscape," that is to say, as architectural scenery or tableau of street activity, both so well and so affectionately portrayed in the Italians. But then, just as surprising, is the atmosphere of technological nervousness imputed by him to the impressionist perception. What Hauser would have us believe, if we remember the wording of his statement, is that the France of the impressionists was a technological, therefore a "nervous" society, and, following the logic of such generalizations, that in such environment all men, the impressionists included, were nervous men. Now the evidence of our own eyes should be enough to expose the absurdity of speaking of an art as urbane and casual as impressionism as a manifestation of the wrenched and disordered excitability of modern "technological man." * Hauser himself realizes this by calling it elsewhere, in still another reversal, "elegant, fastidious . . . sensual and epicurean".[6]** It is certainly true that, for a

* As I have mentioned, Hauser's references to capitalistic rationalism as the floor on which nineteenth-century intellectual movements were constructed are part of the Marxist repertory. In raising the figure of the "technological man," on the other hand, Hauser falls (or climbs) into one of those tenuous conceptualizations (like the "ages of") that have so frequently afflicted modern historical interpretation. There are other instances of Hauser's pliable eclecticism. Sometimes he reaches for a "world-historical" level by replaying some of the "idealistic" stereotypes of the kind that Marx dismissed as "subjective" versions of historical causation. He says, for example, that the whole of Western culture (as a general social fact, we must presume, not just as an intellectual episode) was secularized after the discoveries of Copernicus.
** It is true that in this sentence, partially quoted here, Hauser uses the word "nervous," as he had done when speaking of the "modern technological man." He does so, however, in spirit quite different from that of the previous reference, coupling it in this case with the quickness and "over-refinement" (not, one should notice, over-strained), of the impressionist "sensitivity." Yet, in reversing himself by dropping the naturalist and embracing the "romantic" view of impressionism Hauser falls into curious distortions which are, again, denied by the visible facts. Thus, he speaks of the impressionist out-

number of aesthetic and intellectual reasons, writers and artists, in France and elsewhere, reacted with repugnance and even fear to the beginnings of industrialization and the first developments of the applied sciences. The impressionists, however, never seem to have been aware of the issue. There is nothing technological in their painting as subject matter, reflective mood, or social commentary. The occupations they portray are those of dancers, cabaret singers, circus performers, musicians, barmaids, jockeys, cafe waiters, milliners or fellow painters at their work. Frequently, they simply paint people doing "nothing"—enjoying themselves at concerts and dances in the park or picnicking or rowing on a holiday. Nor are there any impressionist paintings of machinery outside of Monet's famous locomotives at Gare Saint-Lazare.* And he, like Turner,** was obviously attracted to them for "inherent," that is, visual impressionistic reasons; steam emanating from railroad engines makes for marvelous light effects. Finally, had Hauser bothered to check his ideological imagination against the facts of French economic development at the time that the impressionists came to maturity as men and as painters, he would have discovered that neither in France generally nor even in its great capital city was there anything like a "rigidly-organized and rationalized system" of high capitalism capable of producing a machine-induced state of mind to be felt in life or expressed in art.***

look as bent upon "experiences of solitude and seclusion," a statement which must be incomprehensible to anyone who has looked at Manet's bars and music halls, Degas's theaters and beer gardens, Pissarro's street scenes, or Renoir's picnics and outdoor dances.

* There are two paintings by Manet entitled *Chemin de Fer* which show locomotives as they move in the distance across the open fields, but these pictures are, in fact, landscapes.

** Joseph Mallord Turner (1775–1851).

*** According to an economic census of 1896, the 575,000 establishments listed as "industrial" averaged a personnel of 5.5 men, and only 151 of them employed 1,000 men or more. Of the total number, fully 535,000 employed an

Having rejected the vision of the city as a vast and toneless sociological apparatus or as a scene of iron, bourgeois-induced rationality, of overworked nerves, or pounding technology, what can we find in the French impressionists that may be called specifically urban? The answer must begin by pointing

average of less than ten persons. Speaking of metal industries in Paris in the second half of the nineteenth century, J. H. Clapham, from whom these figures are taken, says: "As compared with other metal-using industries, Parisian cutlery was a small affair, merely one of the innumerable artistic or skilled crafts which have always had their home in the capital. *Most of them were still conducted without the characteristic organization of modern industrialism, in the third or even the fourth quarter of the nineteenth century. Paris of the seige (during the Franco-Prussian war, 1870–71) was essentially a town of workshops rather than factories, just as it had been in 1848"* (my italics). (J. H. Clapham, *The Economic Development of France and Germany, 1815–1914,* Cambridge University Press, 1961, pp. 241, 258).

Hauser is also wrong when he discusses the cultural consequences of modern productivity; the abundance of machine-made goods, he says, caused an attitude of *ennui* toward all possessions, including *intellectual possessions.* (Hauser, op. cit. IV, p. 168). Were this true, much of modern French and European and American literature would be incomprehensible. Cheap manufacturing of consumption objects formerly available only to the elite appeared to some intellectuals to have created a crisis of symbolic values, a "trivialization" of the traditional external marks of cultivated existence. What followed, however, was a defiant, even idolatrous over-valuation of "spiritual" goods, of taste and form and the *meaning* of ideas. The state of mind, in short, found in romantic antiquarianism—art for art's sake, Dandyism, and the symbolist dream of a wholly self-contained "hermetic" poetry. Flaubert stated the issue when he said that by making elegance available to ordinary people, the department store has destroyed the traditional significance of luxury as a manifestation of aristocratic sensibilities. The answer, he thought, was to retreat into an untouchable, "pure" cultivation of artistic and intellectual principles. "Let us enlist ourselves in the cause of the ideal . . . now that we have no longer the means of dwelling in marble halls and covering ourselves with the purple . . ." (Gustave Flaubert, *Correspondance* (Paris: Louis Conrad, 1910). Five volumes. II, 427–28). If there is a characteristic of the life of the mind since the nineteenth century, it is this: as cultural depreciation (i.e. democratization) grows, there begins among intellectuals a history of fanatical or, at least, sectarian self-esteem, sometimes despairing (when they see themselves as victims of their own sensitivities), sometimes prideful (when they see themselves as prophets and revealers).

out that, like the city itself, urban painting cannot be described under one heading. If one looks at Daumier's hungry actors, desolate street jugglers, or broken washerwomen, or at Doré's drawings of London warehouses, one sees the city as a place of loneliness, grime, boredom, or at best, pitiful illusions.* The impressionists, on the other hand, with the exception of Degas's *L'Absinthe*, looked upon urban life as an animated artifact, entertaining, provocative, even self-indulgent, and always gracefully worldly.** The latter is in part, but unquestionably, a matter of class values, if we understand these, not simply as politico-economic preference, but as the expression of certain tastes and the staging of behavior styles (impressionist painting chronicles, in this sense, what is most dignified, endearing, and pleasantly cultivated in bourgeois existence). And then, we must take into account the fact that the impressionists were dwellers of a city which was at once singular and archetypal. They were Parisians. They lived, that is to say, in a uniquely alluring habitat that was also to become the source, model, and beckoning sanctuary of modern cosmopolitanism.*** The Paris of their childhood

*Honoré Daumier (1808–79); Gustave Doré (1832–83).

** The "black" view of the city, however, has remained fairly characteristic of American painting, as one can see in the work of Edward Hopper, Reginald Nash, and others.

*** Renoir, born in Limoges, had a wholly Parisian career. Pissarro was born in the Virgin Islands but came to Paris at the age of twenty-five. Berthe Morisot, born in Bourges, came to Paris as a child. Cézanne (assuming that one wishes to count him among the impressionists) was born in Aix-en-Provence but came to Paris at the age of twenty. Frédéric Bazille, born in Montpelier, came to Paris at the age of four. The American in the group, Mary Cassatt, was born in Pittsburgh, and settled in Paris at age twenty-three. All of the others, Monet, Manet, Degas, and Sisley were born in Paris.

The impressionists, it is important to point out, are one of the few natural generations in the history of art. Their chronologies overlap each other, and their biographies parallel some of the classic dates of contemporary history. Only ten years separated the oldest from the youngest of them. They were all born between the final overthrow of the Bourbon dynasty in 1830 and the Revolution of 1848. Their art triumphed during the Second

had been called by Mrs. Trollope "a city of the living above all others," and by John Scott, another English visitor, a "treat to the student of humanity, a glass beehive, the essence of whose people's existence was the consciousness of being observed." [7] The Paris of their adult lives was the classic great city. A place of luxurious public gardens, famous theaters, princely hotels, and legendary restaurants. Of cafes, boulevards, art academies, museums of canonical cultural status, music halls unequaled in their splendor and tawdry glamour. And, of course, the home-ground of bohemian life and its enduring models, Montmartre and Montparnasse. It was, as Mrs. Trollope put it, the stage for a new sort of "busy idleness,"—an idleness in which the impressionists found their repertory of pleasant diversions and elegant amusements.

We will remember that Simmel had spoken, not only of the gray Leviathan of the city but also of the glancing urban eye, "brushing" against a discontinuity of onrushing *impressions* (he used the term several times in the passage quoted earlier). And this would seem to bring him close to the secret of impressionism, with its feeling of supple instability and swiftly moving recognitions and disengagements forever suffusing an external air of contentment. But not quite. For even in this dynamic form there is still something disembodied about Simmel's account of the city and its images and inner life. As I have said before, Simmel's thinking rests to some degree on a sentimental distinction between conscious

Empire and the great age of bourgeois cultural well-being: *la belle époque*). With one exception, they were all dead shortly after the conclusion of the World War I and the establishment of the Soviets in Russia. The dates of the main impressionists are as follows: Edouard Manet (1832–83) ; Edgar Degas (1834–1917); Alfred Sisley (1839–99); Pierre Renoir (1841–1919); Claude Monet (1840–1926); Frédéric Bazille (1841–70); Berthe Morisot (1841–95); Camille Pissarro (1831–1903); Mary Cassatt (1844–1926).

and unconscious forms of social participation. Rural life, a life where personal consciousness was a shared segment of the sustaining milieu, where social experience was the steady re-enactment of daily understanding and where the momentary and the incidental had no significance or, in fact, reality, appeared to him as more authentic or even more "human." * And he also suggested that the city mind, being mobile, unanchored, and able to scatter its attention and interests, was, therefore, insubstantial and unnaturally rarified. He was, in other words, unwilling to accept that urban consciousness was simply a different order of consciousness. Not an inner ritual reaffirmation of social membership nor a thinning of "genuine" social relationships, but a faculty capable of extracting a new human plot out of the city's "gathering of fugitives" and for which passing events *were* passing, but also the not-quite-loose ends of many unstated meanings.

Impressionism is the art of such a novel consciousness. It assumes a world in which *moments* can exist as total units of experience: where self-feeling, as well as the perception of others, has a new swiftness and, within that, a new, flickering poignancy; where the ephemeral and the unguarded can be memorable and must be followed and scanned by the

* This assertion may surprise readers of Simmel familiar with his remarks about the superficial nature of sociability and the superiority of the individual over the collective. I am speaking here of his discussion of the moral life of the city, a discussion which contains, among other phrases, the following: "The reaction to metropolitan phenomena shifted to that organ which is least sensitive to and quite remote from the depth of personality.

The intellectually sophisticated person is indifferent to all genuine individuality. [We should remember, of course, that, for Simmel, urban existence was dominated by the intellect.]

The features of intellectuality contrast with the nature of a small circle in which inevitable knowledge of individuality as inevitably produces a warmer tone of behavior. . . ." Simmel, op. cit. pp. 410–11.

painter with a flashing perceptivity of his own, capable of making visible the combination of the oblique and self-conscious.

Louis Wirth, another famous sociologist of the city, felt that because the mode of social recognition in the metropolis was "purely visual," it tended to ignore the more truthful elements of individual character while taking notice only of the more obvious features of the status front—what Wirth calls "the uniform." [8] Like Simmel, then, Wirth insists on the "depth" of traditional relationships, imagining that human situations can never be trivial if they happen also to be ancestral or customary. And for this reason, one finds in him the same solemn-toned failure of sociological imagination. Wirth can speak of the superficial quality of visual impressions because for him *character* has the conventional significance of a well-sculpted moral constitution or personality type. He would, therefore, not understand that for the impressionists, *character* is something far more delicately poised but also more delicately ambiguous, to be observed in the quickly spent vortex of an incidental gesture or a captured pause.

But can all this actually be *seen* in the work of the impressionists? The answer, of course, must come in the form of illustrations, and I shall begin by comparing three paintings, two by earlier artists, Veronese's *Wedding at Cana* and Hogarth's *The Strode Family*,* and one by an impressionist master, Manet's *Chez le Père Lathuile*.

Veronese was a fashionable artist who worked for Venetian doges and received favors and titles from Charles V and Philip II of Spain, and his *Wedding*, despite its biblical pretext, is an imaginary gathering of Renaissance monarchs and aristocrats; it contains portraits of Charles V, Frances I of France, Eleanor of Austria, sister of Charles V and Francis's

* Paolo Veronese (1528–88); William Hogarth (1697–1764).

second wife, Queen Mary of England, the Turkish Sultan Suleiman I, and personal friends of the painter. Looking at this huge canvas (it measures 21' 10" \times 32' 6"), one is immediately conscious of Veronese's extraordinary effort to translate onto it the movement of psychological relations enveloping not only the attendants to the feast but even the curious, watching from the distance. There is a great deal of "stage business" in the picture. Musicians tune up, butchers chop the meat, and servants pour wine or march across the foreground carrying sumptuous platters of food, while people jostle each other and literally hang from the sides of nearby buildings in order to get a glance at the scene. The guests, crowded around the table, face one another, reach for one another, lean toward one another to whisper some intimate or timely remark or to overhear a conversation. Yet, looking at it, one has a pervading sense of hollow subjective spaces. The moment of living awareness, the "click" and flow of mutual recognition is not there. Everyone seems to have been frozen in a miscellany of mental *stances,* in a tableau of expressive postures which, however appropriate-looking and descriptive of the *idea* of conversation and humming sociability, fail totally to convince us of their reality as psychological events. There is one exception to this—Christ himself, seated at the center of the table (and the picture), who gazes directly at the viewer. However, because its face is illuminated by the aura of sacred light, while seemingly addressing to *us* a silent commentary on the opulent secularity of the banquet, this figure becomes the center of a psychological paradox. By virtue of his direct visual engagement of the viewer, Christ is the only genuinely individualized person in the painting. But by breaking through the internal atmosphere of the scene, he cannot avoid exposing its emptiness to us, the onlookers.

Internal falsity is also the dominant feeling of Hogarth's

Strode Family, a picture which invites us to conspire with a conspicuously transparent imposture: the pretense that we are being made privy to a casually observed social incident when in fact we are looking at a commissioned portrait. Strict obedience to the presumed subject—a domestic English scene at teatime—would have required the members of the Strode household to be shown sitting around the table eating and drinking. We see them, however, deployed in a semicircle to one side of it, in such a way as to afford the artist the "chance" of recording a frontal or near-frontal semblance of the Strodes, their brother, their dogs, and a visiting parson. "Teatime" in the painting, therefore, is not a genuine moment but a visual ruse, not only topically but psychologically. And, as in Veronese, the stratagem is exposed by a breach in the emotional fabric of the picture, caused this time not by the supernatural status of one of the figures, but on the contrary by the realistic modesty of his social position vis-à-vis the people around him. A servant, his eyes on the table, is engaged in doing something actually related to the supposed occasion of the painting: he is pouring studiously from a teapot. The facts of his behavior, his physical separation, and the symbolic invisibility implicit in his facelessness, segregates him from the others. Indeed, he can behave realistically because, as a servant, he is the only person in the group who is not "having his picture taken," while at the same time it is the very adequacy and plausibility of what he is *doing* that makes his presence a truly observed one. For that reason also, of course, it is through him that the human artifice contained in the picture becomes apparent.

Let us now look at Manet's *Chez le Père Lathuile*. The painting shows two young lovers sitting at a table in an outdoor restaurant. They are seen "close-up" to the left of the viewer. To the right, a waiter stands in the middle distance.

The couple appears to be completely oblivious to the ob-
server, the painter. The man, his eyes directly on the woman,
has an air of tactful, graceful, but determined flirtatiousness.
The woman looks downward, somewhat obliquely, perhaps
at the table. But she *is* listening with a visibly felt mixture
of amusement, pleasure, diffidence, and temptation in her
face. By pointed happenstance, the waiter has stopped on his
rounds, coffeepot in hand, to look at the painter and,
through him, at us.

There are certain large points of social commentary in
Chez le Père Lathuile and other more subtle points of social
perception. There have been in the past, portraits of social
inferiors: barmaids, pageboys, buffoons, domestics, trusted
factotums. But such portraits, however affectionate or pene-
trating, tended to look at their subjects as "conversation
pieces." In Hals or Chardin* (think, for example, of the lat-
ter's *La Pourvoyeuse,* the picture of a house caterer, artfully
surrounded by her wares as she strikes a charmingly con-
trived pose in the service room of one of her patrons), the
treatment is picturesque or sentimental. In Velázquez or
Ribera** (if we recall their portraits of royal dwarfs with
their gross faces and their blighted, doltish grins, dressed in
courtly finery), disarmingly and disturbingly perverse. It is
characteristic of the impressionists' casualness and worldly
detachment, on the other hand, that they so easily disregard
self-consciousness in the handling of social situations which
involve people of different social classes. We should not be
surprised, therefore, to discover in *Chez le Père Lathuile*
that it is the waiter, and not the obvious subjects, the lovers,
who stand at the psychological knot-point of the picture. He
is the observer's observer. He catches us catching the lovers

* Frans Hals (1580–1666); Jean-Baptiste Chardin (1699–1779).
** Diego de Silva y Velázquez (1599–1660); José Ribera (1591–1652). Ho-
garth did several portraits of his servants but always in the form of medal-
lions and outside any social context.

in a moment of intimacy. It is really he who embraces the whole of the scene and throws the events in it into the intricacy of psychological dimensions and surprises which it might have had as an actual happening.

Now, the device of permitting one of the figures in a painting to look directly at the painter and, by implication, at us, has been a feature of Western art since the Renaissance and can be found in great works and minor ones. We find it in the child addressing to us the moral of El Greco's *Burial of the Count of Orgaz;* in the glances to the "audience" of Velázquez's *Drunkards;* in the little boy staring wonderingly at the artists of Louis Le Nain's *Peasant Meal;* in John Copley, who shows his children stealing looks at the painter while the family portrait is being done; and such works of romanticism like Runge's *We Three* in which three young people lost in *Weltschmerz** gaze out at us.

But there is always in these works and in the many others like them, something that keeps them from appearing as a spontaneous moment, as an event, *a happening* (I use the word in the conventional sense) faithful to psychological reality, as that reality materializes within itself and as the viewers awaken to its presence. In El Greco's *Burial,* the "gazer" is patently didactic. The picture has two levels. On the lower one, the dead body of the Count is seen in the arms of two ecclesiastics while noblemen standing behind show in their faces expressions of meditation, dignified philosophical resignation, and respectful grief, and possibly utter humble, hopeful, God-beseeching prayer for the fate of the deceased. Above their heads a legion of saints and angels, Our Lady, and finally Christ himself, await the ascent of the Count's soul from its earthly remains. To the left of the

* Domenico Theotocopoulos, "El Greco" (1541–1614); Diego de Silva y Velázquez (1599–1660); Louis Le Nain (1593–1648). Two other Le Nain brothers, Antoine (1558–1648) and Mattieu (1607–77), were also painters. Philip Otto Runge (1777–1810).

body, which occupies the center of the painting's lower portion (Christ reigns over its upper reaches), is the storyteller: a child who looks at us directly and, with his left index finger, quite literally points out the event and invites us to think about it. In Velazquez's *Los Borrachos,* one of the drunkards is being crowned with a wreath of vine leaves (there are additional classical allusions in the form of partially naked Dionysian youths), while two others, occupying the center of the picture, look at the viewer with benign, self-indulgent leers. But whether we think of the painting as a scene of folk conviviality or as a vignette of debauched pathos, the conspicuously conspiratorial flavor of the drinkers' glances blights any feeling of psychological concreteness and "honesty." The *Drunkards* is, in fact, an uneasy mixture of the anecdotal and the allegorical. The child in Le Nain's *Peasant Meal* is by himself convincing enough, but the situation, though carefully and sympathetically documented, is clearly staged. Runge's *We Three,* heavy with mood, is a piece of emotional, even ideological, editorializing.

What is different about Manet's waiter is the disarming unobtrusiveness of his role as the watcher's watcher. The glances and looks of earlier art suffer from an aura of complicity; their too well focused poignancy appears always compounded by the theatricality, blatant or sophisticated, with which social scenes were painted until the nineteenth century. Manet's waiter, on the other hand, is unexpected. We become aware of him in a "double take"; we are surprised by him as he surprises us in the act of being surprised. This is possible because, unlike Veronese's Christ or Le Nain's child, he is completely and naturally *in* the picture, just as in the picture itself there are several planes of psychological awareness but no break in the context of concrete reality. Waiter and lovers, and eventually ourselves are all within the same space, the same portion of air and of time.

The lovers, while oblivious to our "being" there and igno-
rant of the by-play between us and the waiter, are as con-
cretely present as the waiter is or, indeed, as we are as we
contemplate and are contemplated in a moment of total
immediacy.

Such effects and such perceptions are inseparable from
certain social perspectives. It could be argued, no doubt, that
there have been painters of the intimate before the impres-
sionists. The subjects of the great Dutch and French masters
of genre painting: Metsu, Vermeer, Ter Borch, de Hooch,
Fragonard,* and Chardin, were pointedly personal; an army
officer and his lady friend enjoy a discreet flirtation in the
visiting room; a music lesson is in progress; a young woman
writes a letter; another reads one by the light of the window;
a woman, while making the bed, exchanges smiles with a
child who is about to leave the room; a group says prayers at
the table; the artist himself (Fragonard) is quietly engrossed
in the completion of a miniature.

But several qualities separate the impressionists decisively
from the past. In the most accomplished of the traditional
pictorial chroniclers, there is almost always the feeling of a
subtly staged vignette or the unambiguousness of a mani-
festly narrated episode. The impressionists, on the contrary,
are marked by their never compromised yet underscored
naturalness. The most purportedly casual psychological ex-
changes found in earlier art fail to give one the sense of
something undeniably immediate, solely of the moment.
The camera is never quite candid enough. There is a feeling
of "stop-action," of "holding the picture." In Vermeer's *The
Love Letter,* the attitudes of the servant girl who has just
delivered the missive and the young lady of the house who
has interrupted her lute-playing to read it—the first with a

* Gabriel Metsu (1630–67); Jan Vermeer (1632–75); Gerhard Ter Borch (1617–
81); Pieter de Hooch (1629–84); Jean-Honoré Fragonard (1732–1806).

questioning expression on her face, the second standing by and playing the role of the sympathetic, indulging audience —are a shade too telling and the "dialogue" of looks between them too knowing. In de Hooch's *The Bedroom,* the child, standing at the entrance of the room ready to close the door, clearly invites the fond glances of the woman (perhaps her mother). In Chardin's *Saying Grace,* a little girl brings her hands together in prayer a little too charmingly while another looks at her a little too touchingly. And so on.

With the impressionists we move into a world where the vivid and the incidental are inseparable. Their eye and their peculiar genius are for the offhand pathos of unexpected detail and the rendering of the event just as it is about to dissolve itself into another event: a ballerina adjusts a ribbon on her neck, a lace of her shoe; a washerwoman straightens up from her ironing and breaks into a yawn; a gallery visitor leans on her umbrella and tilts her head to look at a picture from a certain angle; a barmaid, walking across the room, stops for an instant to help herself from a mug of beer. And while the impressionists certainly were not the first to paint individuals as individuals, they were the first to paint private moments in public places, to surprise the awakening half-light of curiosity linking two people in the populous midst of others. In this, if in no other way, they were, without doubt, the painters of the modern city.

One must then, in the end, and despite its limitations, credit Simmel's own urban "eye." For when he speaks of the city as a place where sharp discontinuities can be grasped in a single glance, we think of the glimmer of a ballerina's skirts in Degas or of one of his music hall *chanteuses* bawling a song at the top of her voice but seen only in the reflection of a distant mirror and "heard" through the disordered noise of the clientele. We think of Pissarro's boulevards and the sweep of crowds *in motion,* something never painted before

the impressionists. Or of Renoir's *The Rower's Luncheon* and
the young woman in a corner of the picture, adjusting her
hat as she engages her male companions in earnest yet eva-
sively flirtatious conversation. Or of Manet's front "shot"
of horses coming down the home stretch. Or of many mo-
ments in impressionist painting when we glimpse a person
as that person itself becomes aware of an event in its own
surroundings. One of Manet's music hall waitresses turns in
the middle of a crowded room, having caught sight in the
distance, perhaps of a well-known face, perhaps of the hand
or even the eyes of a customer wishing to give an order. One
of Renoir's coffeehouse habitués moves her eyes quickly to
a corner of the establishment (invisible to us) as she notices
perhaps a friend, perhaps a curiosity-arousing incident.

It would be tedious and lengthy to document the pleasure
taken by the impressionists in suspenseful and intriguing
indirection, and startled "candid camera" surprises. In
Degas's *The Orchestra at the Paris Opera,* some musicians
are playing, others wait for their place in the score, thought-
fully or routinely; one glances at the dancers on the stage,
others are only partly visible, a forehead, an eye, and the
dancers can be seen only from the shoulder down, as we
would actually see them (or "perceive" them) if we were
primarily interested in the orchestra pit. It is after a long
time of looking at this picture that we discover the person
with the best view of the stage, the theater, and ourselves:
a man buried in the shadows at the upper left corner of the
picture, his face barely showing above the front of his pro-
scenium box. In another Degas, *Femmes à la Terrace d'un
Café,* two women face each other across the table. One of
them, her eyes veiled and tentative, gazes in the direction of
something she may be trying to see or, for all we know, not
to see, somewhere in the coffeehouse (again, and character-
istically, the object of her curiosity is outside the painting

and invisible to the viewer). Her expression is thoughtful, but there is no sense of a specific act of thought or even ostensible musing. She merely sits there, noncommittally, considering the surroundings. The other woman, a thumb held gently between her teeth, considers her companion in turn. In Renoir's *The Theatre Box,* our mind is taken on a tour of the actually unseen house, as, relay-like, we travel from our own place, in the orchestra seats so to speak, to the occupant of one of the boxes, who is looking at us, to another occupant of the same box whose opera glasses are trained on still someone else.

The Florentine and Dutch masters painted merchants, apothecaries, scribes, and politicians. Carpaccio, Guardi, and Canaletto left a record of Venetian public life, with its canals, markets, and squares. Hogarth painted the fishwives, jails, and whorehouses of eighteenth-century London. But the style of these men never quite escapes the suggestion of social exemplars, panoramas of human reality, or topical situations.* The impressionists, to the contrary, opened themselves to the stimulation of the city in a mercurial and small-focused way, their disposition, half-fascinated, half-detached, looking for crystallizations of mood within a flow of sensations, for instants of muted vividness amidst the easily spent diversity of the urban spectacle.

They were, in other words, *dégagé,* a quality both invited and permitted by the unanchored dimensions of modern metropolitan life. But their aloofness is always intrigued, amused, and even charmed, and one may almost see in it the devious social nostalgia of Simmel's *Stranger,* the man faltering between the yearning for experience and the disenchantment of the world. As an art of flux and ambiguity, impressionism can, no doubt, be called subjective. But it must be added that, despite their intimacy and elusiveness, the im-

* Hogarth's famous *Shrimp Girl,* a unique picture for its time, is an exception.

pressionists were still men called to the surrounding Outside. One is tempted to say that theirs is the last great painting style before the "closing of the shutter," before art decided to discard all transactions with the social world.

Contemporary art is, of course, personal too, but in quite a different spirit. As Daniel Bell has pointed out, whatever its form, "abstract" art has abolished every *natural* distance between the artist and the environment. And it has done so by ignoring all the *given* features of the environment and by dissembling and reconstituting it at will on an artificial plane of the artist's own devising. Or, as in surrealism, by turning its back to outward reality altogether to find vistas and distances within the expanses of self alone. In either case, present-day art stands for an ultimate surrender of the traditional view of artistic vitality understood as a manifestation of psychological and social vitality. A vitality capable of establishing a relationship between the individual and his surroundings through which the individual exerted himself toward the satisfaction of his own needs but acknowledged the terms contained in the surroundings themselves, as challenge, stimulus, and unavoidable limitation.

3 · The Private Lives of Public Museums: Can Art Be Democratic?

"Why should a tradesman or a farmer be called upon to pay for the support of a place which was intended only for the amusement of the curious or the rich, and not for the benefit or instruction of the poor?"

William Cobbett in the House of Commons, 1833

By at least two practical and symbolic standards, American art museums are institutions of the highest spiritual and civic pedigree. In a monetary society freedom from the taint of gain is, curiously, a mark of virtue, and museums as "non-profit" organizations are, like churches or educational establishments, part of the preserve of "pure" values within the social order. As harbors of such chastity and loftiness, the state in return grants museums an accolade which, though fiscal in itself, declares them to be, like schools and sacred houses, temples of the society's better self: Museums are tax-exempt.

They are, then, not only noble places but public ones. In a democratic nation, however, "public" stands for more than merely "non-private." It refers also to a mystical link between the institution and the society, and the society's past and future. Thus the standing of relics and beauty within what the past has entrusted, for all time, to the present has been argued in this country since the foundation of the great storehouses of art and history. Two models of the American museum as an instrument of communal life were born of this argument.

There is first what I will call the *Boston position*. It is patrician and classicist. It believes that works of art should be allowed the full, undisturbed majesty of their meaning, that this meaning should be communicated as a personal experience to those capable of hearing the call, and that, therefore, every man must work his own salvation at the feet of beauty.

The second may be called, with some license, the *New York position*. It is democratic and uplifting. It holds that museums should aid—perhaps seduce—the visitor into a proper understanding of what he is looking at. It believes that art should be ordered, labelled, and interpreted, thus, in the words of one writer, facilitating cultural digestion for the greatest number.

In the early days of the Boston Museum of Fine Arts, Matthew S. Pinchard and Benjamin Gilman, respectively vice-president and secretary of that institution, spoke for the first of these views when they wrote that:

> A museum of art, ultimately and in its widest possible activity, illustrates *one* attitude towards *life*. It contains only objects which reflect clearly or dimly the beauty and magnificence to which life has attained *in past times*. The fruits of this exalted and transcendent life are gathered within its walls, and it is the standard of this life with the noble intellectual activity it presupposes, that a museum offers *for acceptance by its visitors*. [Italics mine][1]

Mayor Cobb of Boston, addressing the audience at the museum's opening in 1876, also argued for the natural radiance of art and its capacity to strike and light up the sensibilities of the citizenry:

> All classes of our people will derive benefit and pleasure from *barely looking* upon objects that appeal to the sense of the beautiful. [Italics mine][2]

However, Luigi de Palma Cesnola, the first director of the Metropolitan Museum of Art, spoke quite a different lan-

guage. In 1887 he said that museums should affect, not only art and the experience of art, but "the manners and the virtue, the comfort and the wealth of our beloved people." [3] Two years later, George Brown Goode, assistant secretary of the Smithsonian Institution, announced that "the museum of the past must be set aside, reconstructed, transformed from a cemetery of bric-a-brac into a nursery of living thoughts." [4] And in 1909, John Carlton Dana, a librarian who organized the Newark Museum Association, drew what may have been the most literal psychological and social lesson from Goode's words, stating that museums should be so organized as to help the community "to become *happier, wiser* and more *effective.*" (Italics in the original)[5]

Finally, there are the voices of social scientists who, at a recent international gathering, spoke of museums as institutions dedicated to preserving the peculiarities of particular places while exalting and diffusing "cultural values" generally, and which, as spiritual centers of the community, contributed both to its enlightenment and its cohesion.

Museums, then, have ideologies. Some of them have been solemn, elegant, "elitist"; others evangelistically democratic or piously utilitarian. And, from the social scientists above, one might conclude that museum-going is one of the rituals of contemporary, post-traditional civilization. These contentions and disparities, however, will become understandable if we look into the fabric of ambiguity and paradox which lies behind museums and their history.

Public museums are one of the newer creations of Western culture; with few exceptions they had their beginning at the close of the eighteenth century or, in the great majority of cases, after the turn of the nineteenth. In spite of this newness, however, they are among the most widespread of modern institutions. In the United States and Canada alone there are about 5,000 of them. New ones are constantly being

established, and attendance figures reveal a genuine "mass" phenomenon.*

There is no question also that museums will continue to flourish, nursed as they are by some of the contradictory trends of our culture. The destruction of local traditions and the assault upon "the past" perpetrated by industrialization and world-wide modernization seem to make large numbers of people susceptible to an appetite for relics of pre-industrial life. This appetite is so intense that it accounts in part for one of the major and most characteristically modern industries: tourism. The most ambitious monuments of earlier life-styles, such as the stately homes of England, and even whole nations, like the prototypically picturesque Spain, have now been reduced to the condition of *objects d'art*. "In the family" events, like the bullfight or royal pageantry, whose mystique was once accessible only to the natives, are now marketed to foreign visitors by the well-organized bureaucracies of popularized cultural romance, both private and governmental—that is to say, travel agencies, tourist bureaus, and even tourist ministries.

Museums, then, express modern ambivalences, even dilemmas. In a very real sense the past can be preserved only when it is overrun by the present, and it *must* be preserved because, we are told, the past is a trust—an *inheritance* left to the present which fortifies and guides us in our future tasks. Museums, therefore, must arouse emotions of homage, but not subservience to the ancestral. Piety for history should not be so engrossing or so yielding that it would keep us from moving forward. In a society like the United States, so com-

* The American Association of Museums includes in its definition of "museum" planetariums, aquariums, botanical gardens and zoos. Based on this definition, attendance figures have, since the 1960's, been upwards of two hundred million annually. Art museums have had a very considerable share of this enormous total.

mitted to novelty and to change, this can create some pe-
culiar predicaments. Arthur C. Parker's *Manual of the His-
tory of Museums* in 1914 spoke of them as places designed to
awaken "feelings of reverence and gratitude" toward the
past. He advised, however, that they be kept from accumulat-
ing what he called "mental dust."

This elusive but real tension between past and present,
which museums induce by their very nature, is made more
perplexing by the character of the past they preserve. Mu-
seums are public, first because the state has assumed the
guardianship of our artistic inheritance, and second because
safekeeping these heirlooms is a way of making them avail-
able to all. It remains a fact, however, that many of the pos-
sessions which art museums so jealously guard are monu-
ments to a past splendor which is inseparable from great
names, great houses, great dynasties, great titles, great wealth,
and great power, a splendor frequently reflected in the sub-
ject matter of the works themselves, no less than in their
Veblenian significance as instruments for the sumptuary
glorification of certain social ranks. On the one hand, there-
fore, art museums offer to the public a panoply of relics
which they claim to conserve as a public heritage. On the
other hand they compel our imaginations to turn toward the
aristocratic past from which museums often derive their
treasure-house magic and their special atmosphere of awe
and worshipful respect.

This is so inescapable a conflict within the character of art
museums, that, unless we understood it, we could not grasp
the significance of the changes which styles of museum dis-
play have undergone.

There are perhaps three historical steps in the "staging"
of museum collections. If one looks at portraits of eighteenth-
century aristocrats as they survey their personal artistic pos-

sessions, at engravings of the first public viewings of the Louvre, at McKenzie's painting of the National Gallery of London in 1820, or even at photographs of the early Metropolitan Museum, one notices at once a common feature: In all of these the walls appear covered with paintings hung frame to frame, sometimes quite literally from floor to ceiling. The atmosphere is that of a storehouse or a counting-room. The point of view is that of the patron and proprietor. What we see is the *exhibition,* the spectacle of treasures which the public is allowed to invade and marvel at.

Later, as the "religion of beauty" and the cult of personal genius created by the doctrines of romanticism began to take hold, the ordering principle came to be dictated by what may be called the *rights of the artist.* The works of one man were now hung together, and the walls were cleared so that different pieces might stand as particular creative achievements allowing the visitor to enter into single and personal communion with them. The final outcome of this is perhaps to be found in the aesthetic chapels of certain famous museums in which a work, like the *Nightwatch* at the Rijksmuseum in Amsterdam, or *Las Meninas* by Velázquez at the Prado, is housed in a particular niche or room of its own and made the focus of carefully if not theatrically contrived contemplation.

The concept of the public, however, remained a severely limited one. In their early days, institutions like the British Museum screened the "curious and the studious" to see who among them were "proper to be admitted." And the visitors themselves were what would now be called self-selected persons who, by virtue of the cultivation attendant to their class and upbringing, constituted the "natural" audience of art. Even today museums must be considered by the way in which they view their responsibility to the public. The director of one of the most conservative museums in Europe (and

one of the three or four best known art treasuries in the world) told me that his public duties consisted of keeping the paintings in good condition and opening the doors in the morning. He realized that many people would leave the premises as unknowing and untouched as when they came in. But that was their affair, if indeed not their fault.

At the same time the spread of the democratic principle has created among many museum professionals a sense of larger obligations, a determination to embrace the public, to nurse its sensitivity, and to mediate between it and the work of art. Such spirit of "community service" has always been very strong in the United States, and American museums, with their film series, lecture programs, gallery talks, children's wings, and contributing memberships, have become the model for younger European administrators and curators who decry the "antiquarianism" and cultural "royalism" of their own institutions.

Yet, even in the egalitarian USA certain implications of the art museum's princely heritage cannot be avoided. For example, it is a routine task at one of New York's most famous collections—privately endowed but open free to the public—to meet the frequent demands of the school system for student visits. Such requests are accommodated to every possible extent, although the director feels that some control over numbers and guidance must be exercised to assure that the visit does not become anything more than a tumultuous outing and an empty experience. Besides, the gallery must also be concerned with the informed visitor, who comes knowing what he wants to see and expects to enjoy it with some degree of serenity. What is particularly poignant, however, is the silent discrepancy between the visiting school children, coming as they do from varying social classes and ancestries, and the symbolic world which they find in this famous house of art—superb baronial wood panelling, great

ornamental clocks, marble fireplaces, ducal chairs crowned with ancient crests, portraits of noble Britons, and an archetypal gentleman's library stocked with Gibbon, Meredith, Carlyle, Thomas Hardy, and Vasari. Inevitably one is left to wonder about the meaning of the encounter. For as they pursue their exposure to art, the children of polyglot New York also find themselves, however tenuously, the guests of a mansion conceived, not only as a monument to "values," but as a re-enactment of the patrician past.

Such tension between the external, "democratic" function of art museums and their more secluded internal traditions appears in at least two forms: between museum functionaries and their public clientele, and between museum objects and their viewers.

It has been said that aristocratic patronage in the past schooled writers and artists in the cultivation of "pure" values—that is to say, values which were above any measurable and obvious social *usefulness*. And further, that with the passing of the actual aristocracy, these value-makers and value-keepers (the "intellectuals") were left as the new (and only remaining) aristocracy. Applying this to the modern art museum (whose function is literally that of custodian of spiritual artifacts) one would say that, while museum men earn their *social* position by discharging a public function, they gain their sense of *self-esteem* from their fellow experts and from the self-satisfactions of their own scholarship and expertise.

Whether every museum man is equally sensitive to the integrity of his own separate status must be at this point a matter of speculation. Nevertheless, the issue dominates a great deal of the discussion and self-searching now going on among museum administrators in Europe, where the strain of democratic cultural expectations is beginning to show its effect. Some European directors regard "gallery talks," films,

and other such "services" as a compromise with scholarship. On the other hand, the British Museum (in the words of its present head) recently described itself as wishing to give "delight and instruction to the widest possible public." It is just as true, however, if indeed not more so, that the British Museum remains dedicated to the academic interests of its research staff. And the impression is hard to escape that, like the great English universities, the British still lives in the aftermath of a convention which brought together two forms of leisure, the scholarly and the gentlemanly. One is, therefore, not surprised to hear that the museum is sometimes challenged to become more concerned with its function as a servant of public culture and less so with the intellectual passions of the scholarly few.

A Dutch art historian, the director of a famous museum in Amsterdam, agreed that museums might be regarded as educational institutions but never, as he put it with some fervor, as instruments of entertainment. To believe the "keeper" of public relations at one of the most distinguished museums in Great Britain, many museum officials of that country view the public with what could only be described as hatred (though, for obvious reasons, they were careful not to show it). And according to a former museum director, now a functionary of the federal government in this country, the struggle between the roles of educational democrat and cultural aristocrat is a real one, even in the United States.

The question—intellectual self-sufficiency versus public information—reaches into such elementary aspects of museum management as the labelling of exhibits. Much labelling is simply an extension of the museum scholar's expertise. If a Chinese collection is labelled "Ming Dynasty," and the visitor knows nothing about Ming, he will simply have to suffer his own ignorance. There are even cases in which museums provide no labelling but a kind of ceremonial naming

presumed to be self-evident to the viewers. At the Louvre the Venus of Milo and Victory of Samothrace are identified as being, in fact, that: The Venus of Milo and the Victory of Samothrace. They are treated, in other words, not so much as works of art or even specimens of Greek civilization but as archeological and aesthetic "celebrities" or self-explanatory monuments of "our culture," whose significance and importance any respectably cultivated person is expected to know.

The problems created by excessively scholarly or insufficiently informative labelling are, then, intimidation and cultural shame in the first case, confusion in the second. Understandably, therefore, it has become the practice among the more enterprising museums to aid the visitor with free brochures which, through some combination of showmanship, casualness, and taste, attempt to make him less solemn about scholarship and more confident of his own sensitivity, thus inducing what one curator calls "guilt-free" museum going.

There remains one other contradiction between the museum as a communal institution and the "inherent" nature of the artifacts which it houses. As an educational institution it should be the museum's principal mission to make available—to diffuse, as the French say—a visible semblance and example of higher cultural creativity, and to awaken in the public a sense of understanding and respect for it. To do this they do not actually have to have in their possession great works of art. Reproductions, as art history courses testify, should be enough. But museums, as we know, are what the sociologist Hans Zetterberg calls "beauty banks," repositories of literal treasures and physical monuments.

They have also been called temples, a metaphor which comes remarkably close to fact. Most of the great museums in the United States and Great Britain and many in con-

tinental Europe are built in the Greco-Roman style which
signals the presence of a civic sanctuary; in this, as in the un-
touchability of the objects and the hushed decorum de-
manded of the visitors, there is much that is symbolically
and behaviorally religious in nature.

The focus of this religion is, of course, the work of art
conceived as a sacred object, whose sacredness emanates from
two things: the holiness of art itself, and the object's original-
ity in the material sense—its quality, that is, of being physi-
cally "an original," a special creation, a singular production,
not a *re*production, a replica, or a copy. The significance of
the *original* may be related to nineteenth-century romantic
notions of the radical uniqueness of creativity (which made
the artist god-like in his powers, a force bringing "all" out
of "nothing"). But it may also be related to the ritual con-
notations ("the first born," the "only begotten") of such
Western traditions as primogeniture. In any case, neither art
museums nor the art market could exist or be understood
without "originals," their aura, and their sumptuously
priced rarity (a "priceless" work of art is usually one of
enormous monetary value).

The possession of originals is, of course, decisive for the
public ranking of art museums and for the social uses to
which those possessions are put. From the point of view of
their civic prestige, the great storehouses of art are the great
storehouses of art *originals*. And local as well as regional in-
stitutions which could perform a much greater service to the
art education of their communities by the wise use of repro-
ductions not only do not do this but rather compete for
whatever originals they may be able to acquire, even when
their artistic merit is doubtful.

Furthermore, the great reverence for originals militates
against some of the specific didactic tasks of art collections.
It is the rule in great museums that they never defile their

most valued original possessions by using them as illustra-
tions of artistic or historical development. Paintings by
Rubens or El Greco are intrinsic entities: "a Rubens," "an
El Greco." Separate masters stand separately, sometimes in
rooms of their own. Art treatises or textbooks may show a
Franz Hals next to a Vermeer to make a point of difference
in style within a national tradition. But the Rijksmuseum
in Amsterdam does not. Just as the Prado does not hang
portraits by Velázquez, El Greco, and Goya in sequence as
episodes in the history of Spanish painting. Even the French
Impressionist Museum (the Jeu de Paume), one of whose
rooms is dedicated to examples of the fine detail of the style
and the stages of its development, uses for this purpose photo-
graphs of canvasses which hang elsewhere in the building.
"Within the walls" museums still regard the didactic as
secular and the contemplative as sacred. Education may be
the task of a gallery lecture or "talk," but great works of
art must not themselves be pressed into such service.

The art museum is, then, a "medium," and today un-
questionably a "mass medium." It is also an educational one.
To say the latter, however, presupposes that museums al-
ready know what they wish to communicate, what can be
communicated, and to whom. But my impression is that the
nature and the basis of the symbolic relationship between
art museums and their public is not yet known and that the
relationship which is now imagined to exist may turn out
to be, in some cases, neither a dream nor a reality for the
public.

Like most museums, art museums are often ancestral places,
the ground on which the present meets the past in the most
self-conscious and organized fashion. But the past is the past,
regardless of how democratically we may make it available
to the present. Cobbett might still ask today, as he did in
1833, how things created for the amusement of the privileged

can be regarded as the rightful spiritual possession of the ordinary man. For the fact is, of course, that in spite of all the rhetorical utterances about "our heritage," in most cases that heritage is not really ours. When the present-day museum visitor, perhaps the child of a working class family, perhaps the descendant of an eighteenth-century yeoman, encounters Van Dyck's portrait of Charles I, with its air of indolent, inaccessible self-assurance and subtle disdain for the common world, does he look upon it as art, as history, as curiosity, as a vague manifestation of grandeur, as an object of awe and obeisance, of anger, moral suspicion, class antagonism, or amused incomprehension?

Museum officials worry a great deal these days about what they call the archaic orientation of some of the great art repositories of the Western world. What they mean by this is, in part, the secret or open preference of museum staffs for the ideal of the elite visitor. However, the deeper questions of the art museum's role and place in modern society may not be answered until we know the manner in which the present appropriates the past. Until, in fact, we know the perception—cultural, historical, and social—which the visitor has of the museum and of his own relationship to it.

Arnold Rockman, a Canadian art critic and sociologist, said recently that the art museum is really a democratic extension of the private palace. In a general historical sense one can certainly understand what he means. But his choice of words only obscures the more intimate features of the cultural and institutional "encounter" (to use a fashionable word) between museums and their "clientele." The museum is not a popular "extension" of the personal treasures of the aristocracy in the sense, say, that the disciplinary powers of teachers are an extension of parental rights of authority.*

* It is possible that Rockman doesn't mean "extension *of*" but "extension *to*," in the sense of an offering. But that would be quite a different thing.

The paradox of art museums, as I have said before, goes beyond the mere throwing open the doors of the palace to the *demos* to the more serious question of whether it is possible to democratize emotionally and intellectually the palace's aesthetic possessions.

Furthermore, no aspect of this debate is solved or clarified by Rockman's impatient (and too confident) statement to the effect that "today the palace is a totally irrelevant model for an institution intended to attract the general public," [6] even if one were to grant that such intention is and *should be* the policy and aspiration of museums. The first difficulty here, strangely enough, comes from the patronizing element concealed in Rockman's obviously well-intended democratic advocacies. For on the basis of this article I find no reason to think of his notion of the public as a nondescript *general* entity as anything more than an assumption. Instead, he could just as well have presumed that art education in American colleges (with their current millions of students), the increasing prominence of art as one of the features of mass periodicals, and the very size of museum attendance figures are, perhaps, in the process of turning the "general public" into individuals equipped with a modest but deserving degree of connoisseurship and who should be regarded, therefore, as more than ciphers to be "serviced" through some sort of collective "experience."

But pronouncements like Rockman's, and their claims and uncertainties, are, of course, only a manifestation of the much larger matter under dispute. When Thomas Hoving, director of the New York Metropolitan Museum of Art, requests, with whatever grave reservations, that we listen to what may be valid in the demands of the "king of happenings" Allan Kaprow[7]—what Kaprow demands is that museums be emptied, turned into night clubs, or used as "environmental

sculpture" in the general landscape—he is, I think, guilty of voicing a new version of an old intellectual fallacy, namely, that what happens at the most recent historical moment defines the nature of the cultural present. In my view *whatever* is happening culturally now is part of the cultural present, and therefore there is every reason to believe that if more people go to see Giorgione rather than Mark Rothko, the first is, in fact, more of a contemporary artist than the second; anything that is experienced and significantly recognized now is a "now" thing. Nor can I find anywhere the evidence for Mr. Hoving's fear that an impatient public may "unceremoniously" push museums into the flux of contemporary change unless the museums decide, and soon, to take the plunge of their own accord.[8] And one can only wonder whether such dramatic imagery does not reflect a horror of being thought of as out of pace with the contemporary rather than any honestly realistic concern.

Haunted by anxiety about being "elitist" and eager to change themselves from "great treasure house(s)" into "more meaningful and enjoyable playfield(s) of the arts" (the words are, again, Mr. Hoving's),[9] museums could very well find themselves engaged in a popularity game which, besides its wastefulness, might in the end betray the real wishes of the public they are presumably attempting to please. For it is just possible that, for ineffable reasons of their own, "the people" actually want palaces, at least symbolic ones (where has the clamor been heard for less Corinthian columns and more cantilevered cement structures?), just as it is something of an interesting mystery that no European revolution, from the French to the Russian has chosen to erase the artistic remains of former "oppressors." *

* *The New York Times* of June 5, 1965, reports the formation by a number of young Soviet people of a Fatherland Club dedicated to the preservation of

The Peasant Visits the Castle (*Bauerlich Besucht in Schloss*)
by Lois Gabl (dated sometime in the latter part of the nine-
teenth century) is a minor work of art with a major social al-
legory. It shows the interior of a baronial house which has,
very likely, been recently opened to the public and in the
house, a number of visitors admiring the treasures now
accessible to them. In the background a distinguished-look-
ing gentleman and a priest (whose very office allows an in-
ference of learning and cultivation) appear to be exchanging
comments on either the symbolic content or the stylistic
character of a canvas hanging on the wall. In the foreground,
however, a peasant woman sits in a monumental and splen-
didly carved chair under the amused and ambivalent gaze
of her young son. The expression on her face makes us part-
ners in the game of "Look at me, I'm a Queen!" while the
boy appears self-deprecating and wishful-thinking at the
same time. The anecdote related in the painting carries two
implications. On the one hand there is a mocking of the
vanity of princely pomp; kings and nobles are after all made
of the same stuff as the rest of us. But on the other hand it
clearly proclaims and relishes the glorious folly of playing
"Queen for a Day." The scene is a near-perfect parable of
the twin and contrary emotions which the museum, as palace,
must arouse in many people. There is an appropriation of
privileged glories by the popular customer-invader. But the
thrill and the joy of this capture could not be what it is if it
did not contain an act of secret veneration for a state of
spiritual *and* material splendor which has never, in actuality,
been part of our own lives.

Maybe the affluence which technology has brought and the

ancient place names and edifices, churches included, evoking "centuries of
Russian history." The club was the object of special praise by the organ of
the communist youth, *Komsomolskaya Pravada.*

social comforts which equality affords have left in us something untouched; a curious ancestral form of respect which is somehow inseparable from the magic of the sumptuary. And, if this is true, the museum could quite possibly be the throne room to which we can now pay a reverence without obeisance from the safety of our democratic rights.

4 · Art and the American Republic

Neil Harris has written a book about "the legitimization of artistic energies in America" which, he states with some emphasis, should be read, not as a history of art and its relationship to American culture but as a history of the American artist and his position in the life of this country during the first half of its national existence. However, like all books of any worth, *The Artist in American Society** goes beyond the strict meaning of its title. Indeed, paradoxically and despite Harris's warning, I find it primarily what he claims it not to be—that is to say, not so much a chronicle of the artist as an occupational personage but a history of aesthetic beliefs in the United States from the end of the eighteenth century to the Civil War.

Harris can claim considerable novelty for his research. His documentation is abundant (his bibliography certainly has a "definitive" look), and he has extracted a great deal of point from it. But the final impression is miscellaneous and soft-edged as though the author had let himself be overrun by

* The full title is *The Artist in American Society: The Formative Years, 1790–1860*. It is published by George Braziller, New York, 1966.

the size of his subject matter and his own unwillingness to hold it within any one point of view.

He might have succeeded in a number of ways. By writing a narrative in the conventional historical tradition. Or an essay on the influences to be found behind this or that artistic doctrine. Or a study in cultural nativism—a search for the spirit moving above the American waters, fashioning the beginnings of a national taste in art and guiding the hand of the New World artist himself.

What he did instead was to allow each one of these possibilities to have their moment or moments—but tenuously, by inference, sometimes one would say by chance, or even by default. However, like other writers about American intellectual history, Harris could not escape having to deal with egalitarianism, not simply as a political or social but as a cultural question. And it was, I decided, through this famous old problem as it appeared in *The Artist in American Society* that a convenient order could be evoked out of the book's difficult eclecticism.

The contention has been generally that equality, aside from its virtues (and in addition to its vices), places special obstacles in the way of art, whether one thinks of art as a symbolic discipline capable of disclosing to people the significance of their life—while by some extraordinary means raising them above it—or simply as a free gesture whose first and last value is its own inherent loftiness and grace. In the case of America the question might be put this way: The United States began as a commoners' republic, pious and austere, unembellished by those institutions and social ensembles—royalty, aristocracy, the church—whose elegance, mysteries, and powers had always been one with leisure and thoughtful refinement. How, then, could such a nation create a new art or comprehend the old? Did it even need such a thing as Art? Or, for that matter, deserve it?

Professor Harris does not himself think that the imagination of early America was all that lean, plain, or unstirred (he points, for example, to the profusion of theological tracts that issued from its eminent men), and, as I have said before, he does not point his narrative toward any one sort of formal inquiry to be met or dismissed. Still the theme or shadow of the democratic *geist* shows itself throughout the book. In some instances, it is a matter of how the press of equality on the face of America would define the kinds of art which this country could or could not produce. In Europe, a whole pictorial tradition of "life-scenes," thoughtful, racy, sentimental, or sumptuary—the world of the peasant, the rakish underworld of the growing cities, or the utopian gardens of the aristocracy—had always depended on specific forms of inequality. But in America, we learn from Harris, there were people who thought that the spirit of levelling had rendered their nation fatally non-picturesque since a sufficiently rich repertory of human diversity could not exist without the preservation of "high" and "low" forms of life.

This is an interesting "issue" to the degree that it is and is not true. America may have no Breughels, Louis Le Nains, Steens, Hogarths, or Watteaus. There is, on the other hand, the small-town reportage of Woodville, the frontier vignettes of Bingham, the popular buffoonery of Johnston, the genre charm of T. W. Wood Negroes, plus a good many romantic glimpses of plantation life and the urban anecdotary of Bellows and the whole Ashcan school. In any case the fact of equality and democracy evoked more general considerations than those having to do with the subject matter of art—classically, of course, in the work of Alexis de Tocqueville. Harris mentions Tocqueville; dealing with nineteenth-century America he could hardly have avoided it. But I found his one reference too brief and disappointingly loose-ended. Tocqueville speculated that equality might lead to a pastoral fashion

in poetry; having caused the death of gods and heroes, the egalitarian mind would have to turn to the inanimate features of the natural surroundings. And Harris is reminded of this remark in the course of his own observations on the craving for solitude and decay and the revulsion for social and specifically for urban life which overtook American painters in the 1830's and 40's. The connection is both doubtful and short of the target. Doubtful, because the romantic cultivation of loneliness and world-weariness in Europe and America has always been inseparable from intellectual self-consciousness (or ego-centricism), whether wistful, self-pitying, or heroic, while Tocqueville's point is that poetic naturalism follows the decline of the subjective. And short of the target because whatever Tocqueville says about the "impersonality" of democracy should always be related to his more inclusive worry concerning the process of "objectivization" (the license to employ these terms is my own; Tocqueville himself did not use them) peculiar to the modern world. The appetite, that is, for the general and the collective which is engendered by the rejection of personal impulse and magical or divine forces as explanations of human events.

According to Horatio Greenough, we read in Harris, "We [the United States] began with experience . . . and the eye of mature reason was on [our] action." Historically and "ideologically" this must be taken as a victory statement, the language of a nation which had left all the fears and darkness of the past behind. Yet we also learn from Harris that even among the most patriotically-minded there was a feeling that the nature of civic allegiances in the United States was simply too abstract, and that the citizens of this country needed public monuments capable of bringing the Republic close to "visible shape" and ordinary emotion. Tocqueville, however, goes beyond the question of civic symbolism to the realm of social imagination. Aristocracies, he says, consecrated social

privilege by paying homage to it as a cultural principle. They held, in other words, that legitimate distances existed among men because certain noble gifts of taste and spiritual disposition belonged only to some of them, and that others discharged their social and moral duties as they bent before those virtues which they did not themselves possess but were able to recognize and obey. Aristocratic life, that is to say, gave a foundation in fact to those habits of mind which we conventionally regard as poetic: to our respect for the remote, the marvelous, the unaccountably superior, and the elusively sacred. And the implication is clear that equality, while establishing justice, had nevertheless deprived America of any *concrete* social realities capable of sustaining what may be called the aesthetics of ancient emotion, the presence of the ancestral with its unspoken and secret ties.

As one would expect, in the beginning there was the hope that America would create an art equal to the extraordinary, indeed, the unique achievement of its historical existence. An art that would be noble but free of vanity, and sober even when monumental. An art, in other words, as brave and pure-hearted as the New Republic itself. For this reason, as Harris very successfully illustrates, the epic anticipation that Columbia, too, would "strike the silver lyre" and display "the finished glories of her risen day" was always accompanied by a fretful and frowing watchfulness aimed at keeping America's moral selfhood from surrendering either to beauty as a mere sport of the senses or to those traditions whose loveliness and grandeur was the other face of a past darkness to which the New World Adam must never return. Old World "charm" was only the drapery of European corruption. Old World majesty was the mask of tyranny. And not even a man of patrician circumstances like John Adams would allow his practical moral sense to be shaken by pedigreed artistry and magnificence. After a visit to some of the great

titled houses of England, he remarked that, of course, such things could be built elsewhere provided that a country were willing to go gratefully or helplessly into debt.

Just as stern were the warnings against the *political* spirit of ancient monuments. Thomas Paine, as Harris recalls, once said that the relative mildness of the British monarchy was due, not to the British Constitution but, so to speak, to the constitution of the British, that is, to their moral inclinations. And, as we learn from Harris also, later Americans never lost their belief either in the people's character as a fount of liberty or in the power of artistic refinement to destroy both liberty and the people. We can, in consequence, regard it as notable, but not surprising, that, in defiance of some of the most solemn commonplaces of educated custom, a Virginia legislator of the mid-nineteenth century should argue not only that civic and artistic perfection did not of necessity co-exist, but that virtue—and not taste or beauty—was to be understood as the measure of civilized attainment.

In fact, it occurred to me as I read Harris that while he does not deny it, neither does he claim for this side of the American response towards art all of the intellectual pluck which I think it has. For in its plain way such attitude was not only irreverent but revolutionary. When, for instance, Marx and Engels considered the established glories of European civilization, they stood in the end for the cultivated conventions of their bourgeois upbringing. Had they applied their own tenets pitilessly enough, they might have spoken of Shakespeare as the dramatist of dying feudalism (as has been done by one of their disciples) and of the Renaissance as the spiritual flower of the post-medieval merchant city. Instead they thought of the first as the greatest playwright of all time and of the second as the supreme artistic achievement of mankind. The Americans, on the other hand, chose to carry on in Rousseau's tradition (art as morality's foe), a

tradition which they put into the most unceremonious language of social fact. John Adams reminded Jefferson that the fine arts he loved so well had always been the servants of "Priests and Kings," while Wilbur Fisk, looking at the Medici Chapel in 1838, could only say unapologetically: "Thus, for the mere purpose of pride . . . princes impoverish their subjects . . . and exhaust the resources of the country." (Quotations from Harris.)

Professor Harris moves easily and resourcefully within the large depository of information his book has brought together. Still, as I made my way through his description of the insistent, sometimes tortured debate about the place of art in America and about the kind of art that would best express and least defile the American idea, I came to feel a puzzling and ultimately inescapable restlessness, punctuated here and there by the pangs of frustration. Let me repeat that this had nothing to do with the author's scholarship or the originality of his topic. Both are considerable and I could easily be persuaded that, in a general sense, one could find in this book the better part of what there is to be known about the social philosophy of art in the United States in the first seventy years of its existence. My impatience came from the "reading" given by Harris to his own evidence. To put it briefly, and no doubt invidiously, Harris is daring where my sociological rearing tells me to be circumspect, and he appears strangely unaroused by the "leads" just in those places where a sociologist would want more answers and ask more questions.

For example, he regards it as an "anomaly" of colonization that Americans used words before they made pictures and believes that this, rather than the raw task of pioneering, is responsible for the anxiety which later generations felt over "national creativity." After all, he says, such pressures did not keep the colonists from producing hundreds of treatises on

free will and conversion. He concludes that we would come much closer to the source of the plainness of early America by looking at Britain itself, which, though an imperial power, was also one of the major nations in Europe without a developed system of patronage, state artists, or in general, that princely and ecclesiastical *haut monde* responsible for so much splendor in countries like France, Italy, or Spain.

I find these explanations either incomplete or too handy. It is obvious that Professor Harris does not play fair with his subject when he compares the rates of theological and artistic productivity in the colonial period since he must know that social purpose in the early American communities depended on religious identification (just as social leadership depended on doctrinal skill). And when he says that hard work alone could not have blighted artistic cultivation, permitting as it did so much sectarian argument, he forgets to add that the men in the pulpit and those ploughing the fields and clearing the woods were not very likely the same. Concerning the artistic sobriety, timidity, or indifference of the British "home" culture, it is true that England had no Barberini, Farnese, or Borghese popes, no archbishops of Salzburg, no Louis XIV's. But the Church of England built majestically enough. The English squirearchy housed itself in premises which were, as we all know, stately. And there were among British monarchs one or two quite impressive patrons. On the other hand, it hardly needs pointing out that cultivated *elites* and the intellectual and "creative" circles for whom these *elites* have traditionally played the patron roles seldom choose to become first settlers on wild continents. (French Canada, as one example, was settled when in France itself official sponsorship of the arts was the custom of the realm, yet very little of these policies transferred across the ocean.)

To put it in other words, symbolic and aesthetic colonization sometimes matches the most eminent and luxurious

features of the metropolitan "superstructure"—as it did, for instance in the case of Spanish America, for administrative and religious reasons—but sometimes it does not. My guess is that the condition of art in the American colonies had to do not with any historic immaturity of England concerning aesthetic development but with the tastes of the population that decided to (or had to) migrate to the British possessions overseas.

It also seems equivocal and unavailing to talk about the existence of a national case of creative anxiety (or to speculate on the ways in which a country may prevent it, such as having a "pictorial" rather than a "verbal" historical beginning) without first asking a plain but fundamental sociological question: *Who* was concerned about the fate and meaning of the arts in the United States and who was *not?* Throughout the book Harris speaks of "the Americans" referring to the proponents of artistic asceticism, religious or political, who could never look upon European artistry without defiance, fear, suspicion, or contempt. But he uses the same expression when talking about those whose admiration for the crafts and monuments of older societies came close to emotional grovelling and envious despair and who, in their trips to Europe, reacted as men swept by a vision or as wanderers out of the desert being delivered of their blindness and bondage. The term is, therefore, useless, and leaves untouched what may be the real question. Namely, whether these disagreements were, not a debate among "Americans," but rather a contest between people whose social ancestry, interests, or position led them to have conflicting tastes, moral and intellectual: a dispute, in short, among different educational, professional, economic, perhaps even regional *elites*.

It is quite plausible to read Harris's book as an account of the American passage from fear and hesitation toward the arts to their acceptance and, in the end, their celebration.

Still, I wonder whether to presume that the author had such a straightforward story in mind is not to do him and the story itself a disservice. In one of Harris's quotations an early American traveler exclaims as he stands at Versailles: "What taste—what art—what luxury—what sin!" This statement, combining intoxication with shocked (but suspiciously defensive) frugality and, finally, religious recoil (which, again, may be both an expected gesture and an act of self-admonition), could serve as a near-perfect confession of mixed feelings. And this and much of the rest of Harris's documentation compels the belief that, from the beginning, the record of American attitudes toward art—both as a social and a spiritual property—was a complicated and ambivalent one. Standing before the Medici Tombs, Wilbur Fisk could only grumble about the impoverishment of the people for the sake of the pride of princes. But Florence, having made Emerson "dazzled and drunk with beauty," brought out in him the unmixed voice of exultation: "O the marbles!" Samuel Morse, speaking within the strictest Protestant tradition, thought that he would "rather sacrifice the interest of the arts" than endanger the souls of people by having pictures in churches (even though himself a painter). At about the same time, however, Charles Leland found himself tactfully insinuating the view that the Roman confession deserved from his countrymen more respect and less suspicion than it had received, if for no other reason than its great generosity towards the arts. While Hawthorne, altogether replacing the religious argument by an aesthetic one, would say in 1863: "Oh, that we had cathedrals in America, were it only for the sensuous beauty." (The quotations are all from Harris.)

The problem, then—and it remains a problem after reading this book—is simply that of explaining the appearance in the United States of what may be called conventional aesthetic sensitivity. I am not speaking of the developments of

American art, a notable enough phenomenon; the country
that produced Thomas Eakins, Albert Ryder, James Whistler,
Winslow Homer, John Sargent, and Mary Cassatt within the
first century of its existence is not to be called upon for any
apologies. I refer to something larger and clearly definable
as a social event. The emergence of traditional artistic tastes
and concerns as a public, even more, as a prominent national
feature of American culture.

In 1848, we read in Harris, the *United States and Demo-
cratic Review* rejected as repugnant to the men of this re-
public not only the "pomp" and "moss" of ancient civiliza-
tions, that is, their vanity and decay but also some of their
most affectionately revered and lovable features: their carved
cloisters, their "irregular, antique streets," their "clothing of
ivy." But not much more than a generation or two later the
cloister (sometimes in faithful replica of age-laden European
institutions) had become a model for American academic
buildings, a natural architectural homage to the very *idea*
of the university, which spread from New England to the
Southern hills, the Midwest, and even the Pacific coast. The
picturesque street, seemingly looked upon by the *Review*
as nothing more than the tatters of a spent world, is nowhere
more greedily preserved, reconstructed, and even invented
than in the changing American cities of today; it is actually
in the process of passing from the condition of a touching
relic to that of a large-scale (and habitable) *objet d'art* whose
pre-industrial aura—through some delicate sociological irony
—has become singularly valuable as a status-giver in an
urban and technological world. As for the "clothing of ivy,"
it came to be in time, of course, the very mantle of pedigree
conferred by nature upon great learning underwritten by
great wealth.

What has happened beyond that, however, is that the
Puritan and Spartan commonwealth wished by some of its

first citizens is now a nation crowded with art, and where art
is literally crowded by those wanting or needing to look at
it. If anything the stereotype of an art-reverent Europe and
a Philistine America has now been entirely reversed. It is in
Europe that, outside the famous *de rigeur* places like the
Louvre or the Prado (where visitor numbers are, in any case,
swelled by the world-wide tourist business, much of it
American), great art frequently lies virtually unseen in dark,
silent, near-empty rooms. It is in the United States that
museums, which happen to be one of the fastest-growing
American institutions, have become makers and breakers of
civic glamour and self-respect, and where through open mem-
bership rolls, they enjoy the kind of public support which is
rare if not unknown in Europe. They are also almost volup-
tuously endowed by people of means in big and small towns
(it is no longer astonishing for an American provincial city
to possess a Giotto, an El Greco, or a Klee) and their at-
tendance figures are so enormous—not millions but tens of
millions—that they appear at first to be totally implausible.

Fisk and Hawthorne, one complaining about waste, the
other calling for glory, are part of a familiar American cul-
tural duel which may be said to address itself to the "Protes-
tant Ethic" (I put the term in quotation marks to signify that
I use it in a general and sociologically non-controversial way)
from mutually unintelligible vantage points. Fisk troubled
himself about the dissipation of economic resources, as Veblen
would do later. Hawthorne speaks for those who regret the
emotional barrenness of "earthly asceticism." Yet neither side
is always sufficiently aware of the irony lying at the end of
the tale. Those seeking for a clue to the passage from the
America of Max Weber's Calvinists to that of Veblen's
"leisure" could hardly do better for a classic locus (I take the
citation from Harris again) than John Adams's question to
Jefferson: "Will you tell me how to prevent riches from be-

coming luxury." Earthly asceticism triumphed, of course,
making the United States the most powerful and technically
gifted nation in the world. But, through the endeavors of
the American businessman turned passionate purchaser of
beauty, so has Art.

How, given the proclaimed political and moral ends of the
American system, did the American republic learn to em-
brace the old forms of artistic reverence and even artistic
sentimentality belonging to a pre-democratic age? How, given
the stern teachings of her churches, did she school herself in
admiration for the sumptuary and largely "high culture"
art of Europe? How did the great wealth generated by the
business ethos come to be spent by the very hand of the
protagonists of that ethos on the creations of pre-industrial
time? What caused real estate men to build themselves Tudor
manor houses? What made a Western magnate want to erect
a Romanesque university in California or a Texas millionaire
a Venetian Gothic one in Houston? How did the descendant
of a Protestant Midwestern family, whose famous wealth
flowed from such prototypical modern enterprises as in-
dustrial fuel, come to underwrite a museum of medieval
religious art? And, further still, what led him, in a giant
tour de force of aesthetic and nonutilitarian delicacy, to join
forces with the scion of another great business family to buy
up the shores of New York's East River in order to keep them
uncursed by industrialization, thus preserving for the mu-
seum visitor who would happen to look from the window an
undefiled and historically appropriate pastoral view?

These are arresting questions for the social historian of
art, and I only wish that Professor Harris had more answers
for them.

5 · Is There a Democratic Architecture?

Max Weber began his study of the Protestant ethic by displaying some musical and architectural examples of what he thought was the pervasive rationalism of Western society.[1] Emile Durkheim, for whom the real explanation of suicide and religion—that is to say, the most personal and the most transcendental of acts and experiences—was to be found in sociology, believed that this science had nothing to say about art. His conclusion, however, was not based on reverence for the presumed autonomous mysteries of artistic creation, but on scientific factuality as he understood it. Art, he thought, was the freest and most original of human pursuits because it was also the least significant to social morality and organization: "a luxury, an acquirement, which is lovely to possess, but which is not obligatory; what is superfluous does not impose itself." [2]

In principle most sociologists would balk before accepting Durkheim's courteous but unequivocal dismissal of art as professional "data." But neither will they emulate Weber's pointed acceptance of it. They are not likely to surrender their claim to interpret all aspects of social existence; yet,

when it comes to art, they seem agreed on a policy of leaving things well enough alone. They certainly feel no obligation—and this does not exclude the "structural-functionalists" who maintain that every institution and manner of behavior must in some way make sense and fall within the peculiar logic of a given society—to explain whether or not celebrated books, renowned paintings, or historic buildings should be counted among the expressions of the "value-system."

Hugh Dalziel Duncan is an exception. He is one of those who think that art is a measure, not only of cultural integrity but of cultural reality or, which is the same, that any form of communal life going beyond mere survival to become a distinct society, will, of necessity bring forth an art to "speak" for it; a great symbolic gesture of the body social, as it were, which consecrates and reveals its essential and particular nature. Duncan's *Culture and Democracy** is, or wants to be, the chronicle of one such emergence—the creation of an "American" architecture. But more than that, it is an account of the precipitation of the life of this country towards a national "style," social and intellectual. Interestingly, he finds his matrix, neither in the ancestral territories of New England nor in the voluble ferment of the Pacific Coast, but in the Middle West and, within that, in the notoriously "vital," even if famously untutored, city of Chicago. It is there that Duncan locates the archetypal American situation: an unalloyed firsthand construction of historical realities upon the clean slate of a historyless land, the self-discoveries of the frontier, a new kind of directness, and a tough, gambling, but seemingly unfailing resourcefulness. The beginnings were plain and bluff, but in time, Duncan tells us, they transformed themselves into the forms and sounds of a "culture." Chicago journalists minted the currency of a new American parlance. A new university, with its celebrated contingent of pioneering

* The Bedminster Press, Totowa, New Jersey, 1965.

minds—John Dewey, Thorstein Veblen, George Herbert Mead—battled against the parochialism hidden behind inherited intellectual solemnities, exposed the conspiracy of privilege behind the ceremonies of polite society, and spoke of the dignity of usefulness, the aesthetics of common pursuits, and even the rising of the innermost self from the marketplace of daily experience. Finally, in the architecture of Louis Henri Sullivan, Chicago and the Midwest discovered a fitting art, vast, unsentimental, faithful to the tasks of a new life and, for that reason, stamped with a forceful and untarnished elegance of its own.

The book is also a gesture of redress. It is one of the fervent items of stereotyped sophistication that Chicago must forever be regarded as a brutal and ignorant place (though there have been literary folk artists who have eulogized the city for a kind of heroic commonness). Duncan contends, however, that Chicago was the site of an intellectual history not only honorable but peculiarly significant and, more still, the soil of a native vision to which the United States must return if it is to fulfill the aesthetic dictates of its social order.

Such vast intentions, particularly when pursued by one so bound in loyalty and enthusiasm to his subject, can conspire to invite certain hazards. And a work which purports to document the sweep of the Midwestern ethos, from frontier settlement to immigrant tenement, and from the gestation of a hearty, inventive common man plutocracy to the outcropping of a tradition-free intelligentsia under the reconstructed Gothic roofs of the University of Chicago, would have to tax itself with a scholarship of iron meticulousness to keep from being more than a cavalcade of episodic inferences. I do not believe that Professor Duncan has overcome this peril. *Culture and Democracy* must in the end be judged as a narrative which attempts to convince us not so much by establishing a visible link between fact and consequence, events and

ideas but rather by allowing our minds to be swayed toward the book's perception of social history through the cumulative, almost conglomerate use of suggestion and implication.

As an instance let me cite the following: "Thus, some ten years before the first significant publications of the Chicago school of philosophy, and nearly forty years before the rise of Chicago jazz, Sullivan and other Chicago architects, Root, Edelman and Wright, raised issues which determined the course of art criticism for their time as well as ours." The statement is not only one of the many tributes paid throughout the book to the revolutionary power and moment of Sullivan's thought; it is also a fair sample of what are, for my taste, excessively easy-going deductions. Chicago may very well have been the ebullient arena for the new possibilities of Duncan's description. But I do not find in what he says sufficient license to force Bix Beiderbecke, Louis Sullivan, and John Dewey into each other's company. It is true that Sullivan read Dewey and that, like Dewey, Sullivan thought that one could not understand art unless one understood the relationship of aesthetics to social life. But there is, after all, a difference between the cautious, laborious, thoroughly native pragmatism of Dewey and the rather swelled, rhapsodic writing of Sullivan who, as Duncan himself knows, first got his notions about the social basis of art from such imposing (and foreign) academic sources as Hippolyte Taine. As for jazz, whose origins are found amidst the barrel houses, brothels, and street parades of what was once, reputedly, the most hedonistic of American cities, New Orleans, it has, of course, nothing to do with the sweat of the frontier or the grit of the industrial metropolis. That it came to Chicago at all was a historical and geographical happenstance. And I for one doubt that a reasoned, formal community of spirit can be established between the Tacoma Building and the *Jazz Me Blues,* arresting as they both are.

In consonance with this style of argument Duncan maintains also that the checkerboard pattern of frontier settlements preordained the model for the Midwestern homestead, surrounded by a yard and looking out upon the stretching fields. He illustrates this process of—presumably—impersonal imagination, however, with self-consciously cogent renditions of the regional spirit by an architectural missionary: the "prairie houses" of Frank Lloyd Wright. He says nothing about more anonymous but indigenous facts, such as the urban brick mass of older Chicago. The problem here is one common to much (perhaps most) of the writing in the sociology of art. The temptation to argue, à la Spengler, from the articulate inventions of intellectuals to the supposed "will to form" lying latent but breathing in the breast of the collective. I find it, therefore, difficult to accept Duncan's belief that contemporary suburbia stands for a compulsion to return, architecturally, to the archetypal frontier. My own guess would be that suburbs present a somewhat more contrived case of symbolic re-enactment. Grimly reserved as I am towards Professor McLuhan's free-form speculations, I am inclined to agree with him that when "Bonanza-land" (as he calls it) really existed, nobody, that is to say, very few people, lived there. It is only now, after its destruction at the hands of developers, that it has become possible for "everybody" to live there.

In other respects, also, reality appears to be far less orchestrated to the general vision of *Culture and Democracy* than its author would like to have it. And this may mean that we should look for the logic that holds Midwestern culture together (assuming *this* to be the case as a fact and a need) somewhere other than in what Duncan calls the "struggle for form." If the creative geniuses of the region, like Sullivan or Wright, fed on a spirit which ran from common public sources, the uninstructed architecture of Chicago does not

show it. As one drives from the airport into the city today one may observe, against the naked bulk of commercial and industrial structures, the silhouettes of an eighteenth-century Warsaw painted by Canaletto. A disconcerting incongruity, but only to those who demand of a culture that it have the compositional logic of a work of art, with all its parts and features obeying a central expressive principle. For these baroque profiles belong to churches built for an industrial populace of New Americans, the Chicago Poles, who evidently attended them undisturbed by any perceived lack of coherent aesthetico-historic vision.

There are other, I feel, somewhat impulsive and overly momentous generalities. "The past destroyed the future in Chicago," according to Duncan, and he cites Kipling's recollections to prove it: "They told me," Kipling writes, "to go to the Palmer House . . . and there I found a huge ballroom of tesellated marble, crammed with people talking about money and spitting everywhere." It seems like an obvious enough commentary upon the encounter of old styles and new wealth, and it is thus reported. But I think it must be read more ambiguously and, therefore, more realistically. The noise and irreverence are certainly part of the point. So are the spittoons. The other part, however, is the tesellated marble, which speaks not so much for the destruction of the future at the hands of the past as for the appropriation of the past by the forces of the present. As Veblen taught us, it is one of the curious facts about money and utilitarian skill that, irrespective of their power or even their prestige, they will seek the blessings of consumption, particularly the consumption of traditional forms of splendor. Families like the Palmers, whose fresh millions had been hatched by American enterprise, built Rhenish castles on Lake Michigan and, by Duncan's own account, treated themselves to remarkably eclectic samplings of historic styles: Spanish music rooms,

Louis XIV bedrooms, English dining rooms, Turkish parlors, Moorish corridors. Nor should Duncan allow the implication, as I feel he does, that the use of business wealth for the staging of status ornamentation was peculiar to the Middle West, either among the members of the moneyed class itself or among those who would be the singers of the poetry of riches. Duncan cites Scott Fitzgerald, but Fitzgerald, though a Midwesterner, wrote of the glory of Eastern opulence. And when Dixon Wecter said that there was beauty in money he was speaking of New York and Boston, not the Midlands.

Duncan is right, certainly, in pointing out that such dreamlike transmutations of material puissance were brought about by female consorts rather than by the merchant princes themselves. The genius of the Castle on the Gold Coast was *Mrs.* Potter Palmer. But Duncan is wrong in seeing her and others like her as the embodiment of a novel and uniquely Midwestern sort of plutocratic feminism. The dowager art patrons and spiritual boosters of the city of Chicago had their counterparts in Massachusetts and California, and these had their ancestors in Europe. As French businessmen in the eighteenth century began to accumulate wealth and social pretensions, their wives turned their otherwise unspent energies towards the running of such cultural institutions as the *salon,* in which the husband played the role of investor (or, in Broadway language, the "angel") and the wife that of the producer and manager of literary and scientific occasions. Duncan tells the story of Potter Palmer eating alone while Mrs. Palmer entertained guests at the Castle. But one must also recall that when one of the cultivated retainers of Mme. Geoffrin, one of the ruling queens of eighteenth-century *salon* life, happened to ask her "what became of the silent gentleman who always sat at the head of the table?" she responded: "That was my husband. He's dead."

I agree with Duncan that Sullivan was the greatest of

American architects, but just because of that I would find it reassuring to the sociologist (and decisive to Duncan's argument) if proof could be given that his works were in some sense the flower of a historical period; that they did, in fact, incorporate the breath of a general impetus. As we saw before, however, Sullivan's theories—he conceived of Chicago as the new Athens by the inland sea and had a vision of the coming "World Drama of Democracy" whose protagonist, the new "creative man," would convert the vigor of the rising age into the shapes of a triumphantly original and monumental art—came not so much from some inspired promenade through the life of America as from the reading of Taine's books. Taine conceived of nations as entities whose "spirit" was put together in the manner of an artistic object, and who had "motives" seeking certain kinds of formal expression. It is not surprising, therefore, that Sullivan too would see art emerging in inescapable stylistic ways out of the inducements of the collective mind. But what were really the facts behind such gilded talk? Sullivan spoke of the energies, the "vibrancy," and other virtues of the American commoner. What he actually built were banks, marketplaces, and storehouses. He also stated his "profound faith in the beneficence of power." Indeed, if one looks for a translation of social reality into the forms of Chicago architecture one is somewhat more likely to find it in the aesthetic language of money than in the more elevated though hazier evocations of the democratic man and his poetry. "The presence of power as a mental characteristic in one class of our people," said Sullivan—he was speaking of businessmen—"augurs for the belief that it may pervade the ranks of architects." And in *Architecture: Nineteenth and Twentieth Centuries,* Henry-Russell Hitchcock says (the passage is quoted by Duncan) that "Enlightened commercial patrons demanded and often received the best architecture of their day. Undoubtedly the

functional and technical challenges of commercial buildings brought the capacities . . . of architects as no other commissions did consistently." If this is true, one would have to ask whether the technical and artistic novelty of Chicago architecture was the outcome not of the "democratic spirit" but of the character of the structures, constructed in large number and on a vast scale to serve the surge of business and manufacture following the Union victory. One is left to wonder, moreover, whether Sullivan's talk of a democratic aesthetics was not a means of providing a lyrical legitimacy for what was in truth an institutional art for the new American market.

Even granting nothing but the most generous civic outlook (though the above in no way questions Sullivan's honesty; it merely interprets his rhetoric), it would still seem the duty of the sociologist to remain alert to the sound of ideology. Sullivan claimed that art could not survive without democracy. He also claimed that democracy could not survive without art. And then, again, conceded that architects could not create a democratic art unless a democratic society asked them to. But societies of course, except metaphorically, do not "request" their artistic or, for that matter, their social forms. And, in any case, it turned out that, like its "ethnic" populace, the civic powers and plutocratic benefactors of Chicago often preferred the pretty and the traditional to the "manly" and the "American," as witness the neo-classical museums of the Park District and the English Gothic of the University. When Chicago failed to call upon Sullivan to find the expression for its soul, therefore, his pain must have been equaled only by his surprise. To say, on the other hand, as Duncan does, that he was "betrayed and deserted by the people whom he loved so deeply" is a piece not of social history but of intellectual sentimentality.

Despite their ring of noble thought and even nobler am-

bitions Sullivan's pronouncements speak for a profoundly arrogant and profoundly naïve intellectual tradition. As Duncan himself admits, Sullivan was an autocratic aesthetician quite free of the common touch. He did not really think that democracy would create its own architecture. He thought, in fact, the opposite. He wanted a "democratic" sublimity but expected that *he* would be the maker of it. I suspect that his near-religious democratic tone was one way of investing his own gifts with the blessings of historical necessity. The awe of the "World Drama of Democracy," with its fresh powers and its "ceaseless song," is Sullivan's version of a not unfamiliar *motif:* the conviction that, unless a political system is aesthetically moving, it cannot command the respect of the man of ideas.

6 · John Dewey's Social Art
and the Sociology of Art

The most general statement that can be made about Dewey's philosophy is to say that for him life was experience, and experience was two things: a vision of man as an organism which was creative and responsive in its relations with nature, and a vision of society as part of the natural surroundings of man.

It was through individuals, of course, that experience became actuality, the substance of life's events. But always with the understanding that for Dewey the individual was the marshaling point of social realities, a gathering fold in which collective demands, intimations, and challenges were thrown into the machinery of articulation, and returned to the historical environment as specific acts, as distinct exhibits of social agreement and purpose.[1]

In 1934 Dewey published *Art as Experience,* a work which one critic at once embraced not only as the greatest American contribution to aesthetic theory but as a summation of Dewey's entire philosophical message.[2] We meet again in this book Dewey's never-relaxed advocacy of empiricism and social realism. This is to be expected. But, given the subject,

one finds it difficult at first to suppress a customary patroniz-ing surprise. In what way, or even by what right, could the pragmatic mind concern itself with something so gilded, so regally nonsecular as art? If, as Dewey said, art, however refined or forceful in its form, was rooted in "the everyday doings and sufferings universally recognized to constitute experience," [3] where did one find the passage from the or-dinary to the extraordinary, from the homely predicaments of existence to art's singular imagination and skill?

The answer, we might think, lay in the search for those day-to-day meanings to which art lends a peculiar voice and eloquence. In reality it went much beyond that. For Dewey, the greatest obstacle to aesthetic understanding was the ac-cepted classification of art as objects made by professionals, possessed by institutions, or bought and sold under the rules of the cultural market. Instead, in a pointedly chosen con-trast, he turned at the beginning of his book to workaday events:

> the fire engine rushing by; the machines excavating enormous holes in the earth; the human fly climbing the steeple-side; the men perched high on girders, throwing and catching red-hot bolts; . . . the tense grace of the ball-player . . . the delight of the housewife in tending her plants.[4]

Like others of us, Dewey experienced a sense of welcome and ardent admiration for the psychological and dramatic decisiveness of such acts; for the courage, verve, precision, elegance, and articulation that men brought to them. But he also knew that, though we may call them "beautiful," our views of high culture would not consent to their being "artistic." It was Dewey's intention to convince us that the daily language of our aesthetic emotions held a truth far deeper than that of any lofty conventions; that aesthetic meaning was not a property of things but a parcel of experi-

ence; and that no real borderline existed between the quality of art and the content of life.

It is quite accurate to regard *Art as Experience* as a primer of Dewey's ideas, for what he has to say in this book about aesthetic events is only an extensive illustration of his general philosophy of human acts. As he so tirelessly repeated, man was a *live* creature, an organism linked to the surroundings by relations of dominance over it, defense against it, or acquiescence with it. Even ideological issues were discussed by him in the language of organic adjustment. Intelligence was the capability to restore on the plane of meaning that union of the sense of need, impulse, and action which marked the living being. Sensitivity was the gauge of man's well-tuned response to the solicitations of the environment. Not, of course, that man and reality stood always poised in felicitous balance. Strain occurred, as did discord, but when they did, intelligence and sensitivity were at once mobilized to restore organic comfort and fulfillment. Art, too, was for him an act which, while involving intellection and imagination, stood basically as a symbol of organic conformity and control. Explaining the transformation of ordinary emotion into artistic expression he says in *Art as Experience:*

> Irritation may be let go like an arrow directed at the charge and produce some change in the outer world. But having an outer effect is something very different from ordered use of objective conditions in order to give objective fulfillment to emotion. The latter alone is an expression, and the motion that attaches itself to, or is interpreted by, the resulting object is esthetic. If the person in question puts his room to rights as a matter of routine he is an esthetic. But if the original emotion of impatient irritation has been ordered and tranquilized by what he has done, the orderly room reflects back to him the change that has taken place in himself. He feels not that he has accomplished a needed chore but that he has done something emotionally fulfilling. His emotion as thus "objectified" is esthetic.[5]

All of Dewey's writings are, in a sense, episodes out of a
great struggle against the traditional image of human
thought as something surveying the world from a detached
eminence of its own, that is to say, against the "spectator"
theory of the mind attributed by Dewey to the historic con-
nection between intellectual pursuits and aristocratic leisure.
What he saw instead was a resourceful organism, dwelling
in the midst of reality and forever redefining itself as it
gauged the character and demands of oncoming events.

Most sociologists looking at such a philosophical prospect
would find nothing in it to alienate their relativistic and
secular standards. As an instrument for investigation, on the
other hand, they might find it, as they do most *philosophies,*
either too schematic or too grand. After all, it is the particu-
lar badge of sociological theories of the mind that they place
the mind's work within a collective situation to be under-
stood in its concrete complexity. It is, however, unlikely that
Dewey would have acknowledged this as an argument count-
ing him out of the sociological camp. In many cases the
social emphasis of his work was chiefly contained in the ad-
monition that education and the art of thinking should
train men for co-operative tasks, and not merely enrich and
adorn the person, as the traditions of honorific individualism
demanded. But the social teacher did not exclude the social
theorist. In a language which almost duplicates William
Sumner in *Folkways and Mores,* Dewey upheld the reality
of social customs as facts whose force was "comparable to
the momentum of physical objects once they are set in mo-
tion, and the resistance to movement possessed by the same
object once they are at rest." [6] And, in the best anthropolo-
gical manner, he based this belief on the assumption of a
human nature capable of hardening into structure around
any given body of social inheritance. It is from this psy-
chology of custom, aided perhaps by the influence of cultural

historians like Spengler, that Dewey may have derived his explanation of the specific social characteristics of art. At the beginning of *Art as Experience* Dewey's attack on handed-down aesthetic judgment insists only on the link between aesthetics and experience. Later Dewey adds that art is, in the largest sense, a social phenomenon and that men should understand it as a manifestation of their *collective* spirit. Whole societies, and not individuals alone, could be the agents of experience in his sense. Such terms as Negro, Gothic, Chinese, or Greek art, were not simple labelling distinctions. They stood for the "veridical significance" of culture as a collective individuality capable of producing art forms.[7]

As with others of his books, Dewey's *Art as Experience* is written in a taxing style, tangled by superfluous devices, and always moving with stubborn and meticulous artlessness. And the paradox is, of course, that, as in all of his other books, the tortuousness of Dewey's academic manner is exercised in behalf of philosophical plain talk. In this respect *Art as Experience* is not only a professional treatise but a cultural document: an expression of intellectual preferences by a man who, like others of his time, wanted to find a poetic, moral, and psychological language for the deep historical strain of American pragmatism. For, even from the distance of its professorial prose, Dewey's admiration for the hardy glamour of makers and doers inevitably suggests the utilitarian rhetoric of Carl Sandburg's *Chicago,* just as his rejection of the leisure class tradition recalls Thorstein Veblen's belief in the inner law of craftsmanship and the righteousness of efficiency and engineering.

However, it is one thing to speak of Dewey as the philosopher of the workaday world—or, perhaps, as the American aesthetician of democratic productivity and its inner life—and another to evaluate his work as a method for the analysis

of art. Convinced as he was that aesthetics was an expression
of society, Dewey employed all of his philosophical industry
to bring it from heaven to earth, and in this sense *Art as
Experience* can be considered a declaration against solemnity
and snobbery, and the treatment of art as a kind of ideo-
logical narcissism ("the beauty parlor of civilization"). It is
obvious, on the other hand, that there is very little analytical
profit to be derived from something so sketchy and overex-
tended as Dewey's view of culture. No one who spends a
moment remembering that the sheltered intellectuality and
orderliness of Raphael's art was produced in an age of daz-
zling political ruthlessness will be able to speak confidently
of the "veridical significance" of the Renaissance as a seam-
less historical event. And the same is true of the rest of
Dewey's cultural sampler: Gothic, Mohammedanism, An-
cient Greece, the South Seas, which is to say anything from
architectural styles to social-religious movements, historical
periods, and "culture areas." Only great haste would take
these bluntly miscellaneous illustrations as similar instances
of the kind of reality upon which art is thought to stand, and
one can only puzzle at the promptness of the great empiricist
in giving way to academic habit and embracing as facts what
he should have regarded as intellectual conventions.

A sound sociology of cultural life requires first an account-
able view of the social element itself. It should be imagina-
tive and resourceful but, obviously, precise and circumspect.
For centuries European literature rested on the narrowest
of cultural foundations: aristocratic patronage. But, though
literary creations of this period are stamped with their ori-
gins, they are not easily or manifestly labelled. The hand of
aristocratic favor did not turn all of literature into a series
of gestures of class adulation. Some writers looked at princes
and noblemen as creatures with a capacity for moral concern
and moral resolution immeasurably beyond the spiritual

powers of most humans: to great men great duties and great sorrows. But others devoted themselves to that formalized sentimentalization of the game of love which provided so much of the reading of fashionable *salons*. The essential feature of aristocratic literature was something more general. It was, Tocqueville said, the link between traditional power and artistic craftsmanship and the way in which this alliance made possible the perpetuation of certain concerns of taste and imagination. One of these concerns was the careful regulation of style by an audience with leisure enough to nurse artistic perfectionism. Another was the promotion of what Tocqueville calls, in a particular sense, poetic, that is the suggestion of things marvelous and remote flowing from two social characteristics of the aristocracy: an inscrutable reverence for the past and the aristocrat's awe-inspiring personal and spiritual distance from the rest of men.[8]

It is not only the content of art that challenges the sociologist but the very nature of artistic expression. Art and literature may be reportorial, propagandistic, "subjective," "objective," explicit, implicit, personal, or social. But what makes them different from philosophical disquisition, ecnomic doctrine, political papers, and the observations of psychologists, anthropologists, and sociologists, is that they are, in a literal sense, creative and aim to bring into existence as concrete presence a world like life itself. The paradox is that this very intention of art as an act of expression makes of its analysis a constant intellectual gamble. Our need for a seen and felt sense of reality conspires only too easily with the convincing power of artistic creation to go beyond interpretation to passionate and ingenious misinterpretation.

The provocative ambivalence of this predicament will be made clearer by this quotation from Henry Berenger's *L'Aristocratie Intellectuelle*. "Men of genius," says Berenger,

"listen to the millions of little souls around them, then they themselves speak, and their voices are heard through the silence of history." [9] This is, of course, a mythological statement, however flattering to the intellectual's occupational fondness for the presumed powers of the mind. Still, we must recognize the inverted truth hidden in it. Creative intelligence does furnish the voices heard in history because of its overriding wish to reveal, to affirm, and above all, to cast understanding into an unmistakable legacy of expression. We are, therefore, perennially beset by the fact that what we assume to be the meaning of the lives of most people comes to us from the words and the images of the few. The others, those whom artists paint and write about, are the voiceless ones. We choose to think that they are voiceless *because* they cannot tell us what they are and that the artist speaks *because* he can tell us about others what they cannot themselves say. In other words, we concede to the act of communication itself the title of reality.[10]

This is in many ways an unavoidable decision. It is also a sensitive question and another example of the kinds of problems that cannot be met by any of Dewey's methods. Panoramic conceptualizations about culture will only reduce the social element of creativity to a simplified romance between the "people" and "their" art and works of art to the stature of ideological posters. Needlessly, too, it denies art much of its real autonomy, even at the price of confusion since, as we shall see, a forced choice between the aesthetic and the social meaning of art may be not only false but sociologically misleading. For instance, speaking of the Parthenon, Dewey tells us that we might better understand this monument by turning away from the building itself to look at the "bustling, arguing, acutely sensitive Athenians with civic pride identified with civic religion," who built it, he says, "not as a work of art but as a civic commemoration." [11]

This is a statement that wavers between the deceptive and the erroneous. Of course Athenian religion was civic. But if the Parthenon was intended as a public gesture and no more, why did Pericles and the Athenian assembly entrust it to a notable architect and a famous sculptor? The answer is simple and denies nothing to the pride and sensitivity of the Athenian citizen. The Parthenon tells us something about the Athenians, not aside from its being a work of art but *because* of it. Which is to say that we understand the Athenians better when we know that they wanted their civic temples to be monuments of great beauty.

In a general way Dewey acknowledges that to speak of art as a representation of reality is not a simple matter when he says that photographic reproduction in painting is not art, nor is tramping through a museum art appreciation. These statements are true. How could they *not* be? For unless Dewey is attacking simple-minded "realism," or the unthinking hunting expeditions of sight-seers and culture-vultures, they say nothing that a sensible person would not easily take for granted. The same is true of his remark that an artist does not approach a subject with an empty mind but through subtle affinities between the subject and his own experience as a "live creature," which cause line and color to assume one pattern rather than another. Since experience teaches us that different artists work differently, the statement is both unimpeachable and unrevealing. Whether the artist approaches his subject with or without an "empty mind," however, is a matter which may be simply beyond our reach. For nothing would seem harder to reconstruct than the specific psychological history of a work of art, that is, the sequence of intellectual and emotional promptings (deliberate and unconscious) leading to its creation.

If there is an issue here, it is to be found in the meaning of the familiar expression "live creature." Does it mean that

we must put aside a purely spiritualistic view of art or avoid a capricious and empty mannerism in our tastes? And would not the men guilty of these tendencies be live creatures all the same? In short, what human being that is breathing and moving is not a "live creature"? The only answer seems to be that this term, like "experience," is not neutral but what Dewey himself calls "emotional." That is to say, a term presented as descriptive but really pledged to some subsurface preference. Dewey argues for a wholeness in man's intellectual, moral, and aesthetic experience, recalling the Greek view that good conduct was graceful, and graceful conduct good. Our morality, he says, is the product of dogmatic artifices and induced anxiety, and, for that reason, inharmonious, struggling, ragged, or in one word, ugly. But, however we may decide on the intellectual comforts of proper conduct, the application of such a view to art would mean that anything is artistic that creates well-being, is the product of well-being, or is capable of "conflict-resolution." This would be a difficult theory to document indeed. Mozart sometimes knelt in supplication for creative strength. He also had a bawdy sense of humor. But his music flows with a feeling of unchecked ease and purity, wholly and perfectly "composed." And, looking at the other side of the matter, we might ask into what realm of comfort and balance is the mind cradled by Goya's sketches, or by the paintings of Hieronymus Bosch, bristling with mystifying fears and laden with the rot of human venality as these are? In other words, what is a resolution of conflict to the artist, in the sense that he finds the form to state the problem, may be only the beginning of conflict for the viewer, who finds himself challenged by the power of the artist's statement.

It was nevertheless Dewey's intention to judge artistic success as part of a symbolic accommodation to the surroundings, including, of course, the social surroundings. "Inner

harmony," he says, "is attained only when, by some means, terms are made with the environment." [12] And reading further and more closely we find that, in a social sense, the significant terms of the environment are not just events, the inescapable conditions of human life, or in a large sense, experience. They are "the normal processes of living" and what is "characteristically valuable in the things of everyday enjoyment." [13] Meaningful aesthetic expression, Dewey adds, depends on the development and accentuation of a continuity between these realities and art. The answer to what the artist as a "live creature" might be is, then, clear. He is someone who makes creative use of the characteristically valued and enjoyed normal processes of living.

Curiously, when Dewey discusses form as such he contradicts some of the things he says when he discusses social content. He quotes Henri Matisse on the emergence of form through the building of balanced relationships of color. He also recalls an illustration from Max Eastman's *The Enjoyment of Poetry* which runs more or less as follows. A number of men are riding the ferryboat between New Jersey and New York City. Some of them must go into New York and pass the time of the trip as best they can. One man, a real estate agent, tries to calculate the value of the land from the height of the buildings. Another, who is on his first journey to the city, is excited but bewildered. Somewhere on that boat one man may be looking at the buildings as colored and lighted masses in relation to one another. He, says Dewey, sees aesthetically, "as a painter might see." [14]

This rings a note of unexpected and remarkable aesthetic purism. Dewey says nothing about civic or public character, as he did in the case of the Parthenon, or about the social or institutional significance of the buildings. For that matter it does not occur to him that art has *also* been created to express excitement, sudden experience, and the glorification

of wealth. The reason is that Dewey is engaged here in show-
ing that form, as "an operation of forces that carry the ex-
perience of an event, object, scene, and situation to its own
integral fulfillment," is true of art as it is true of all experi-
ence. Form makes experience possible, because it gives ex-
perience structure, articulation, and a point of resolution.
It also determines the basis of expressive adequacy. "If the
matter is of a jolly sort, the form that would be fitting to
pathetic matter is impossible. . . . In comedy a man at work
laying bricks while dressed in evening clothes is appropriate;
the form fits the matter. The same subject matter would
bring the movement of another experience to disaster." [15]

These generalizations show Dewey's unwittingly stubborn
tendency to simplify art for the sake of a point of theory. Of
his statement about the over-dressed bricklayer as an alterna-
tive form of expression one can say that it is genuinely in-
comprehensible. What *else* does Dewey have in mind that
can be expressed by a man in formal clothes laying bricks?
What *is* the subject that would upset another experience?
Comicality as such? The man laying bricks in a frock coat?
The scene is not the formal expression of a funny subject
matter. *It* is funny. In another sense Dewey does not seem to
realize the complexity of his own suggestion. Is the funny
always "funny"? Dewey's little fiction evokes Chaplin, but
with Chaplin such a situation would pantomime the spec-
tacle of desperate straits and absurd pride, which is more
than comicality, or at least, any easy notion of it. Is a Wat-
teau clown self-effacing, accusing, or just an innocent fool?
It is certainly wistful, which might mean all three. Dewey
says that if the matter is jolly it could not take a pathetic
form, and he would no doubt maintain the opposite as well.
But, obviously, neither is true. Oddly, Dewey writes as if
there were no such thing as irony. The very greatness of
Don Quixote, as a work of art and of thought, depends on

our inability to separate the comical from the tragic. What makes Kafka so depressing is that he regarded what he had to say about the human condition as a joke.

Dewey's arguments about form are inseparable from his attacks on the nineteenth-century concept of sensation. In an early article on the theory of stimulus and response, he showed how the character of an observed object, and the character of the action toward it, were one with the nature of the complete experience. Or, as he put it, that impulse is not just discharge but must have medium and form to become expression.[16] These are important observations in the sense that they dispel systematically a false proposition. They are also a demonstration of the power of precise intellectual schemes, like the stimulus and response theory, to confound the testimony of reality, since all experience, social, aesthetic, and intellectual, shows that human acts are inseparable from a condition of quality and a means of expression.

"Perceptions fall into the brain rather as seed into the furrowed field. . . . Each image breeds a hundred more." These words of Santayana, quoted by Dewey, are not only true but inescapably true. And Dewey should certainly have assumed this of art, for if art is not an expressive medium and an act of form it is nothing. Dewey was right in insisting on the aesthetic quality of daily acts (we should happily concede that good pitching is a beautiful thing). But the essential point left undecided is whether there is no distinction between the aesthetic and the artistic. The distinction is important because of Dewey's unspoken assumption that the closer one is to a direct aesthetic experience the more social that experience is, and that the more social an aesthetic experience, the closer it is to artistic expression and form. If one is thinking of the aesthetic aspects of a collective ritual, such as tribal singing and dancing, aesthetic feeling is, of course, indistinguishable from social feeling. But Dewey

might have recognized that even popular aesthetic traditions
of our society, such as the contemplation of nature, may be
cultural properties and private practices which depend for
their meaning on the individual's belief that he is the subject
of a solitary experience. It is true that Emile Durkheim, who
described so well the rituals of collective feeling in *The
Elementary Forms of Religious Life,* thought that even the
supreme act of loneliness, suicide, had social causes. But
Durkheim did not deny the reality of individual emotions
as a concrete experience. To deny this would be to deny in
life, and in art, the presence of intimacy, fantasy, or personal
sensuousness, anger, and love. Dewey ignores this possibility
because he tends to think that all psychological energy, at
least all meaningful and real psychological energy, flows to-
wards the environmental "others." This makes it difficult to
imagine examples of art based on common experience which,
according to his formula, would not result in some form of
popular or folk piousness. Would Ernest Hemingway, Mark
Twain, or Ring Lardner be instances of the social artist?
They all turned to popular life, and Hemingway was, if
nothing else, concerned with Experience. Yet Hemingway is
fundamentally a romantic writer whose fishermen, boxers,
and bullfighters are really heroes of transcendental daring
for its own sake. As for Twain and Lardner, one wonders
what in them would have been the social *function* of litera-
ture, since they were both native-grown iconoclasts, un-
moved by the edifying preoccupations which dominated
Dewey.[17]

If we cannot accept that experience is always, in Dewey's
particular sense, social, what will make it so? The answer
would seem to be art, which, by removing aesthetic emotion
from the realm of direct experience and giving it formal ex-
pression, makes it communicable, that is, social in a true

sense. Not only that. Contrary to what Dewey assumes, art is also capable of giving aesthetic values (in his sense of a meaningful life-experience which resolves a human question) to something that is not aesthetic in actuality. To have to listen to the barbershop conversation in Lardner's *The Hair-cut* would make anyone desperate with boredom. But reading it we feel the boredom only as a structured and synthetic image-idea, that is, as a symbol. We know that both the teller of the story, the barber, and his subject, the town's practical joker, are insufferable bores. But we are not ourselves bored because of the formal powers of expression of the artist.

Dewey's psychological populism seems a notably well-meaning view today if we consider the world-wide surfacing of the masses' capacity for the glossy, the ingeniously fraudulent, the stereotyped, and the transient, or the post-traditional wave of philistinism in changing societies whose passionate goal seems to be to embrace the consumption tastes of industrial societies, no matter how frivolous or how ephemeral. Neither can one forget that among the art forms dedicated to the "things of everyday enjoyment" none are more conspicuous than the anecdotal prints and reproductions hanging in countless living rooms. This might seem to invite an unfair inference, since Dewey intended his philosophy as a technique for *dealing* with problems, and the avoidance of problems is the first canon of kitsch and sentimentalism. Besides, someone will say, there is plenty of art which is topical and also great. To the first the answer is that, while no one will want to accuse Dewey of advocating calendar scenes as aesthetic models, his persistent talk about "normal processes of living" happens not to be the strongest argument against them. To the second one can only say that great descriptive art, great in a formal sense *and* as an expression of a "life-experience," has been created under an

infinite variety of personal and social circumstances, normal and "abnormal," if for no other reason than that art is precisely what Dewey said philosophy ought to be: an endeavor dedicated to the apprehension of meaning rather than the discovery of "truth." [18]

7 · Cultural Dreams
and Historical Frustrations
in Spanish American Literature

Spanish America has always appeared to many as the very model of the foibles and travesties of the tropics: an impressive but unsanitary wilderness peopled by a picturesquely unsound society and dominated by histrionic and savage politics. It could only appear unlikely, as well as amusingly perplexing, therefore, to discover that there too, as among the triumphant societies of the Western world, Britain, France, or the United States, men have spoken of the historical destiny and the special spiritual gifts of their countries and civilization. This, however, has been and continues to be, passionately, the case.

Two words are employed in the Spanish-speaking countries of this hemisphere to refer to their civilization. One is descriptive, explicit and refers to the facts of history, anthropology, and the social psychology of mores and politics. Indeed, it presisely translates the English term *Americanism* which, according to Webster's Dictionary, refers to American customs, singularities of speech, and to a devotion or preference for American traditions and ideals. But the air changes as soon as one tries to grasp the intentions of an-

other, more elusive, but also more momentous term—*Americanidad. Americanidad,* "Americanity" (one must contrive the equivalent), is not related to the concrete historical, political, or sociological stamp of Spanish America, or to any fact within the reach of linguists, ethnologists, folklorists, or literary critics. It is not even a signpost to some *je ne sais quoi* evoking the effect or ring of Spanish America as a social spectacle, aesthetic image, or "culture personality." It is not one actuality but a felt *presence.* An ultimate reality which events echo and toward which they move. A force pressing, so to speak, from behind time and into the future, driving the gamut of Spanish American experience into the mold that will make of it a finished historical and spiritual edifice.

A number of Spanish American writers have been touched by the rhapsodic historical speculations of Count Keyserling and Oswald Spengler and, more recently, by existentialists like Martin Heidegger, from whom they have adopted an untiring responsiveness to words like "Being" and "Non-Being," which they use within a peculiarly arranged system of intuitions and suggestions. And it would be easy to imagine that the tone of books like Emilio Uranga's *Análisis del Ser Mexicano*[1]* is to be explained by such influences; disdaining sociological, anthropological, or historical considerations, Uranga moves at once into the language of metaphysics in order to distinguish between the "substance" and the "accidents" of "Mexicanity" by means of the "ontological" method. Actually, however, the taste for high implication and vast cultural prophesy is an old one in Spanish America and, indeed, in its earliest examples, returns us to the life of Simón Bolívar himself, linking the vision of America to

* The title is, of course, typical. Uranga does not speak of the "culture" of Mexico or even of its "national character." What he seeks is its "Being."

the legend of the *libertador* in a characteristic scenario of incandescence and revelation.

When Bolívar, as a wealthy twenty-two-year-old colonial making the grand tour of Europe, visited Rome in the company of his tutor Simón Rodríguez in 1805, he found himself one summer evening looking down on the city from the side of the Aventine Hill. In the spirit of retrospection and musing almost *de rigueur* in such a setting, he and his teacher sat at the base of a fallen column talking of the ancient world and the new. Suddenly, according to Rodríguez, Bolívar stood up and "breathing heavily, his eyes glistening, his face reddened, almost in a fever," swore "by God and by my honor" never to rest "arm or soul" until Spanish America had been freed.[2] The travails of history of course rarely make good on epiphanies such as these, and Bolívar did not in his later life blind himself to the realities of Spanish American society. Its fund of political experience, he thought, was thin, and its heritage of civic morality questionable and flawed. And though he wished "more than anyone else to see formed [out of the erstwhile colonies] the greatest nation in the world," he did not believe, at least as late as 1815, that this would ever happen. Still he could never abandon the fateful voice he had once assumed on the Aventine hillside. In 1824, having become President of the Gran Colombia* and Dictator of Peru, he called for a congress at Panama to launch a federal union of the new republics and wondered whether the Panamanian Isthmus, placed as it was between Asia on the one side and Europe and Africa on the other, might not have been chosen by history as the site of a future world's capital.[3] Later, in a letter to Simón

* The Gran Colombia was the name given by Bolívar to the temporary union of Venezuela, Colombia, and Ecuador created by him between the years 1819 and 1822.

Rodríguez, he struck the tone of the oracle and, in some sense, the mythologist of Spanish American civilization:

> Come to Mount Chimborazo.* Tread with daring foot the stairway of the titans, the crowned of the Earth, the invincible watch tower of the new universe. From its height you will gaze upon the miracle of terrestrial creation, and you will say: there are two eternities before me, the one that is past and the one [that] is to come, and this throne of Nature, equal to its Author, will be as lasting, indestructible, and eternal as the Father of the Universe. . . . In that declining world [Europe] you have seen but the relics and the remnants of an Old Mother. There she lies, bent by the weight of her years and her ailments. And here stands this Maid, immaculate and beautiful, garlanded by the very hand of the Creator.4**

Perhaps because of the early involvement of Venezuela and Ecuador in the wars of independence, and perhaps also because of the millenarian atmosphere surrounding Bolívar, and in part created by him, the first self-conscious portents of Spanish American civilization and its forthcoming glories are found among the writers of those countries. José Olmedo, an Ecuadorian poet (1780–1847), combined theatrical adulation of Bolívar with a vision of Spanish America as the haven of liberty. He borrowed in both cases from French artistic and intellectual models. His description of Bolívar as the young Achilles, rider of the storm, lightning in his eyes, victory flashing from his sword, reads like a transposition of the glorification of Bonaparte by painters like David, Gros, and Géricault to the literary cult of the New World hero. His conception of liberty as a creation of Greek and Roman antiquity was no doubt also inspired by the rhetoric of the French Revolution, though Olmedo rearranged the plot to make Spanish America, rather than Europe, its bene-

* Mount Chimborazo, in central Ecuador, is the highest mountain in northern South America.
** All translations from the Spanish are my own.

ficiary. Members of the Convention might have regarded themselves as the descendants of Brutus and of Cato, but for Olmedo, the rights of man, having first been born on the banks of the Eurotas and the Tiber, would now build their altars by the Rimac and the Magdalena.[5]*

Another heralding voice was that of the Venezuelan Andrés Bello (1781–1865). A prototype of the Spanish American self-made universalist, the *pensador*, Bello was a grammarian, a legal and classical scholar, and the founder and first president of the University of Chile. He also put his thoughts about America's place in the future world in two famous poems: "Ode to the Agriculture of the Torrid Zone" and "Call to Poetry." The first is a nature song of the tropics, a celebration of its fruits, and a didactic pastorale ending with this hope and admonition:

> Honor the fields, honor the simple life
> Of the farmer and his frugal plainness
> Thus there will always be in you
> A dwelling for liberty
> A bridle to ambition, a temple for the law[6]

The words have a vague Jeffersonian ring, a feeling of virtuous optimism one might think natural in a New World poet writing at a time of revolution. But they are actually closer to the classical idyll than to the American promise, since both in content and style the poem is a return to Virgil's *Georgics* with its rejection of the greed and vulgarity of city life and its idealization of the countryside as the home of piety and right living. Nevertheless we read at its conclusion:

* The Eurotas is located in Laconia, the site of ancient Sparta (evidently in Olmedo's school-book classicism all things Greek, Sparta included, stood for the tradition of liberty). The Rimac runs through Lima (Peru was the country where Bolívar fought the concluding battles against the Spanish armies). The Magdalena is the largest river in northern South America (where the wars of independence began).

Oh young nations
Whose head crowned with early laurels
Are raised above the astonished West.[7]

These lines take us into the "Call to Poetry" whose theme, like that of Bolívar's Chimborazo letter, is the unveiling of Spanish America as an historical creature, and which like it, is written in a tone of sumptuous, epochal presage. What Bello offers, however, is an expectation of dramatic splendor rather than social or political greatness. His impulse is essentially poetic and concerned not so much with the construction of a virtuous daily life as with episodes of aesthetic glory. In fact, the "Call to Poetry" is a document of lyrical anti-rationalism whose premises, both as literature and as ideology, are those of the European romantic movement. Bello too, like the great protagonists of that movement, thought that reason and an excessive civility would turn human experience and imagination to dust. And he felt that America, "the young bride of the sun and of the ancient ocean youngest daughter," a land of untried energy where birds sang an "untaught song," was the source of a life-feeling which Europe, spent by history and beholden to the barren orderliness of what Bello called "philosophy," could no longer sustain in all its flow and wholeness.[8]

With the Chilean Francisco Bilbao (1823–65) we come to what is without doubt the most dramatic and obsessive feature in all the visions of Spanish America's place and future: the literary idealization of the life of those countries repeated as a gesture of solace and reassurance before the march north of American social energy and economic and political power. Bilbao was an excitable and rather naïve *penseur* and grandiloquent historical theorist, as well as a poet, critic, pamphleteer, and political agitator. He was also a religionist of beauty in the nineteenth-century fashion, though he coupled this last posture with a democratic pas-

sion and trust in the masses rare among the aestheticians of
the period—at least in Europe. While some Spanish Amer-
ican writers have looked at the colonial past as heroic and
venerable, Bilbao regarded it with repugnance and resent-
ment; it was for him an inheritance of darkness, superstition,
and indolence which could only be stamped out by a great
social and psychological revolution. He wanted for Spanish
America the strength that came from political stability, and,
in this respect, he was something of an envious admirer of
the United States. He certainly had nothing of the polemical
bitterness so common among the Spanish American writers
of the Theodore Roosevelt era, and dispassionately com-
pared the orderliness and economic growth of North Amer-
ica with the chaos, poverty, and endemic despotism of the
South American countries. Indeed, he sometimes spoke of
Americans as the paragon of virtue, of their Puritan an-
cestors as "sublime," and of their country as the "new
Greece."

But his tone changed perceptibly after the American
annexation of Texas. The United States had exposed the
weakness of its neighbors with a show of force made possible,
of course, by the very social vigor and soundness that Bilbao
had so much admired. And, unable to deny this reality, he
turned, instead, away from the political shortcomings of the
Spanish American world to what he chose to regard as its
unique *cultural* claims.

> There lives in our regions something of an ancient and divine
> hospitality, and in our breast there is room for love of mankind.
> We have not lost the tradition of the spirituality of man's destiny.
> We love and believe in everything that unites. We prefer the
> individual to the social, beauty to riches, justice to power, art to
> commerce, poetry to industry, the pure spirit to calculation . . .
> we are of those who believe in art, in the enthusiasm for the
> beautiful regardless of the consequences. We do not see in this
> earth, the ultimate end of men. . . . It is this that the citizens

of South America dare to place on the scales next to the pride, the riches, and the power of North America.[9]

One well-known item from the romantic code book, the battle between imagination and material gain, spirituality and calculation, is easily recognized in these words. But there is more. The contest between creativity and the commonplace has taken historically at least two forms, one solipsistic and one communal. The first speaks of the creative *individual* versus the unfeeling masses. In the other, the scale of values still being the same, the protagonists become holy and unholy *societies*, soulful and soulless *nations*. Bilbao, a romanticist and a sentimental populist, sought to rescue Spanish America from its secular failings by giving the Spanish American *people* a special role in the stock literary war between the artist and the philistine, that of the collective hero of sensibility, and by portraying the whole of Spanish American society as a loftily poetic, even engagingly bohemian civilization.

This conception flows into the language of political struggle in the writings of the Cuban patriot José Martí (1853–95). As with so many other Spanish American figures of the nineteenth century, Martí's career was pieced together from the most extraordinary miscellany of pursuits. He was a doctor of law, a magazine editor in Mexico, a professor of political science in Guatemala, and consular agent for a number of South American nations in New York. He was also an orator of celebrated emotional powers and a precursor of the so-called *modernista* movement in poetry. Historically, however, Martí earned his place as the unwearying "apostle" of Cuban independence for which he ultimately died in one of the early battles of the Cuban war.

As a political figure Martí was steeped in the nineteenth-century cult of genius, of the man who could foresee in detail what others could only anticipate in outline and

whose intuitive powers made him the unerring servant of historical forces. Furthermore he did not hesitate to apply this principle to himself, describing his own voice as that not of an individual but of a people. And since such theories inevitably envision the great individual not just as the instrument of collective wishes but as the vehicle of ultimate destiny, it is not surprising that Martí thought of the Spanish America for which he spoke as fated for nothing less than an epic future. Addressing a literary gathering in New York in 1889 he said:

> Our America, resourceful and indefatigable, triumphs over all obstacles, and her standard rises ever higher, from sun to sun, by the power of the soul of the land, harmonious and artistic, created out of the music and the beauty of our nature. . . . This is so because of the millennial power with which this natural order and greatness has overcome the disorder and meanness of our beginnings. This is so because of the expansive and humanitarian liberty, above place, race, or sect, which came to our republics in their seminal hour . . . a liberty which, perhaps, finds no dwelling place so generous as this. Would that my lips were branded by the fire of what is to be! For our lands are being readied boundlessly for honorable effort, loyal solicitude, and true friendship.[10]

One may see in this statement a version of the "American dream," as the expression is used in the United States. An expectation, that is to say, of an embracing humaneness granting liberty and asylum to all, irrespective of social ancestry or condition. But there is also a rhapsodic ambiguity, a mingling of wish, sentiment, speculation, description, and exhortation totally beyond unraveling, which one learns to recognize as characteristic of Spanish American cultural theories or, rather, illuminations. There is too, the peculiarly Spanish American aesthetic posture. The insistence on the promise of those countries, not only for social justice but for artistic fulfillment. The belief that an original civilization can be no less than a dramatic miracle. And

there is something else. Bello had invited contemporary civilization to surrender itself to the uplifting powers of American nature. Bilbao thought he saw in the American republics the emergence of a fraternal sociability. But Martí portrays these historical and psychological virtues as emanations of the "soul of the land" and thereby anticipates the mystical doctrines of geographic determinism to be found in later literature.

In this climate, a composite of artistic emotions and cultural self-congratulation, it was perhaps inevitable that certain writers, like the Nicaraguan poet Rubén Darío, should have been tempted into a restaging of Spanish American history as a pageant of lustrous moments and opulent vignettes. Although Darío (1867–1916)* was of Indian ancestry, there is nothing nativistic in his personal and literary tastes. He was a disciple of the French symbolists, lived mostly away from his own country (Paris, not Managua, was his chosen home), and was as conscientiously cosmopolitan and unprovincial as only a provincial can be. His poetry suggests a curious revival in an obscure ex-colony of the aristocratic spirit of Watteau's paintings. It contains the same aesthetic glorification of the luxurious garden party, the same atmosphere of mannered eroticism among marble and satin surroundings. Darío's own circumstances, however, were never so genteel. He spent his youth dragging himself through years of itinerant work and could not have survived later without such friends as the editors of the Buenos Aires daily *La Nación* who, by making him a "foreign correspondent," virtually subsidized his long stays in Europe. He finished his life as an impenitent alcoholic, an exhibit on

* I include Darío as a cultural imagist. But it should be mentioned that he has an eminent place in the history of Spanish (not only Spanish American) poetry, being regarded as the great divider between traditional and contemporary poetic styles in the language.

the lecture curcuit, and the personal charity of the Nicaraguan dictator of the day.

The discrepancy between Darío's life and his poetry should be mentioned as the parable of a reality larger than either. For both his anti-Americanism and his role as a cultural propagandist were dependent on an intellectual posture which could not separate a diabolical image of the United States (a country about which he probably knew very little) from a convenient ignorance of the uglier truths of his own society. Darío's poetic world, a realm of swans, Versaillesque gardens, colonnades, aristocratic plumes and swords, and glossy renditions of classical mythology, could only have been constructed by someone in full flight from his own original surroundings. When his imagination turned toward Spanish America, moreover, it did so by refashioning its history into a medley of elegant cultural episodes which he then contrasted with the sweaty and sordid pragmatism which Darío, like others, devotedly imputed to the United States. These are the final words of Darío's ode to Theodore Roosevelt (a poem in which he speaks of Americans as worshipers of Hercules and Mammon, and of their famous president as part pagan tyrant, part Asiatic despot):

But our America,
The one who had poets since the old Netzahualcoyotl,
The one who, on an ancient day learned Pan's alphabet,
Who consulted the planets that Atlantis knew,
Atlantis whose name since Plato's day has echoed
Through the centuries.
This America, since the first of its days,
Has lived of light, of fire, of perfume, of love,
The America of the great Montezuma, of the Inca,
Fragrant America of Christopher Columbus.
This America . . . Man of Saxon eyes and barbarous soul.
This America lives.
And it dreams, and it loves and is vibrant.

She is the daughter of the Sun.
Beware. Spanish America lives!
The Spanish lion has a thousand cubs.

. .

You have everything but one, God.[11]

It should be clear that this cry is motivated not by political and social indignation but rather by what Darío considered to be the nature of the cultural question. One of the obvious features of the poem, borrowed in this case from stock European affectations about the "barbaric" North, is a crudely romanticized element of racial pride. "Saxon eyes" and a primitive soul are regarded as one and the same thing, while "Spanish" is presented as a self-evident epithet signifying spiritual high caste. As in Bilbao and Martí, we find in Darío a belief in the bounty of sentiment which is somehow a part of the lives of the Spanish Americans: what he broadly calls "love." But while in the other writers this idea carries the implications of a fund of humane and brotherly passions, in Darío it appears as an effusion of enthusiasm for its own sake, not unlike that unspecified gift for sensitive and imaginative responsiveness which he calls "vibrancy." In other words, while previous writers had been Hugoesque, Darío might be called Baudelairean. When he says that Spanish America "dreams," he does not mean it in the sense of historical, social, or even cultural visions, but literally in the sense of the "dreamer," casting all of Spanish America, as Bilbao had, in the romantically admired role of the impractical man. Clearly, and for the same reason, Darío's title of "energy professor" for Theodore Roosevelt, reflects the contempt of the nineteenth-century aesthete for all busyness and utilitarianism. The vitality and stateliness which other writers had found in Spanish American values is transmuted by Darío into such evanescent properties as "light," "fire," and "fragrancy." As for his appeal to Catholicism one has

the impression that it is put forth as a means of evoking an atmosphere of ceremonial pedigree: a matter of beckoning cupolas and mysterious tabernacles rather than any serious religious concern.

In Darío's ode to Roosevelt the literary vision of Spanish America as the poet-continent and North America as the national embodiment of the successful bore may have been given its classical formulation. The Hispanic countries, prostrated by poverty and political ineffectualness, could always take consolation in their devotion to *l'art pour l'art,* while the United States, heavy with wealth and power, lay, nevertheless, under the curse of dullness and greed. Andrés Bello had spoken of Spanish America as a new arena for dramatic historical behavior. Bilbao, in words echoing with the rhetoric of modern social piety, looked upon Spanish America as the home of "divine humanity." In Darío all of Spanish America, past, present, future, substance and expression, has become inextricably "poetic" and, therefore, wholly "divine." God was on the side of the "Latins."

The man who, with Darío, dominated Spanish American poetry in the early twentieth century was the Peruvian José Santos Chocano (1875–1924). In the tradition of the great egocentric freelancers and colorful intellectual opportunists, Chocano served as occasional diplomat, public relations man for a Central American dictator, and reputedly, agent for Pancho Villa in the United States. He also murdered a literary rival and was himself gunned down while riding a streetcar in Chile. Writing in the preface of Chocano's first book of verse, Rubén Darío called him "the muse representative of our culture, of our modern Spanish American soul," which happened also to be Chocano's own view of his life and work. He looked upon his personal willfulness and bombast as sparks flying from the wheel of some vast historical force, and regarded his imagination as, in his words, a vortex where the

"fancies" of the Iberian Moors, the passions of Spanish "blood," and the echoes of Inca history eddied and whirled.

Chocano's great aim was to create the kind of gorgeous lyricism and epic intonation capable of speaking poetically for the "romance" of Spanish American history, and for its rivers, jungles, prairies, and exotic populations. In his prose writings—chiefly as a raconteur of travel experiences and literary camaraderies—this manner resulted in nothing more than an annoying and embarrassing failure. He seemed unable to separate description and style from artifice and posturing; in his *Memorias,* for example, he never rises above a clutter of pseudo-sensitive observations and indiscriminate phrase-making. As a poet, however, he could make his verse swell and ring, even though, save for the best of it, he always seems to leave the reader with an uncomfortable sense of ephemeral agitation. Yet Chocano is a representative writer. Representative, that is, of the cultural fears and boasts as well as of the epiphany-like visions of fulfillment recurrent in Spanish American literature. His poetry is in part a gesture of racial and spiritual pride thrown in the face of North American potency and success. It is also underlaid with trepidation and self-doubt of the kind that can only be quieted by avenging dreams.

Unlike Darío, who was so obviously an escapist writer, Chocano was at least sensitive to questions of public power and its distribution in the Western Hemisphere. His political ideas are a fabric of blithe aphorisms, often dictated by personal predicament and convenience. But he wanted for Spanish America the things of the modern world: highways, schools, productivity, railroads, exports, a solid currency, and unassailable sovereignty. He was also a continental nationalist, dreaming like others of a union of the Spanish-speaking countries. Yet, curiously, he regarded the latter as imperative because of a profoundly negative view of the

Spanish American people, who appeared to him as "sick," verbose, will-less, and racially predisposed to excitability, ineffectualness, and credulity. Such conclusions made him look favorably upon dictatorship as a way of getting things done and upon revolutions as a means of shaking the Spanish Americans out of their social torpor. They also explain why he put so much reliance upon the primitive force of Spanish American nature, rather than the people, as a bulwark against the thrust of the United States. In a poem entitled "The Epic of the Pacific" he writes of the planning of the Panama Canal:

> Let us distrust the blue-eyed man
> When he attempts to steal from us
> The warmth of the home-fire
> With his buffalo blankets.
>
> .
>
> But let us not weep over a future conquest.
> Our jungles will not acknowledge a master race.
> Our Andes disdain the whiteness of the White.
> Our rivers will laugh at the greed of the Saxon.[12]

As a reception for the blond intruder Chocano also promises miasma, fever, swampland, reptiles, and the fire of the tropical sun. In any event, though Americans might *pay* for the Canal, they would never be able to cut the Spanish American soil with their own hands. This could only be done, Chocano chose to imagine, by dark-skinned West Indians or by a Spanish American populace metaphorically transformed by him into a glamorously eclectic Mediterranean breed, which he described as follows:

> The builders of the Pyramids,
> Of Alexandria's lighthouse
> Of the Temple of Jerusalem
> Those whose blood was spilled
> On the Colosseum's sand.[13]

The poem, one should remark, represents a departure

from earlier views of Spanish American nature and its role in Spanish American civilization. For Bello this nature was crowned with nobility and such majesty and benevolent power that it beckoned an exhausted Europe to gain new life in its midst. Martí's "soul of the land" was a creative force which provided the leaven for the social and moral enthusiasm of the new nations. But Chocano's is a belligerent, punitive nature, a trap awaiting an antagonist whose human powers cannot be humanly overcome. As in Darío, there is in Chocano a measure of racism, not excluding a considerable catalogue of racial clichés, used both as historical explanations and as props for his many-sided self-infatuation. For instance, he attributed his taste for the fanciful to the Andalusian origins of his father (this is not only a racial but a cultural cliché which assumes that anything related to the Spanish South is congenitally precious and charmingly capricious). His taste for hard work (*really* a fanciful claim) he attributed to his mother's Basque ancestry. And because he had had Negro and Chinese servants as a child, he declared his mind to have been afflicted by the "tormented sensuality" of the first and the "excessively refined" disposition of the second (one wonders how many Mandarins were brought to Peru to do coolie service in the late nineteenth century).[14]

On the whole, however, Chocano's racism, when applied to society as a whole, is a somewhat grudging one, based rather on animal pride in primitive endurance (in the face of the outsider's power) rather than on traditional beliefs about race as the biological instrument of reason, grace, and beauty. He was actually convinced that "pure" races were always more potent and creative, and sounded at times worried about the consequences of racial miscegenation in Spanish America. But, above all, he needed to reassure himself that the native would prevail on his own grounds and

inherit the land of which he was a creature, and that his vague Africans and theatrical Mediterraneans and Levantines, and not the blue-eyed Nordics, were intended to be the masters of the tropics.

Another feature of Spanish American cultural prophesies has been the search for a grand beginning. This is not uncommon in the history of national and cultural mysticism (the same is true, of course, of the belief in the powers of race and soil), since it provides societies as collective heroes with an episode essential to the hero's myth: a unique and mysterious birth. But the Spanish American version of this principle does hold a rather spectacular surprise. For either as a legend which invites acquiescence or as a suggestion of literal fact, some of the cultural seers of Spanish America have proposed to find the matrix of their countries' destinies in the ancient tradition of Atlantis.

We have already seen this in Darío, who alludes to the Lost Continent in the midst of a number of other glamorous historical evocations, from the god Pan to the Inca emperor. But a much bolder reference is made by José Vasconcelos (1882–1959), a Mexican *penseur*, author of approximately twenty volumes of philosophy, literary criticism, and history, at one time minister of education and rector of the National University of Mexico, and one of the cultural personages of Spanish America in this century.

Like others, Vasconcelos wrote of the discovery of America in a tone of echoing, transcendental intimation (but assuming, as we might expect, that this event related to the western Hemisphere only south of the Mexican border). He conceded that Columbus might not have been the first European to reach America. Yet he looked upon the traditional discovery in such a way as to let us conclude that the America that Columbus discovered was the America that history had intended to have discovered:

> [In] christening with the name of Indies those lands which are today ours, a breath of the same illumination which led him to discover new routes in the sea, Columbus raised himself to the conception of a new era of civilization, an era in which collective life was to crystallize in universal and definitive form.[15]

In any case, there were other more awesome signs to be read. Having discussed the possibility that America might be the Atlantis of the Platonic dialogues, Vasconcelos quickly moves to this pronouncement:

> If we are, then, ancient, both in our geology and in our traditions, how can we accept the fiction, invented by our European ancestors, of the newness of the continent which existed at a time when the land from which conquerors and discoverers came had yet to appear upon the surface of the earth? [16]

The statement, of course, willfully and egregiously misrepresents the conventional understanding of America's "newness," which has always referred to the Continent's relationship to Europe and never to its geological age. But by dismissing known events as an embracing rumor instead, Vasconcelos achieves a much desired effect. The creation of an aura of "metaphysical" and oracular pedigree which he, with others, believed should always envelop the history of Spanish America.

Vasconcelos's mythological tastes were strong but certainly no less melodramatic than his racial beliefs. For it should give anyone a start to learn that a man called "Teacher of the Youth of Spanish America" by the university students of the twenties could have been guided by the pastiche of racial fables found in Vasconcelos's *La Raza Cósmica,* a book in which Vasconcelos likened the ethnic mixture of Spanish America to the "profound scherzo . . . of an infinite symphony" whose themes contained "the abyss of the Indian soul, the black man's thirst for sensual happiness, the Oriental whose oblique glance [sic] makes

him see everything in unexpected ways, the Judaic strains in the Spanish blood [this is presumably self-explanatory], the melancholy of the Arab [also a Spanish inheritance] and the rationality of the white man whose thought is as limpid as his skin is clear." [17]

One can only speculate as to what appetite for cultural salvation could account for such spurious and hollow grandeur.* Yet Vasconcelos's ideas move within a characteristically Spanish American style concerning matters of race which could, perhaps, be given the name of positive racism. In the United States the tradition has been to argue that universal rights, irrespective of ancestry, are justified and demanded by the capabilities of all races to accomplish the same things. Or, stated in another way, that differences of behavior are due to social conditioning not genetic inheritance, and that equality should be granted to people of every racial origin because they are all (at present or potentially) equal *to* the tasks and duties, political, managerial, technical, or intellectual, of a rationally organized society. What has been maintained in Spanish America is that race *does* determine psychological and intellectual differences, but also

* It should be insisted, on the other hand, that Vasconcelos is only one among the number of "Latin" intellectuals whose social theories depend on some form of race-thinking, a group which includes social scientists such as the renowned Brazilian anthropologist Gilberto Freyre (1900–). In the preface of his *Casa Grande e Senzala*, the work on black slavery in Brazil that gave him his lasting reputation, Freyre announces that his studies under Franz Boas at Columbia University had emancipated him forever from racial explanations of social behavior. Yet in the same preface he speaks of the "Semitic tendencies of the Portuguese adventurers inclining them towards trade and barter." Later on he states that the truly typical style of Portuguese colonization was dictated by the patriarchal feudalism of the plantation system. The contradiction is obvious. The more significant thing, however, is that Freyre uses "Semitic," not as a psychological metaphor or even to describe the inherited economic traditions of a given social group, but as a genetic explanation of cultural practices. *Casa Grande e Senzala* (Rio de Janeiro: Mais e Schmidt, 1934).

that this is fortunate since it enriches the cultural variety of a civilization. The American view would have no use for the "abyss" of the Indian soul or the "obliqueness" of the Oriental outlook. The Spanish Americans, on the other hand, advocate racial tolerance, or better yet, miscegenation, because they assume that different races will contribute different perceptions of reality and different styles of "expressive behavior." Their racial doctrines, therefore, are rooted, as their cultural philosophy often is, in an aesthetic conception of social life, concerned with transcending gestures rather than the more "secular" and less "memorable" aspects of the "value system."

La Raza Cósmica attempted to create a great epic of promise out of the wedding of races on American soil. But among Vasconcelos's own contemporaries there were writers who, however proprietary about their culture, were suspicious or contemptuous of the nativist ethnic spirit. One of them was Francisco García Calderón (1883–1953), the author of another "classic" prognosis of Spanish American civilization, *La Creación de un Continente*. The mood of this book is a mixed one of apology and optimism. The apology comes from García Calderón's discomfort concerning the Indians and Negroes of Spanish America, whom he regarded as retarding influences. The optimism came from his hopeful and, as it turned out, erroneous prediction that the darker populations would be displaced, at least in the cities, by "those ancient [and] energetic races," the European immigrants.

García Calderón, who spent most of his life in France, was a spokesman for the Europeanized urban upper classes of his generation, intent on the fashioning of a society to which they could give their allegiance. And *La Creación de un Continente* may be called the work of a post-colonial sophisticate eager to dissociate himself from the colorful

indignities of tropical backwardness and to exhibit his membership in the consecrated values of Western culture. As a result García Calderón found himself tailoring convenient interpretations around the endemic presence of violence and disorder in Spanish American life. They were, he said, nothing more than the turbulence of a young and vital society still unsure of its way, adding to this the familiar romantic concept that the failure of practicality among the "Latins" was only the other side of their more lasting cultural gifts. As with the man of genius who will on occasion squander his talents, turmoil and confusion were the price of Spanish American "artistic sensitivity."

But, perhaps, most revealing of all is that, despite his "sociological" intentions, García Calderón could not escape the language of the visionary tradition. He had hesitated between pride in the New World and subservience to the Old, but toward the end of *La Creación,* having resolved all ambivalence, veers suddenly into an oracular *fortissimo* which, sweeping without pause through the theory of evolution, Nietzsche, Virgil's *Eclogues,** Plato's Atlantis (again), and the "Seer of the Caravels" (that is to say, Columbus) brings us to this conclusion:

> Perhaps she [America] has been destined from the beginning of time to give birth upon her wide plateaus to the Child of the Sun,

* García Calderón's reference is undoubtedly to the Fourth Eclogue which reads in part:

> Come to the last of the Ages,
> In song Cumean foretold.
> Now is the world's grand cycle,
> Begun once more from old.
> . . .
> Now from the sky is descending
> a new generation of men.

What Virgil had in mind when he wrote this poem has never been settled.

as in the imperial legends of the Incas. To the master of proud mountains and venerable rivers. To Superman, solitary and irresistible.[18]

The willingness of Spanish American intellectuals to let their imagination dangle between historical recollection and symbolic spell appears once again in Alfonso Reyes (1889–1959). Reyes, professor of literature for many years at the National University of Mexico, was an extraordinarily fertile writer and occupies a venerable standing in the world of Spanish American letters. But his learning did not prevent him from dipping, as fondly and fancifully as others, into the legendary past. Thus for example, in a section of his *Ultima Thule* entitled "Presages of America," * having reviewed the history, real, possible, or imagined of the contacts between the Old World and the New, Reyes settles the matter by affirming that, prior to its discovery, America was "sensed" in the dreams of poets and the glimmering of men of science, making herself "felt by her absence" before she was "felt by her presence" for, as he says, appealing to the language of pre-Socratic philosophy, a "world without America was a case of disequilibrium, of *hubris, of injustice.*" [19]

Now, Reyes does not say that the world *needed* something like America and that, therefore, its discovery was a fortunate turn of events for mankind. What he says is that America was an imminent "teleological" necessity leading to the completion of history or, as he puts it, to the filling out of its historical profile. Such an assumption (it goes without saying that Reyes is not bothered by the thought that the *geological* America just might not have been there

* It is probably beside the point that, applied to America, the antique evocation in Reyes's title aims, literally, in the wrong direction. *Ultima Thule* in pre-Christian tradition referred to the northernmost portions of Europe, possibly Norway, Iceland, or the Shetland Islands.

for Columbus to encounter) makes possible, not only the prediction of the future, but a judgment of the past and the present by its adequacy to the future since, according to Reyes, should America fail to bring to the world the happiness that the world has for so long desired, history would have no meaning. Yet, we are assured, history has meaning: "Passing circumstance, superficial shortcomings, may throw us off course for a year or a hundred years, but the main trajectory will remain undisturbed. The path of America is as certain as that of the planet." [20]

Still further consequences of this speculative style are found in the "idea" of America's discovery provided by another Mexican, Edmundo O'Gorman (1906–), whose acumen as historian of his country has received such praiseful notice in F. S. C. Northrop's *The Meeting of East and West*.[21] The most significant feature of O'Gorman's thesis is that he treats matters of fact, that is evidence relating to events, and matters of interpretation, that is philosophical generalizations about the meaning of these events, as one and the same thing. In most instances such a procedure would seem senselessly capricious and a failure of the most primitive demands of reasoning. But not if we conspire with the terms of O'Gorman's own exploration whose aim it is to unmask the "historical intention" of America as a world event, what he calls the "ontological" problem of it, for, in such a light, nothing unrelated to the discovery of the continent, however elusive or inconsequential in appearance, could be without "meaning." One by one O'Gorman dismisses as either irrelevant or pointlessly theoretical the known versions of when and how America may have been first encountered by outsiders. For the same reason he discards the notion that America might have been known by another name to the people of ancient times. The Platonic Atlantis is, for once, thrown out, as is the biblical land of

Ophir. The eighteenth-century view that the Discovery was an example of the world's march towards universal enlightenment is attacked as a piece of abstract universalism which deprives America of its concrete historical reality. Finally, and particularly, O'Gorman states that whether the traditional account of Columbus's voyages is related to intended or fortuitous events is in itself inconsequential.

It is easy to see that O'Gorman's quest points from the beginning toward what America *is,* aside from the date of its "discovery" or the origins of its name. In the face of this, the temptation of those unmoved by "ontological" considerations would be simply to say that America *is* a portion of land located within certain latitudes, first opened to modern travel by a (presumably) Genoese professional sailor in the pay of the Spanish crown, peopled by many races, and the site of a number of nations speaking different languages, having certain traditions (native and imported), facing certain prospects, confronted with certain problems, social, political, and economic, and possessing (presumably too) certain aspirations, also social, political, economic, etc.

But we can guess that O'Gorman would regard such a suggestion as naïve and schoolboyish. The question, as he puts it is this: If America was "discovered," does that not presuppose that it was a "discoverable entity"? [22] To put it this way, of course, means that the word "discovery" has been subject to a sudden metaphysical inflation, and we must stop to wonder whether O'Gorman could possibly intend to say that America, as a physical entity, would *not* have been discovered unless it had already and always been "America," a historical creature with an especial and appointed fate. This is precisely his assumption *and* conclusion, since "[the] idea that America is the continent so called presupposes the being of America." [23] America as geography, in other words, becomes an "expression" of America as

"reality." And the same, according to O'Gorman is true of all things and traditions connected with America. American philosophy, literature, or life itself are not American in *themselves* but presume the existence of a being of which they are a manifestation.

It would seem to some as if O'Gorman had merely chosen the most tormented and pretentious language for saying that this must be the place because if it were not the place, it would not look so much like the place. In any case, his way of evoking a sort of retroactive misplaced concreteness is well shown in the one version of the Discovery to meet his "ontological" approval. There is, among the tales connected with the life of Columbus, one, first reported by Bartolomé de las Casas, about an anonymous pilot who had been carried by storms across the Atlantic to the American shore and who had later returned to Spain after an extraordinary number of tribulations. According to de las Casas, Columbus knew the Anonymous Pilot, and what he learned through this acquaintance decided him upon the enterprise of 1492. O'Gorman concludes that this story alone represented "the truth of our elders" and held the key for an understanding of America as a "peculiar form of Being." [24] And the reason is, of course, that in it O'Gorman found, properly flavored with the taste of divination, a parable of destiny showing its hand. Indeed, what the tale of Anonymous Pilot really unfolds is, not the discovery of America by Christopher Columbus but the discovery by America of Christopher Columbus as the man that would draw the curtain aside to let history look upon its future.

This gift or need to keep the mind standing now on one foot now on the other, halfway between ideological wish and its consecration as fact under the banner of a higher reality, is present again in the writing of Ricardo Rojas (1882–), dramatist, historian, literary critic, university rector, and

one of Argentina's senior men of letters. Rojas is also a be-
liever in the "metaphysical forces" of racial inheritance and
the powers of the soil as a matrix of cultural energies. And
his terminology is nothing if not high-flown. A culture, he
says, is the product of two kinds of personalities, one in-
dividual, one collective, the second being a "metaphysical"
(once more) extension of the first; true cultures were the
expressions of such collective souls manifesting themselves
through time. Rojas had no hesitation in discussing the
"angelic numina" and "place gods" of nations, which in-
habited their earth, created the unity of their race, and
provided the continuity of their traditions and social types.
And he conceived of the entire history of Spanish America
in terms of the ebbing and rebirth of these energies and
spirits, present in their original impetus during pre-colonial
days, put to flight by the crimes of the conquerors and the
exorcisms of the Church, finding their voice again through
the founders of national independence, but assaulted in our
time by "the materialistic appetites of the immigrant and the
intellectual materialism of the men of science." [25]

In Rojas, therefore, we revisit the spectacle of Spanish
America as a harbor of indigenous sensitivity assailed by the
forces of shabbiness and greed. The threat, however, no
longer appears in the form of the outsider. Rubén Darío,
reared in an isolated and unchanging society, could only see
the challenge to his rather chic version of high culture as
coming from abroad, that is to say, from the Yankee. Rojas,
the citizen of a nation which had absorbed vast numbers of
immigrants and which early in this century had led all of
its neighbors in commercial and industrial development, was
compelled to discover that not the philistine ogre of the
North but the hunger for gratification among the newly ar-
rived in his own country constituted the great peril to cul-
tural dignity and grace. Rojas's opposition to what he calls

"materialistic science" is, of course, part of the tradition of modern literary hatred for all forms of utilitarianism, philosophical or technological. His more general attack on the secularity of modern Argentina, cn the other hand, is clearly directed against the egalitarian pressures, social and economic, the parvenu demands, as he obviously saw them, of the immigrant masses. His dream is pointed to the recovery of what he regards as an older and nobler communal spirit, and it is again formulated in the vocabulary of subjective and artistic values; he hoped that the gods of America would again return to infuse the people with "new aesthetic and moral forms." But it is clear that within this intellectual position there echoes also a social or even a political one and that Rojas's racial and geographical mysticism is a language with which to defend aristocratic, ancestral, and leisurely values and to resist the social new-comers, with their reputed acquisitiveness and opportunism, and their ignorance of older loyalties and venerable manners. In Rojas, then, the battle against materialism has become a domestic question. A cultural question, no doubt. But also a struggle between social classes, between natives and foreigners and country versus city.

The nature of this conflict, a product one might say, of the failure of Europeanization, as García Calderón had envisioned it, becomes wholly transparent in another Argentinian, Eduardo Mallea (1903–), a highly regarded essayist and novelist. In his intellectual autobiography, *Historia de una Pasión Argentina,* Mallea decries the dissolution of the "spiritual physiognomy" of his country under the drive for wealth and well-being of the immigrant numbers whom he condemns for their eagerness to grasp at the superficial, "visible" rather than "deeper" Argentina, even though he recognizes that they had come in flight from poverty and political oppression. But neither did he exonerate the new

Argentinian elites. He acknowledged the excitement and brilliance of urban life in Buenos Aires, but he saw something feigned, unsound, and even treacherous in it. An Indian in the fields, he said, was truly "cultured" because for him culture was a state of being, not an exhibited possession. The cosmopolitan man, on the other hand, despite his intellectual skillfulness, could never escape the temptations of a nervous yet bloodless faddism or, worse, the self-betrayals of opportunism. Mallea despaired particularly of the new leading figures of Argentinian life, the lawyers, doctors, teachers, academicians, the "cultivated public, all of them successful or merely pretentious, but no longer able to live like men, love like men, suffer like men, hate like men, have men's devotions, passions. . . ." [26]

Time and a different sensibility separate Rojas and Mallea. In Rojas, thinking and writing take the form of a conspicuous montage of social generalizations and cultural prescriptions. He views Spanish American history as a drama of the native soul divided in four acts: the Indian world, assimilated by colonial civilization; the arrival of the Spaniards, givers of the language and creators of the social forms; the colonial whites, who furnished the political style and the native artistic synthesis; and finally, the reforging of all these into a way of life at once national and universal. A large lesson in cultural reconstruction resting on vague, aphoristic, and questionable concepts and delivered in a momentous public tone. Mallea's *Pasión* is a more private record of experience. It is, in fact, that characteristic modern literary document, a story of self-discovery in the midst of a world which conspires to hide itself from its own sham. But the public facts both Rojas and Mallea lamented were, nevertheless, the same. The acquisitiveness which accompanies social mobility. The trading and bartering of cultural possessions. The corrosion of personal relations under the

rule of the marketplace. In other words, the spiritual conse-
quences of democracy. And the same is true of what they
wished to enthrone. The key to Rojas's concept of cultural
integrity was his theory of the social mind as an extension
of one supremely harmonious type of individual person-
ality.* Mallea sought a similar uprightness in what he called
the "deeper" Argentina, an Argentina capable of a "severe
exaltation of life," free from the shallow, wasteful impulses
of the present day. He found the model for such a calling
in the "natural" Argentinian man, the farmer and the
gaucho whom he envisioned as the "national monad" from
which all manifestation of cultural existence would arise "as
the foliage from the stem."

I believe that we must all agree with Donald Malcolm
when he says that what marks the pursuit of "identity" is
the inherent insatiability of the search. The inescapable
feature of the question "who am I" is that it cannot be
given a final or even a good answer.[27] It is possible to speak
of a man's biography, of his profession, of his interests or
social position, of his defects, virtues, problems, vices, and
aspirations. But if one is determined to look for absolutes
and ask what someone "really" is, the result will be at once
tormenting and elusive, leaving as the only means of re-
trieval the monistic bliss of some healing oracular sign
which says, "You are and you shall be."

As should be fairly evident, this concept, extended to the
whole of a society, is at the heart of the besieging rituals

* As is frequently the case with these theories, conformity between the
cultural model and its historical consequences is based on a circular prop-
osition. In order for a society to be a transcendental projection of indi-
vidual personalities, that is to say, in order for one social creature to emerge
out of the behavior of particular persons, individual minds must be re-
garded as so universally homogeneous, that one could just as well turn the
argument around and say that individual psyche is a metaphysical extension
of the collectivity.

(sometimes ordeals) of cultural self-discovery performed by Spanish American intellectuals. It is important, therefore, to consider somewhat more closely the manner in which such an anguish burns and such a passion for certainty operates. Two models for this are provided by the contemporary Mexican writers Samuel Ramos (1897–1959) and Octavio Paz (1914–). According to Ramos:

> To say what Mexican culture is *like* . . . we must naturally select materials that reliably represent the object of our examination. But in order to identify this object . . . it would be first necessary to know what constitutes Mexican culture. We are in a vicious circle. To know what Mexican culture is like we need first to grasp the meaning of our object; but we cannot grasp the meaning of our object without a previous notion of what it is like.[28]

To overcome this difficulty, Ramos proposes leaving aside whether or not Mexican culture exists at the present time and to imagine what culture "would be like if it existed." Ramos claims to find himself confronted with a vicious circle, though, transparently, he is himself the author of it. Why should we try to imagine what Mexican culture would be like *if* it existed? Isn't there now in Mexico a way of life, rural and urban, local and cosmopolitan, Indian, Spanish, European, and "American"? * But, as we might anticipate, Ramos never bothers to put the question in this way. What he wants is something more lyrically or monumentally unique, created by the "motivating forces of the Mexican soul." [29] And it would be just as wasteful to demand to know why the potency of that soul allows itself to be distracted by extraneous influences and is taking so long to arrive at its full expression. Ramos's "methodological" opening, therefore, is not only a spurious question but a hidden

* Using this term in the *North* American sense. Like many other societies, Mexico has been influenced by the contemporary civilization of the United States, particularly at the popular level.

statement. "What would Mexican culture be if it existed" is simply his way of saying that Mexican culture *would* exist if it *were* to be as Ramos's archetypal imagination conceives of its being.

Paz certainly possesses greater eloquence and far more poignancy in portraying the problem of identity, with all its ravaged urgency, than anything found in Ramos's all too disingenuous arguments. But when he tells us that the critical moment in the history of nations comes when they ask themselves "what are we and how do we fulfill our obligations to ourselves," [30] we realize that he also shares in the determination to embrace dreams as attestations of reality. First of all, Paz's words show the proneness to "ontology" so characteristic of these pronouncements (looking at them carefully, we realize that *what* and *how* have identical meanings, since, from Paz's point of view, we could only discharge our obligations to ourselves "as we are" by being what we are, and so on). And then, beyond that, he asks us to imagine that a whole people could collectively conceive of such questions to put to itself (which alone would presuppose a degree of group self-perception and self-definition sufficient in itself to answer the question).

In any case, what would be the examples, past or present, of whole societies performing such acts of introspection? Since the answer is clearly impossible, the query itself must be regarded as a symbolic way of appeasing the burden of self-doubt. Let us, therefore, consider what Paz wishes to see as he stares into his glassless mirror.

> All of us, at some time, have had a vision of our existence as something unique, untransferable and very precious. This revelation almost always takes place during adolescence. Self-discovering is above all the realization that we are alone: It is the opening of an impalpable, transparent wall—that of our consciousness between the world and ourselves. It is true that we sense our aloneness

almost as soon as we are born, but children and adults can transcend their solitude and forget themselves in games or work. The adolescent, however, vacillates between infancy and youth, halting for a moment before the infinite richness of the world. *He is astonished at the fact of his being.* [Italics mine] [31]

Let us compare Paz's version of the emergence of personality with a thinker far removed from the Spanish American taste for vast and vibrant intuition, like the pragmatist William James. This, according to James, is the experience through which we are led to a recognition of our own capabilities and our position in the world:

> an element of active tension, of holding my own, as it were, and trusting outward things to perform their part so as to make it a full harmony, but *without any guaranty* that they will. Make it a guaranty—and the attitude becomes to my consciousness stagnant and stingless. Take away the guaranty and I feel . . . a sort of deep enthusiastic bliss, a bitter willingness to do and suffer anything. [Italics mine] [32]

What James appeals to may be called the spirit of specific intellectual courage. He asks us to hold ourselves before the world as poised but pliable observers, marching toward a reality which is comprehensible but not tame (nor a shining and redeeming cloister), while we savor the pleasures of thinking as a consequence of encountering given problems and reaching given solutions. For James, selfness, the consciousness of self-definition, organic, ethical, and intellectual, is inseparable from the capacity of the self to act coherently and fruitfully towards the world. Identity, then, appears as the mind wrestles with an *unfinished* reality always renewed in its challenges, while in the resolution of those challenges, the self gains a harmony which will once again be broken and again regained as other engagements are met and overcome.

What Paz, the "Latin," craves on the other hand is the

kind of intellectual guarantee that the Anglo-Saxon pragmatist would have regarded as stagnation—a cultural universe the experience of which would be indistinguishable from a perennial, uninterrupted, unthreatened, "astonished" act of self-*contemplation*. Paz would probably say, with Miguel de Unamuno, who also unceasingly searched after national essences:

> Don't you agree, my true-blooded brother [*castizo hermano*], that the end of our life must be well-being, that is, not to do but to be well; O, what sweet joy it is just to be being.[33]

No psychologist would dispute Paz's statement that the quest for identity is a characteristic of youth. What is remarkable, however, is that Paz should equate the trials of adolescence with the problems of cultural definition. His reason for doing this, I feel, is the obvious attraction of early youth as a model of behavior resting on a *pure* state of consciousness which is, as Paz says, neither work nor play. It no longer enjoys the innocence, the "unconsciousness," of childhood games, but neither has it dissipated its "wholeness" in the struggle with the thousand mundane obligations of work, as adults must eventually do. Seen in this way, adolescence becomes a self-absorbed, uncompromised, unspent condition of existence which, when translated by Paz into a social model, joins the family of Spanish American dreams of culture as, above all, a tableau of memorable properties broadcasting and reenacting forever their "meaning" and their "being."

Inevitably this determination to employ any method, learned or obscure, rhetorical, historical, legendary, or intuitive, to arrive at a sufficiently reassuring prototype, results sometimes in nothing but the most incoherently grandiose outbreaks of cultural self-adulation—"Colombia is a nation of poets," writes Carlos García Prada (1898–),

born in that country and for several years professor of Spanish American literature in the United States, and continues:

> This is our historical sign, accepted with pain and pride, following its mysterious trajectory, as one follows the arrow of the Great Bowman, shot in the direction of the Infinite and the Eternal. . . . We are a chivalrous people, and our poetry . . . is the prelude to a new religiosity, at once spiritual, pagan and scientific.[34]

Typically, as we have seen, it has also prompted many a perfervid and obscure "reading" of the forces of race and soil. Victor Raúl Haya de la Torre, the Peruvian political figure (1885–), though himself Iberian in ancestry, could allow himself to believe that the "Indian subconscious" had somehow transformed the thinking and life-feeling of all Spanish Americans.[35] While the Colombian man of letters Germán Arciniegas (1900–), in a work he regarded as "sociological," described the volcanoes of South America as "the bonfires of its earth spirit." [36] There is finally the language of the cultural visionary wedding redundance to incantation and rising to virtually senseless (if not delirious) levels of "ontological" prophecy. Mallea calls for an "a priori knowledge of our destiny" (a knowledge which would eliminate all future worries about the character of that destiny, from political behavior to economic policy or the right sorts of artistic and literary expression), presuming, of course, that the "becoming" of Spanish America is already contained in its "natural origins" (the adjective in this last expression is left, as we might expect, undefined). Emilio Oribe (1883–), a Uruguayan professor of philosophy, speaks of the "nurturing nebulae" of Spanish American civilization, carrying within themselves the "inevitable verdict" of its forthcoming history, a history dictated by a destiny which rests "upon the knee of the divine, [of] reason, science and freedom," thus leading to "the reign of intelligence linked with beauty [and] the cre-

ativeness of the individual resting in the profound freedom of Being." [37] Alberto Zum Felde (1889–), a literary critic and historian, and also a Uruguayan, considered the problem of Spanish American culture as "identical with the definition of our historical Self," a substance driven by an "a priori historical imperative" residing in "the radical subliminal zone," and which "pre-exists and pre-acts" through the powers of the "Sublime unconscious." [38]

A particularly transparent instance of such rigged and rhetorical momentousness is found in *Existe la América Latina?*, a book by the Peruvian literary critic Luis Alberto Sánchez (1900–). On glancing at the book's title one's first impulse is, of course, to reassure the author. To tell him that there is an *América Latina*.* That the place thus called comprises a number of political communities with certain economic and social characteristics and certain problems, possibilities, and limitations. But this would only be regarded as innocent and shortsighted. Sánchez does not use the words *Existe la América Latina?* in order to invite either an account or an analysis of observable facts. He uses them as an "existential" trigger, as a way of precipitating an outburst of introspective, philosophico-cultural agony and revelation. We find ourselves, therefore, once again in the twilight between prediction and its self-fulfillment. The present is regarded as describable but lacking in "true" significance and, in that sense, unreal, while the future is

* Sánchez uses this term to speak of countries I include under the term Spanish America. There is no denying the currency of his usage. It also is true that it was introduced early in this century as a way of denying or downgrading the one European tradition which has clearly remained dominant in those societies, that of Spain, and of suggesting—more fashionably and self-importantly, it was thought then—a connection with Mediterranean culture generally. It is, in any case, for other ethnic and cultural reasons as well, an endlessly misleading term. For example, the expression "Latin rhythms" in the United States describes rhythmic patterns and drumming styles brought into "Latin" America by the large number of African slaves.

regarded as indescribable but, for *that* reason, real, since when that future becomes fact, it will consist of unalterable and all-embracing forms of life and expression. We musn't speak then, of what we can see, hear, or know at this time. Of what, in effect, exists. That is not the way the game is played. We must speak of what Spanish America will be when it *is*.[39]

The secret of this logic lies always in the formalization of intuition by means of two master devices. I shall call the first the *anthropological fallacy* and the second the *anthropomorphic metaphor,* a pretentious-sounding set of terms, certainly, but one which I find indispensable in this case.

By the *anthropological fallacy* I mean the habit of transposing a conception of culture derived from the observation of deeply homogeneous societies, such as have been traditionally studied by anthropologists, to far more complex, pliable, and elusively integrated ones. What marks the *anthropological fallacy* is the notion that a culture, in order *to be* a "culture," must be a closed organism each one of whose manifestations is understandable as an expressive facet of the general entity. One has only to think of Spengler's *Decline of the West* to recall the spell of this idea, suggesting as it does that the history of peoples or periods is something akin to the dance in time of a single organism, making of each cultural event one of the dance's movements and gestures.

The *anthropomorphic metaphor* is simply a more "visible" and, therefore, more seductive version of the *anthropological fallacy,* because, either in the novelistic or in the stage sense of the words, it is also a more dramatic one. The *anthropomorphic metaphor* portrays societies as personages and historical *events* as biographical *acts* which stem from a body of motives. And curiously too, but within the artfulness of the illusion inescapably, it regards the biographies

of societies as more inexorably coherent than those of the biological individuals of daily life. In the latter we presume or permit ambivalence, doubt, caprice, self-contradiction, or just nonsense. But social anthropomorphism depends on an application of the theory of the personal soul to whole collectives in nothing but the most unqualified way. Either a culture is of a piece or it is nothing. Either it radiates a core of disposition or it is empty. And if we cannot sense the pulse of its *character* in every feature of its *life,* we think that it either hides itself from us or is engaged in betraying its own integrity. The outcome is a tendency to blend anthropomorphic and anthropological attitudes to portray whole cultures as finished "compositions," as pageants of choreographed values or panoplies of symmetrically arranged parts.

Works of art, says Hippolyte Taine, are not monuments because they are documents, but documents because they are monuments. This statement would not be plausible or, for that matter, comprehensible, unless one thought also that individual artistic creations are capable of summing up the total content and meaning of a given culture (this presumed power of synthesis being what Taine understands as their "monumentality"). Yet, of course, this belief would be equally untenable unless one first conceded that culture *itself* is a work of art whose motif and formal construction are capable of being "voiced" or "reflected" through one particular aesthetic object. In other words, while some ideologies demand of history that it flow in certain "teleological" rhythms, others ask of social systems that they be aesthetically impressive. And it is not difficult to see why the second of these views should be so appealing to writers such as those I have discussed here, men unwilling to separate the sociological from the "poetic" understanding of history, uninterested in its prosaic aspects, and moved only

by elegant generalities, conventionally noble enterprises, the spectacle of great events, and the "soul" and "ideals" of peoples and nations.

Andrés Bello, though a public figure and a lawyer (as well as a poet), ultimately looked upon América as a new garden for the promenades of the cultivated man. Rubén Darío may have been in some respects a special case, a classic instance of the provincial aesthete concerned above all with showing himself a protagonist of cosmopolitan intellectual manners. But even among figures absorbed in the political struggle like José Martí, the temptation is always to look at Spanish American civilization from an essentially dramatic perspective. His famous essay, *Nuestra América,* a call for the creation of original institutions in a new society, is dominated by figures of speech which almost preempt the question conceptually in their emotional obeisance to the grandeur of the native image: "Can Hamilton's theories stop the charge of a *llanero's* colt? * Can a phrase from Sieyès make the frozen blood of the Indian run again? [The] password of our generation is 'create.' Let our wine be our wine be banana wine. Should it turn sour, it would still be our wine." ** [40] Vasconcelos's racial ideas are really a discourse on what he thinks are the indigenous aesthetic sensibilities of the Spanish American populations. García Calderón, for all his concern with the "advances of civilization," in the commonplace sense of that word, ended in a pure note of Nietzschean artistic heroics, his Spanish American Superman reigning, "overwhelming and lonely," over Andean peaks and jungle rivers. In Ricardo Rojas's recon-

* The *llanero* (plainsman) is the horseman figure of Colombia and Venezuela, the northern counterpart to the *gaucho* of Argentina, Uruguay, and southern Brazil.

** In a poem about the American domination of Cuba, Alfonso Reyes speaks of the eradication of malaria by the Yankees but adds, "at least the mosquitoes buzzed in Spanish."

struction of Spanish American history each component is treated as a supporting arch in the construction of a vast, stately, and everlasting temple. And when Octavio Paz says today that "to become aware of our history is to become aware of our originality," [41] he is, of course, once again, asking the social order to conform to the prerequisites of artistic achievement.

Glancing at the careers of Spanish American men of letters it is impossible to avoid the impression of an improvised miscellany of tasks and interests. Poets are also political essayists (or even politicians). Historians and philosophers are also the heads of governmental offices. Novelists are also diplomats or librarians.* To some this might suggest a singular devotion to cultural universality and a respectful support of the arts on the part of public institutions. What it really points out, however, is the dependence of Spanish American intellectuals on political accommodation and literary piecework in a society lacking a large and dependable reading public and a sufficiently large and well-paid educational system.** And this means also that intellectual

* The famous Argentinian story writer, Jorge Luis Borges, is the director of the National Library at Buenos Aires. Pablo Neruda, undoubtedly the best known Spanish-language poet writing today, was for some years in the Chilean consular survice and is now a member of the Chilean senate. The recent Nobel Prize winner for literature, the novelist Miguel Angel Asturias, is the Guatemalan ambassador in Paris.

** Eric Hoffer's remarkable sociological instinct is shown in this connection in his recent book *Working and Thinking on the Waterfront* (New York: Harper and Row, 1969). The book is a diary, and in one of its entries, the record of a day spent loading a Chilean boat, Hoffer remembers being told by a clerk that the ship's second mate spoke English with an Oxford accent and that officers of all ratings had shelves of books in their cabins. The ordinary, masochistic American near-intellectual, always willing to think the best of foreign cultures and the worst of his own, would very likely have inferred from this that a high level of literate refinement prevailed in the Chilean merchant marine. Hoffer himself concluded, simply and correctly, that Chilean intellectuals were hard pressed to find jobs befitting their status.

labor will be conducted in an atmosphere of haste that makes dilettantism almost inescapable. García Calderón once spoke praisefully of the Spanish American "cult" of general ideas, never thinking that it stood also for a tradition of glossy verbal maneuvering allowing the writer the conviction that any question could be dealt with if only he would strike the widest and most evasively lofty rhetorical chords. But then again, one wonders what other style could be possible in an atmosphere of utopian expectations which few if any societies would be assumed to meet. Caught between their mythic visions and what has often been a melancholy history, Spanish American writers seem to have been driven to find consolation and reassurance in the fancy jewelry of their terminology and what may be called the spiritually *nouveau riche* tone of their speculations. They forever convey the impression that no social meaning can be reached or insight communicated except through a language of conspicuous intellectual consumption and high-class mental travail, filled with words like "sublime," "inner," "destiny," and of course, the always recurrent "ontology."

In what may be the single most accurate critique of *Latin* American philosophical schools, including under this name Brazil, Euryalo Cannabrava has described them as the product of a "superstitious attitude toward the inner life" which seeks to reduce philosophy to "the vindication by argument of purely instinctive beliefs." [42] He might have added that, as theories of culture, they also constitute an extraordinary if unconscious form of intellectual procrastination. Sanguine in their imagery of the future, Spanish American writers define the object of their expectations in such apocalyptic terms that no new day seems to bring any measure of their realization. But this only means that the *literati* are forever put in a position of acting as heralds and spokesmen

for the great accomplishments yet to come. And what this makes clear, in turn, is that the now classic topic of "cultural identity" is not a spontaneous phenomenon of social psychology but a conceptual invention of the intellectuals—or, at least, of certain kinds of intellectuals—which, both as a problem and as an object of pursuit enables them to act as brokers for cultural issues which they themselves define as crucial. Here again Octavio Paz is revealing, perhaps despite himself. As he explores the sources of "Mexicanity" he writes:

> My thoughts are not concerned with the total population of our country, but rather with a specific group made up of those who, for one reason or another, are conscious of themselves as Mexican.[43]

Now, if Mexico is a functioning society and, as such, possesses describable characteristics, it must be because Mexicans *are* Mexican within the ways of life made possible by the conditions of their country at the present time. Yet Paz regards as Mexicans only those who *think* of themselves as Mexican according to some total intuition of what this may mean. However, since, like the majority of people in most societies, most Mexicans do no more than walk the streets being simply what they are and lacking a final and total sense of themselves, they are declared by Paz as being not yet "Mexican." The true Mexican, therefore, will be found only through those specific groups which make it their business to seek a paradigmatic Mexican self-consciousness. In other words, the intellectuals.

There has developed in recent years a whole sociology of the *intelligentsia* whose chief problem invariably turns out to be that of giving this term a meaning distinct and comprehensive enough to identify its internal characteristics as a group and to describe the general nature of its function in society. And since this sometimes involves bringing within

one concept poets and laboratory technicians, economists and political ideologists, art critics and engineers, it is easy to understand why those who have written on the matter often can do nothing more than to argue their preferences in ad hoc and inconclusive ways. It is enough for the discussion here to say that there are at least two sorts of intellectuals. One that I will call the *solution-oriented* and another that I will call the *predicament-oriented*. The first is concerned with productive activities and ways of organizing collective existence which require the rational manipulation of science, technology, and social and institutional behavior. The solution-oriented thinkers, in other words, are the men of calculable endeavors aiming at calculable results. The second class of intellectuals are the guardians and proprietors of the more inaccessible aspects of human experience, the exegetes of its intricate transcendence and its dramatic dignity, the observers of the *condition* of man, or the *problem* of the times, or the *crisis* of the age, as well as the dealers in those questions of mind and sensitivity whose very "depth" is in some degree measured by their insolubility.*

This is precisely the way in which the "problem of cultural identity" has "legitimized" the literary interpreters of Spanish American history. We remember that, according to Octavio Paz, national culture could not exist, *be,* except as something at once particular, all-meaningful, and in its fullness, inexhaustible. And if it should occur to us that only art or religion can claim to offer us a similar kind of reality, we will have discovered also why such a view is so dear to Paz and the tradition of which he is a part. Alberto

* When Lewis Coser says that "intellectuals exhibit in their activities a pronounced concern with the core values of society," he should have added that frequently the reason for this is that they arrogate to themselves the right (which naturally they see also as a duty) of *defining* those values. (See: *Men of Ideas* (New York: The Free Press, 1965), p. viii.)

Mallea, in search of the indefeasible kernel of Argentinian personality, suggested that it might be found through the instrumentality of a Platonic reminiscence and thus spoke both of a psychological and moral ideal as well as a monument of human harmony and completeness. And in fact, the pursuit of an archetypal basis of history is inseparable from an artistic and mystical model of culture and experience; to conceive of society as a piece of finished architecture implicitly holds the promise of a unifying and lasting spiritual principle.

But further, it casts the vehicle of the principle, the cultural interpreter, in a particularly triumphant role. Intellectuals, the temple servants of Culture, forever tracing its contour, unveiling its meaning, and reaffirming its presence, are themselves sustained by the powers of the deity. It is in that service that cultural "truth" and historical "destiny" are brought together with the sensitivity of special individuals and that the originality of national biographies, the total personality of collectivities, is made "real" through the uniqueness of individuals.

The history of Spanish America has been one of perennial stumbling in the solution of social problems, economic stagnation, unpredictable politics, impotence, and confusion. And the question arises as to how the splendor of its cultural speculations could have survived its unhappy realities. The answer, not a difficult one to guess at, is that the prophetic tone of cultural "ontology" has always had an underside of profound anxiety breathing next to all the brave words of expectations. His reflections on Argentina, Mallea tells us, were occasioned by the "anguish" he felt about that country, and Zum Felde, having asserted the surety of Spanish America's "destiny," falls the next moment to considering the "torment" of its culture. Luis Alberto Sánchez undertook to answer the question of Span-

ish America's "existence" not as a mere exercise in historical curiosity but as a means of "putting the finger in the wound." Even the most passionate claims are uttered in the form of boastful consolations for special burdens borne: "No land could be loved with greater pride," Martí wrote, "than our sorrowful republics." The phraseology of certainty, then, must be regarded as inseparable from the phraseology of fear, and it is only after thinking of their antidote value against an endemic mood of mournfulness and defeat that we can look more charitably and, indeed, more "understandingly" upon such otherwise embarrassing rhetorical shadows as "a priori imperatives," "eternal trajectories," and "national monads."

Like other seekers of "identity," Spanish American writers have not been able to escape the dream-nightmare ironies of a quest which, after all, represents the most acute version of the conflict between the powers and the risks of estrangement. On the one hand the intellectual hears that the integrity and depth of his perception is to be gauged by the sternness of his detachment from the community. On the other he learns that "alienation" takes away from him the support of specific social affiliations and the comfort of concrete social loyalties. Exposure and aloneness, then, are the price of the intellectual's self-conception and his sense of mission, the resolution of this vivid dilemma being usually the search for a cultural reality grand enough to quiet his discontent or to enact the magnitude of his expectations. The strain to link up with the sources of cultural identity, therefore, entails a secret and actually desperate gesture of survival. I agree with Donald Malcolm that the pursuit of "identity" must ultimately drown itself in hypnotic self-deception and that the "man who steps outside his house and rings his own doorbell should not be astonished to find nobody home." [44] Still the temptation seems inexorable.

Speaking of the Russian *intelligentsia* of the nineteenth century and its elevation of The People to a "mysterious and compelling force which holds the secret of life and is the depository of some special truth," Berdyaev postulated that cultural populism always signaled the social weakness of the man of letters.* [45] But beyond that, it is generally true that the quest for impressive collective instruments of cultural redemption has been a characteristic feature of a number of ideological movements and literary currents or episodes. For the Marxists, it was the proletariat. For the Pan-Slavists, the Russian nation. For uprooted souls like D. H. Lawrence, Paul Gauguin, or Lafcadio Hearn, the exotic populations of New Mexico, Tahiti, or Japan. Among contemporary observers of the American scene there are those who look upon the new adolescent, with his unbending rebelliousness and his remarkable capacity for inventing unheard-of styles of life, as the saving instrument of present-day society. To feel the call of oneness with some shining and necessary force is to become the conveyor of its imminence, to be rescued from impotence, to become history's creature and history's master. The features of the cultural condition which many intellectuals seek are, in fact, the features of the divine: uniqueness, totality, and self-sameness. In this sense one could say of Culture what Berdyaev said of The People. That in it, intellectuals had found the God they had renounced.

On the other hand, societies do not find it very easy to arrange themselves into spectacles of majestic coherence. After all, they exist and preserve themselves by obeying the mundane rather than the transcendental. Reading E. K. Brown's *Essay on Canadian Poetry* one runs across the following anecdote:

* This assumes that intellectuals will stop idealizing the masses as soon as they gain power, a hypothesis which also bears looking into.

In a gathering of ruminative historians and economists, speaking
their minds one evening in Winnipeg years before the war was
imminent, the unanimous opinion was that a destroyer or two
would do more than a whole corpus of literature to establish a
Canadian nationality. *The dissent of two students of literature
was heard in awkward silence.* [Italics mine]46

It must be regarded as natural for poets to reject the
notion that a society could find its "identity" in something
as tangible as the reality of its power. But this cannot deny
(and this is a revelation which sociologists should regard as
reassuring) that the appetite for "deeper" cultural meanings
can be prompted by the specter of worldly failures. "The
itch to study the psychology of our Spanish people," says
Miguel de Unamuno, "came only after the 'colonial dis-
aster,' " that is to say, after the American defeat of Spain
in 1898.* Very much the same thing, one must conclude,
of the long history of Spanish America's haunted utopian-
ism. The Spanish-speaking nations of this hemisphere have
always regarded themselves as part of the "American
Dream." But a career of stumbling difficulties in fulfilling
their part of that mission turned that promise into a painful
paradox, naggingly deepened by the triumph of North
American power, including, of course, political and eco-
nomic power of the life of Spanish America itself. "We are
those who believe in art, in the enthusiasm for the beautiful
regardless of the consequences," wrote Francisco Bilbao
[my italics]. These are, no doubt, brave words, suggesting
a heroically elegant cultural choice which, in fact, Spanish
America never made. A closer glimpse at the secret reality
is offered by Vasconcelos who, turning for a moment away
from ethnic self-congratulation, has this comment to make:

* If Alberto Mallea thought that he could find the "national monad" of
Argentina, Unamuno believed that he could discover the "national proto-
plasm" of Spain.

Let us admit that it was our misfortune not to have developed the cohesion of the extraordinary breed to the North, which we cover with insult because it has beaten us at every game in the material struggle.[47]

The might and the plenty of the United States has, on the whole, excused the American intellectual, certainly since the Civil War, from the necessity of being a cultural nationalist. The opposite is true of Spanish American writers. The voice of their cultural dreams, whether mellifluous or melodramatically chimerical, is the voice of a repressed yet never spent nationalistic passion. Cultural ontology in Spanish America is the metaphysics, perhaps the poetry, of cultural frustration.

Notes

Chapter 1. Social Optimism and Literary Depression

1. Emile Durkheim, *The Social Division of Labor* (The Free Press of Glencoe, Illinois, 1949), p. 3.
2. Isaac Disraeli, *The Literary Character of Men of Genius* (London: Frederick Warne and Co., 188?), p. 15.
3. Alexis de Tocqueville, *Democracy in America* (New York: Alfred A. Knopf, 1945). Two volumes. II, pp. 48–52; 55–60; 72–76.
4. Cited in: René Wellek, *A History of Modern Criticism* (New Haven: Yale University Press, 1955). Two volumes. I, p. 16.
5. Ibid., p. 21.
6. Jean-Paul Sartre, *Baudelaire* (Paris: Librairie Gallimard, 1950), pp. 137–39.
7. Cited in: Jules Bertaut, *L'Epoque romantique* (Paris: Talladier, 1947), pp. 111–12.
8. François Guizot, *Histoire parlementaire de France* (Paris: Michel Levy, Frères, 1863–64). Five volumes. V, pp. 385–86.
9. Johan Huizinga, *The Waning of the Middle Ages* (London: Edward Arnold and Co., 1924), pp. 48–50.
10. Sister Catherine Theresa Rapp, "Burgher and Peasant in the Works of Thomasin von Zilcaria, Freidank and Hugo von Trimberg," *The Catholic University of America Studies in German* (Washington, D. C.: Catholic University of America, 1926–54), VII, pp. 91–92.

11. Bernard Groethysen, *Les Origines de l'esprit bourgeois en France* (Paris: Librairie Gallimard, 1927). Two volumes. I, pp. 165–76.

12. Alexis de Tocqueville, *Recollections* (New York: The Macmillan Co., 1896), p. 6.

13. Voltaire, *Works*, Tobias Smoollet, editor; William F. Fleming, translator (Paris: E. R. Dumont, 1901). Forty-two volumes. XXXIX, p. 18.

14. Cited in: Louis B. Wright, *Middle Class Culture in Elizabethan England* (Chapel Hill: The University of North Carolina Press, 1935), p. 24.

15. Roy Lewis and Angus Maude, *The English Middle Classes* (London: Phoenix House, 1949), pp. 22–23; 41–42.

16. Thorstein Veblen, *The Theory of the Leisure Class* (New York: Modern Library, 1934). Chs. I–II.

17. W. H. Auden, "The Dyer's Hand," *The Anchor Review* (II) (Garden City, New York: Doubleday Anchor Books, 1957), pp. 255–56.

18. Cited in: Alfred Kazin, *On Native Grounds* (New York: Reynald and Hitchcock, 1942), p. 132.

19. Stendhal, *Mélanges de litterature* (Paris: Le Divan, 1929), Three volumes. I, pp. 48ff.

20. Sigmund Freud, *Civilization and Its Discontents* (London: The Hogarth Press, 1949), p. 73. See also: "Civilized Sexual Morality and Modern Nervousness," *Collected Papers* (London: The Hogarth Press, 1934). Five volumes. II, pp. 79–89.

21. Honoré de Balzac, *La Comédie humaine* (Philadelphia: Barrie and Sons, 1897). Fifty-three volumes. XVIII, p. 285.

22. Charles Baudelaire, *Œuvres Complètes* (Paris: Editions de la Nouvelle Revue Française, 1923). Six volumes. VI, p. 95.

23. D. H. Lawrence, *Studies in Classical American Literature* (Garden City, New York: Doubleday Anchor Books, 1955), p. 50.

24. D. H. Lawrence, *A Propos Lady Chatterley's Lover* (London: Mandrake Press, Ltd., 1930), pp. 25–30.

25. D. H. Lawrence, *Lady Chatterley's Lover* (London: Mandrake Press, Lt., 1930), pp. 142–43.

26. Ibid. p. 142.

27. Lawrence, *A Propos Lady Chatterley's Lover*, p. 59.

28. Arthur Miller, *Death of a Salesman* (New York: The Viking Press, 1949).

29. Emile Durkheim, *Suicide* (The Free Press of Glencoe, Illinois, 1951).

30. Cited in René Maigron, *Le Romantisme et les Moeurs* (Paris: Honoré Champion, 1910), p. 10.

31. S. A. Rhodes, *Gérard de Nerval* (New York: Philosophical Library, 1951), pp. 42–43.

32. John Steinbeck, *Tortilla Flat* (New York: The Viking Press, 1935); *Cannery Row* (New York: The Viking Press, 1945), William Saroyan, *My Name Is Aram* (New York: Harcourt, Brace, 1940); Du Bose Heyward, *Porgy* (New York: George H. Doran, 1925); Moss Hart and George S. Kaufman, *You Can't Take It with You* (New York: Farrar and Rinehart, 1937).

33. Norman Mailer, *The White Negro* (San Francisco: City Lights Books, 1957), pp. 33ff.

34. Jack Kerouac, *On the Road* (New York: The American Library, 1958), pp. 148–49.

35. Eldridge Cleaver, *Soul on Ice* (New York: Dell Publishing Company, Delta, 1968).

36. Cited in: Francis Steegmuller, *Flaubert and Madame Bovary*, (London: Collins, 1947), p. 250.

37. *The Selected Letters of Gustave Flaubert*, Francis Steegmuller, editor and translator (New York: Farrar, Straus and Young, 1935), pp. 23, 33, 39, 77, 159, 171, 177.

38. Norman Mailer, *Advertisements for Myself* (New York: Signet Books, 1960), pp. 379–80.

39. Sigmund Freud, "The Origins and Development of Psychoanalysis," in: *General Selections from Sigmund Freud*, John Rickman, editor (Garden City, New York: Anchor Books, 1957).

40. Sigmund Freud, "Character and Anal Eroticism," *Collected Papers*. II, pp. 45–50.

41. See: Article "Bourgeois" in *Grand Dictionnaire universel du XIX^e siècle* (Paris: Larousse, 1967). Seventeen volumes. II, p. 1124.

42. Karl Marx and Friedrich Engels, *The Communist Manifesto* Part I.

43. See: Article "Bourgeois" in *Grand Dictionnaire universel du XIX^e siècle*. II, pp. 1121–24.

44. Albert Dresden Vandam, *An Englishman in Paris* (London: Chapman and Hall, 1892). Two volumes. I, p. 239.

45. Gustave Flaubert, *Correspondance* (Paris: Louis Conard, 1810). Five volumes. II, p. 25; Baudelaire, *Intimate Journals*, Christopher Isherwood, translator (Hollywood: Marcel Rodd, 1947), p. 75; Stendhal, *Memoirs of Egotism*, Matthew Josephson, editor (New

York: Lear Publishers, 1949), p. 120; Flaubert, *Selected Letters,* p. 264.

46. *From Max Weber: Essays in Sociology,* Hans Gerth and C. W. Mills, editors (New York: Galaxy Books, 1958), pp. 196 ff. For a discussion of Weber's concept of ideas as historical causes, see: Reinhard Bendix, *Max Weber: An Intellectual Portrait* (New York: Doubleday and Company, 1960) pp. 85ff; for a general analysis of Weber's concept of bureaucracy see pp. 48ff.

47. Thorstein Veblen, *The Theory of Business Enterprise* (New York: Mentor Books, 1958). Chs. II, IX.

48. *The Communist Manifesto,* pp. 128–29.

49. Charles Baudelaire, *Œuvres Complètes* (Paris: Editions de la Nouvelle Revue Française, 1923). Six volumes. VI, p. 442.

50. Charles Baudelaire, *Œuvres Complètes.* VI, p. 442.

51. Cited in: Philip Spencer, *Flaubert: A Biography* (New York: Grove Press, 1952), p. 190.

52. John Stuart Mill, *On Liberty* (New York: Appleton-Century-Crofts, 1947), pp. 6–62.

53. Ibid. p. 61.

54. Ibid. p. 61.

55. Ibid. p. 59.

56. Cited in: Raymond Williams, *Culture and Society* (Garden City, New York: Anchor Books, 1960), p. 55.

57. Bertrand Russell, *A History of Western Philosophy* (New York: Simon and Schuster, 1945), p. 678.

58. Charles Baudelaire, *Intimate Journals,* p. 49; Pierre Flottes, *Baudelaire* (Paris: Perrin et Cie, 1955), p. 47.

59. Cited in: Enid Starkie, *Petrus Borel, The Lycanthrope* (London: Faber and Faber, 1954), p. 82.

60. Cited in: Sartre, *Baudelaire,* p. 148.

61. Charles Baudelaire, *Œuvres Complètes.* VI, p. 95.

62. Ibid. 241.

63. Cited in Sartre, *Baudelaire,* p. 148.

64. Charles Baudelaire, *Œuvres Complètes.* IV, p. 243.

65. Ibid.

66. *History of Western Civilization: Selected Readings* (Chicago: The University Press, 1956). Nine volumes. IX, p. 53.

67. Emmanuel-Joseph Sieyès, *Qu'est-ce que c'est le Tiers Etat* (Paris: Sôciété de L'Histoire de la Revolution Française, 1888), p. 28.

68. Tocqueville, *Democracy in America*. II, p. 152.
69. Anatole France, *Penguin Island* (London: John Lane, The Bodley Head, 1927), p. 203.
70. Charles Dickens, *Hard Times* (New York: Sheldon and Co., 1863). Two volumes. I, p. 316.
71. Cited in: Spencer, *Flaubert*, p. 118.
72. Cited in: Eric Bentley, *Bernard Shaw* (New York: New Directions Paperbacks, 1957), pp. 35–36.
73. Thomas Mann, *The Confessions of Felix Krull, Confidence Man* (New York: Alfred A. Knopf, 1955).
74. Benjamin Disraeli, *Coningsby* (London: J. M. Dent & Sons, 1959), pp. 177–80.
75. Tennessee Williams, *Suddenly Last Summer* (New York: New Directions Paperbacks, 1958).
76. André Gide, *Lafcadio's Adventures* (New York: Alfred A. Knopf, 1951).
77. C. P. Snow, *The Two Cultures* (New York: Cambridge University Press, 1959).
78. *From Max Weber: Essays in Sociology*, p. 293.
79. Edward Shils, "Political Developments in New States," *Comparative Studies in Society and History*, Vol. II, No. 3, April 1960, pp. 265ff.
80. George Orwell, *Nineteen Eighty-four* (New York: Harcourt, Brace, 1949).
81. Charles Baudelaire, *Paris Spleen* (New York: New Directions Paperbacks, 1947), p. 22.
82. *History of Western Civilization: Selected Readings*. IX, p. 26.
83. *From Max Weber: Essays in Sociology*, p. 293.
84. *Bertrand Russell Speaks His Mind* (New York: Bard Books, 1960), pp. 137ff.
85. Honor Tracy, *Silk Hats and No Breakfast* (New York: Random House, 1958).
86. Daniel Defoe, *The Complete English Tradesman* (London: J. Rivington, 1745), p. 66.
87. Lawrence Lipton, *The Holy Barbarians* (Julian Messner, 1959), p. 147.
88. Yurii Olesha, *The Wayward Comrade and the Commissar* (New York: Signet Books, 1960), pp. 76–77.
89. Cited in: Lewis and Maude, *The English Middle Classes*, p. 56.

Chapter 2. French Impressionism as an Urban Art Form

1. *The Sociology of Georg Simmel,* Kurt H. Wolff, editor and translator (New York: The Free Press, 1967), p. 410.
2. Honoré de Balzac, *La Comédie humaine* (Paris: André Martel, (1964). Thirty volumes. IX, 346–47 (translation mine).
3. Arnold Hauser, *The Social History of Art* (New York: Random House, 1957). Four volumes. IV, 168.
4. Ibid. p. 166.
5. Ibid. p. 167.
6. Ibid. p. 176.
7. Frances Trollope, *Paris and the Parisian in 1835* (New York: Harper and Bros., 1836), p. 108; John Scott, *A Visit to Paris* (1815), p. 53.
8. Louis Wirth, *On Cities and Social Life,* Albert T. Reiss, Editor (Chicago: University of Chicago Press, 1964).

Chapter 3. The Private Lives of Public Museums: Can Art Be Democratic?

1. Theodore Lewis Low, *The Educational Philosophy and Practice of Art Museums in the United States* (New York: Columbia University Bureau of Publications, Teachers College, 1948), p. 33.
2. Ibid. p. 13.
3. Ibid. p. 16.
4. Ibid. p. 24.
5. Ibid. p. 41.
6. Arnold Rockman, "The Great Universal Extrasensory Emporium and Display Mart in the Old Curiosity Shop," *Museum News,* November 1968, p. 9.
7. Thomas P. F. Hoving, "Branch Out," in *Museum News,* September, 1968, p. 16.
8. Ibid. p. 15.
9. Quoted in: "Hoving of the *Metropolitan,*" *Newsweek,* April 1, 1968, p. 42.

Chapter 5. Is There a Democratic Architecture?

1. Max Weber, *The Protestant Ethic and the Spirit of Capitalism,* translated by Talcott Parsons (New York: Charles Scribner's Sons, 1958).

Weber's *Wirtschaft und Gesellschaft* also contains an appendix now published as a separate volume entitled *The Rational and Social Foundations of Music,* Don Martindale *et al.,* editors and translators (Southern Illinois University Press, 1958).

2. Emile Durkheim, *The Division of Labor in Society* (The Free Press of Glencoe: 1949), p. 51.

Chapter 6. John Dewey's Social Art and the Sociology of Art

1. John Dewey, *Human Nature and Conduct* (New York, 1930). Especially Introduction and Part I, sections I–V. For the relation of Dewey's social view to education and philosophy, see among others: *Democracy and Education* (New York, 1916), and *Reconstruction in Philosophy* (New York, 1920).
2. Horace Gregory, *New York* Herald Tribune, May 6, 1934.
3. John Dewey, *Art as Experience* (New York, 1934), p. 3.
4. Ibid. pp. 4–5.
5. Ibid. p. 78.
6. John Dewey, *Problems of Men* (New York, 1946), p. 178.
7. *Art as Experience,* pp. 330ff.
8. Alexis de Tocqueville, *Democracy in America* (New York, 1945). Two volumes. Vol. II, pp. 71ff.
9. Henry Berenger, *L'Aristocratie Intellectuelle* (Paris, 1895), p. 166.
10. Though hardly sociological in an age of mass polls, questionnaires, and interviews, this statement is still true in two important ways. Historically, because our information of the social past comes from the testimony of its articulate men; and generally, as a description of social imagination, because the commonplace portrayal which a given public has of its society tends largely to be derived from literary and artistic creation, both good and bad.
11. *Art as Experience,* p. 87.
12. Ibid.
13. Ibid.
14. Ibid. pp. 136, 135.
15. Ibid. p. 137.
16. John Dewey, *Philosophy and Civilization* (New York-London, 1931), pp. 233–48.
17. It would also be well to remember that in genuine folk and popular art, as in the great artists of folk and popular inspiration, from Villon to García Lorca, one finds lyrical sadness, lyrical

sensuousness, human fellowship, human cynicism, and bawdy good spirits, not just some form of wholesome and organic "democratic" feeling. "Genuine" folk and popular art is taken here to mean the significant art of which people are capable outside of formal sponsorship and the tutoring of "high culture." In this sense it stands for the opposite of the manufactured popular art of today and its mass acceptance. As the concluding paragraph of this article makes clear, people are also capable of surrendering their autonomous traditions and developing the psychological characteristics required by the mass market, both in art and otherwise.

18. *Philosophy and Civilization,* pp. 2–5.

*Chapter 7. Cultural Dreams and Historical Frustrations
in Spanish American Literature*

1. Emilio Uranga, *Análisis del Ser Mexicano* (México: Porrúa y Obregón, 1952).
2. *Proclamas y Discursos del Libertador,* Vicente Lecuna, Editor (Caracas, 1933), p. 293.
3. "Carta de Jamaica" and "Invitación a los Gobiernos de Colombia, México, Rio de la Plata, Chile y Guatemala a Formar el Congreso de Panama," in: *El Pensamiento Político del Libertador,* Lucio Pabón, Editor (Bogota: Imprenta Nacional, 1955), pp. 45, 245ff.
4. "Delirio del Chimborazo," in: *El Pensamiento de América,* Francisco Monterde, Editor (México: Secretaría de Educación Pública, 1943). 14 volumes. V, 201.
5. José Olmedo, "La Victoria de Junín: Canto a Bolívar," in: *Poesías Barcelona*: Editorial Maucci, n. d., pp. 73, 94ff.
6. "La Agricultura de la Zona Tórrida," in: *Antología,* Pedro Grases, Editor (Caracas: Jaime Villegas, 1963), p. 59.
7. *Antología,* Pedro Grases, Editor, p. 59.
8. Ibid. pp. 28–29.
9. *El Pensamiento de Francisco Bilbao,* Armando Donoso, Editor (Santiago: Editorial Nascimento, 1940), pp. 155–56.
10. José Martí, *Nuestra América,* G. Quesada, Editor (Habana: Rambla 7 Bouza, 1909), pp. 91–92.
11. "A Roosevelt," in: *An Anthology of Spanish American Literature,* E. Herman Hespelt, Editor (New York: Appleton-Century-Crofts, 1946), p. 504.

12. "La Epopeya del Pacífico," in: *An Anthology of Spanish American Literature*, p. 554.

13. Ibid.

14. José Santos Chocano, *Memorias* (Santiago: Editorial Nascimento, 1940), pp. 18, 51.

15. José Vasconcelos, *Obras Completas* (México: Libreros Mexicanos Unidos, 1958). 4 volumes. II, pp. 1112–13.

16. Ibid. p. 908.

17. Ibid. pp. 1112–13.

18. Francisco García Calderón, *La Creación de un Continente* (Paris: Ollendorf, 1913), pp. 261–62.

19. Alfonso Reyes, *Ultima Thule* (México: Imprenta Universitaria, 1942), pp. 93–94.

20. Ibid. p. 93.

21. F. S. C. Northrop, *The Meeting of East and West* (New York: The Macmillan Co., 1947), pp. 57ff.

22. Edmundo O'Gorman, *La Idea del Descubrimiento de América* (México: Centro de Estudios Filosoficos, 1951), p. 17.

23. Ibid. p. 16.

24. Ibid. pp. 13, 381–82.

25. Ricardo Rojas, *Eurindia* (Buenos Aires: J. Roldan y Cia., 1924), pp. 137–38.

26. Eduardo Mallea, *Historia de una Pasión Argentina* (Buenos Aires: Espasa-Calpe, 1944), p. 26.

27. Donald Malcolm, "The Author in Search of Himself," *The New Yorker*, November 25, 1961, pp. 233–34.

28. Samuel Ramos, *Profile of Man and Culture in Mexico* (New York: McGraw-Hill, 1963), p. 16.

29. Ibid. p. 57.

30. Octavio Paz, *The Labyrinth of Solitude* (New York: Evergreen Books, 1961), p. 9.

31. Ibid.

32. Cited in: Erik H. Erikson, "The Concept of Identity in Race Relations," in: Talcott Parsons and Kenneth B. Clark, Editors, *The Negro American* (Boston: The Beacon Press, 1967), p. 229.

33. Miguel de Unamuno, *España y los Españoles* (Madrid: Afrodisio Aguado, 1955), p. 134.

34. Carlos García Prada, *Estudios Hispano-Americanos* (México: El Colegio de México, 1945), p. 12.

35. Victor Raúl Haya de la Torre, *Adonde va Indoamerica* (Santiago: Editorial Ercilla, 1936).

36. Germán Arciniegas, *América, Tierra Firme* (Santiago: Editorial Ercilla, 1937).

37. Emilio Oribe, Editor, *El Pensamiento Vivo de Rodó* (Buenos Aires: Editorial Losada, 1944), p. 12.

38. Alberto Zum Felde, *El Problema de la Cultura Americana* (Buenos Aires: Editorial Losada, 1945), pp. 9–26.

39. Luis Alberto Sánchez, *Existe la América Latina?* (México: Fondo de Cultura Económica, 1945).

40. José Martí, *Selección,* Mauricio Magdalena, Editor (México: Ediciones de la Secretaria de Educacion Publica, 1942), pp. 27, 32.

41. Octavio Paz, *The Labyrinth of Solitude,* p. 10.

42. Euryalo Cannabrava, "Present Tendencies in Latin American Philosophy," *The Journal of Philosophy,* March 3, 1949, pp. 113–19.

43. Octavio Paz, *The Labyrinth of Solitude,* p. 11.

44. Donald Malcolm, "The Author in Search of Himself," p. 234.

45. Nicholas Berdyaev, *Dostoevsky,* cited in: George B. de Huszar, *The Intellectuals* (The Free Press of Glencoe, 1960), p. 109.

46. Cited in: Mason Wade, Editor, *Canadian Dualism* (Toronto: University of Toronto Press, 1960), p. 8.

47. José Vasconcelos, *Obras Completas,* p. 918.

Index